# LOST DIVAS

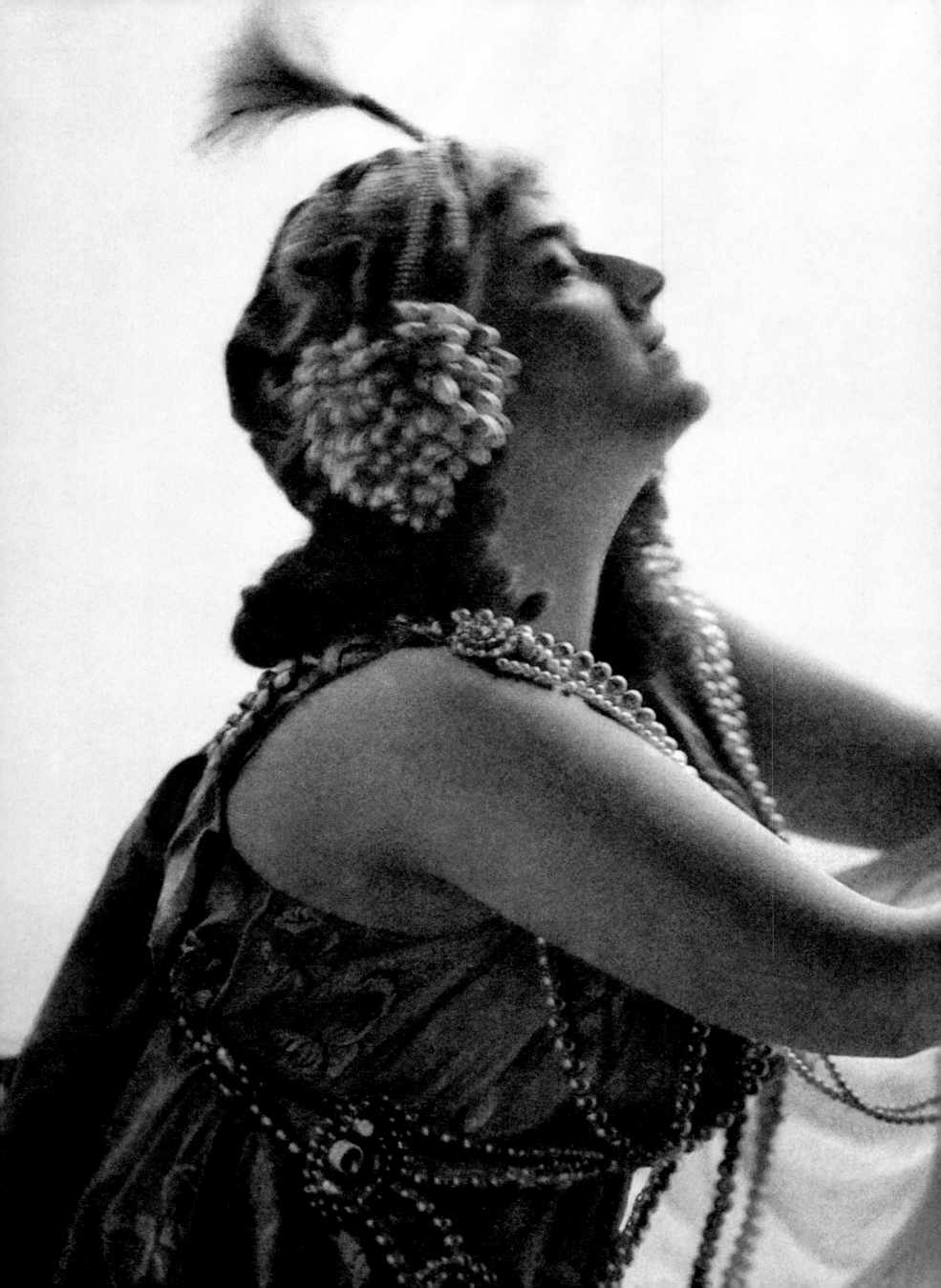

# LOST
# DIVAS

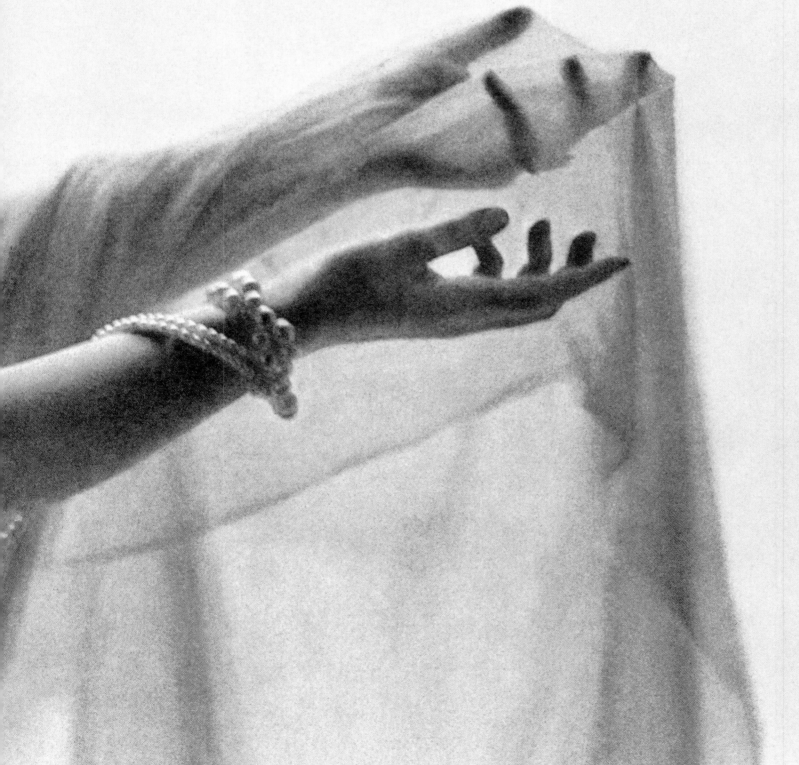

© 2005 Assouline Publishing
601 West 26th Street, 18th floor
New York, NY 10001, USA
Tel.: 212 989-6810  Fax: 212 647-0005
www.assouline.com

Translated from the French by Nicholas Elliott

ISBN: 2 84323 735 1

Color separation: Gravor (Switzerland)
Printed by Grafiche Milani (Italy)

ANDRÉ TUBEUF

# LOST DIVAS

ASSOULINE

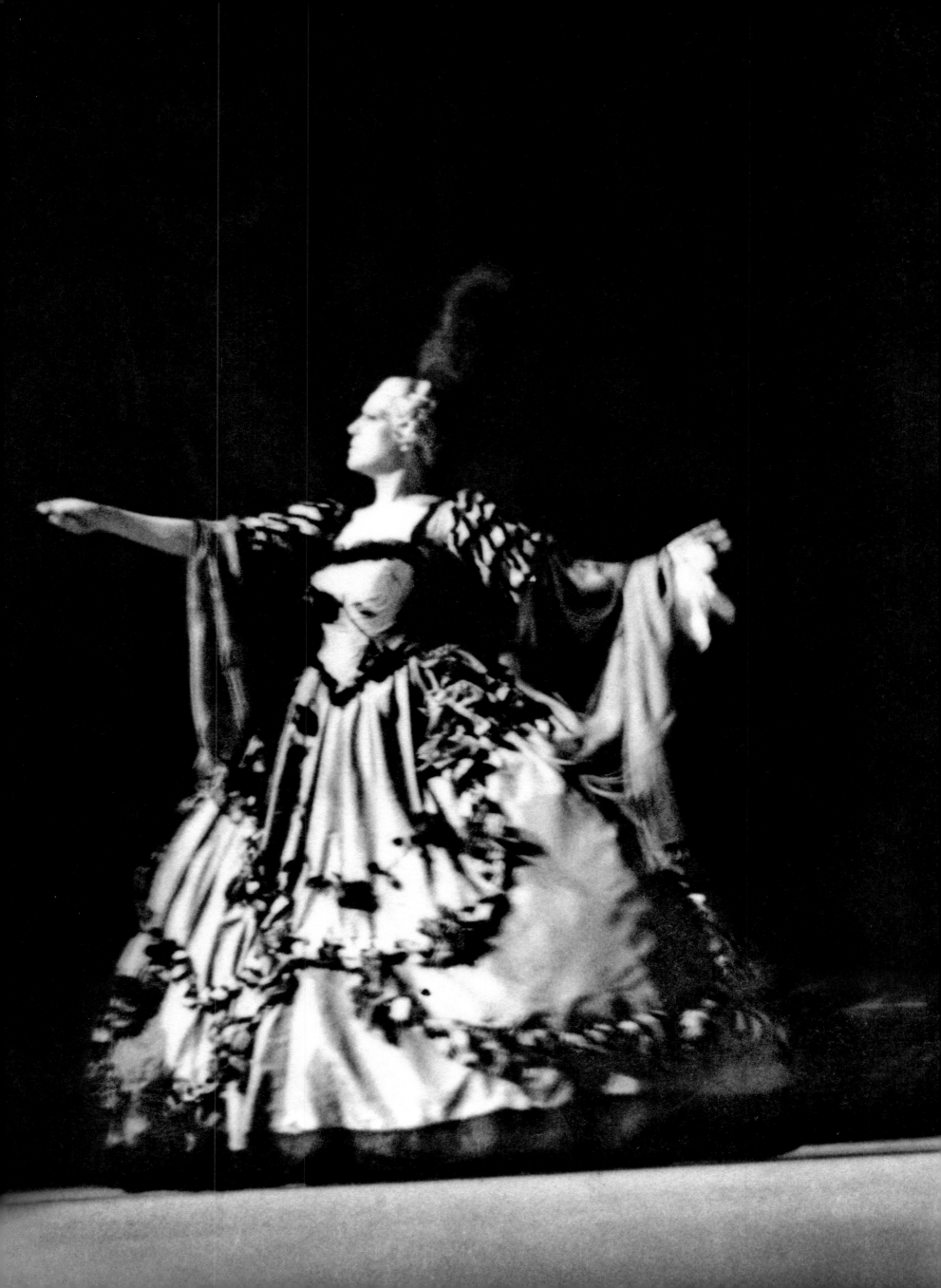

It wasn't just opera that I loved, it was the human voice: its tone, its inflections, and, above all, its individuality. Think about it. Was there ever anything more opaque than a black 78-rpm record? And yet, the voice would rise out of it, with a power of suggestion that was pure magic. Back then, a record was only as long as a single aria—and that was if you were lucky. Sometimes arias were cut off mid-flight, and the entirety of a character's role was never conveyed. Nevertheless, certain voices broke through. They called out to me with irresistible eloquence and urgency.

The means for documenting opera at the beginning of the 1950s were practically non-existent. Today, an Internet connection and the click of a button deliver all you need to know about a singer, from her place of birth to her entire discography. (You may even be able to listen to some of her famous pieces or view her picture.) Back in my day, you had to dig through secondhand-book stores and flea markets for out-of-print books and almanacs and fantasize over the odd issue of *Le Théâtre,* an arts and theater magazine founded at the end of the nineteenth century. I was in the habit of going to rue Lamartine, where a heavy-set woman with two inches of makeup ruled over a chaotic junk shop and four cats named after opéra-comique characters. Her regulars evoked the golden age of the Salle Favart theater, in the company of its faded glories—or their dressers. Kneeling on the floor, flipping through old programs, I wouldn't miss a word they said.

One day when I was feeling particularly enterprising, I decided to take a chance on a buried carton that allegedly contained nothing but meaningless forms and papers. In fact, I had stumbled upon hundreds of cardboard-mounted pictures from the portrait studios of Reutlinger, Nadar, Bert and Benque studios. The subjects were political figures and authors and, especially, Comédie Française actors and opera singers, who were the era's photographic best sellers. Pencil inscriptions on the backs of each picture detailed the names of the singers and the titles of the pieces being performed. The unassuming box was nothing short of a goldmine. Unfortunately, a sagacious Canadian had already gone through it, snatching up pictures of all the most famous singers. The Canadian had limited himself to one picture per singer, however, and I was left with enough material to create a vivid portrait gallery that

spanned the gamut from Rose Caron to Félia Litvinne among the women, and from Victor Maurel to the legendary Jean de Reszké among the men.

Most of the names I discovered that day were new to me. I could hardly wait to put a face to their voices. The greatest surprise was that women I had expected to be stocky and graceless turned out to be magnificent creatures blessed with dramatically penetrating eyes. Their gestures and attitudes revealed an authentic art of the pose as well as a clear understanding of how to use the photographer's eye to offer themselves up to an adoring public in the best possible light. Singers such as Maria Kousnezoff, Fanny Heldy, Rose Caron, and Emma Calvé carried their stage presence wherever they went—it was innate. And though they might require luxury fabrics to play Thaïs or Salomé, they needed only the plainest of frocks to represent Iphigenia. Their bearing said it all: These women were divas. And then there were those eyes, which had so much to say about their tone.

At the time, I was able to acquire the whole set over a two-year period without risking bankruptcy. Then, during my first trip to Salzburg, in 1957, chance, or rather predestination, drove me to the shop run by Frau Ellinger, the official photographer for the city's opera, music, and theater festival since it had been founded. Beside her photos from the current festival, Frau Ellinger offered a box of archival prints. I made a dash for it and immediately uncovered two stunning portraits of Maria Ceborati and Viorica Ursuleac. Would this be my opportunity to find Germaine Lubin as Donn'Anna, my greatest wish?

Though I was a stranger, the enthusiasm I displayed as I stretched my rudimentary German to ask for more pictures tickled the old lady to the point that she spent an entire afternoon sharing her memories with me. She pulled out pictures of Sigrid Onegin and her limousine in front of the Mozarteum and was simply over the moon when I was able to identify French singers whose names she had forgotten, such as Gabrielle Ritter-Ciampi, shown at the Glockenspiel with Franz Schalk and Bruno Walter. These new discoveries piqued my curiosity. Suddenly I knew faces without voices. Luckily, around the same time, the *Lebendige Vergangenheit* (Living Past) collection in Vienna began resurrecting voices thought to be permanently lost to the foolishness of technological progress maniacs who had destroyed the old wax discs

"to make room," as Reynaldo Hahn had painfully predicted. Now, times had changed and lost voices were resurfacing, captivating the public as part of the great boom in opera and, most significantly, the LP.

Divas! They were the most prestigious, unforgettable characters of their era! When cinema first unveiled its silent magic, it turned to opera stars such as Lina Cavalieri, Geraldine Farrar, Mary Garden, Maria Kousnezoff, and Emmy Destinn for its pedigree. The simple fact was that opera singers were the only stars in the world. Theater actresses such as Sarah Bernhardt and Eleonora Duse were also world-renowned, and Réjane was famous in France, but the opera singer's craft was far more demanding, far more unusual. Audiences were entirely justified in placing them at the top of their pantheon.

And when vocal performance combined with authentic physical beauty, as was sometimes the case, the lucky chanteuse scaled heights of glory previously unimagined.

Divas! Divine creatures, inaccessible, stellar creatures. In Saint Petersburg, grand-dukes attached themselves to Patti's carriage and pulled her through the streets. Cavalieri's carriage traveled over a bed of roses all the way from her hotel to the Opéra. Postcards, the nuts and bolts of this sweeping fame, were sold by the millions and brought the singers' splendor and suggestive poses to starstruck dreamers the world over. To this day, it's rare to find a book dealer in Paris or Vienna who doesn't have something featuring the twin champions of global popularity—Lina Cavalieri and Geraldine Farrar. Of course, the postcard trade moved on with the twenties and the arrival of the silver screen's own stars. Business continued, but with a different breed of subjects: Theda Bara, then Garbo. Opera remained vibrant and popular, but only in a few rarefied places such as Berlin, Vienna, and Munich. (Certainly more so than in Paris, where it experienced a real decline). Yet the cult of the opera star survived, and people took to writing each other on the backs of photos of Claire Dux, Maria Ivogün, or Maria Jeritza in the same way that today's museum-bought reproductions of Monet's *Water Lilies* and Van Gogh's *Sunflowers* are a popular mode of communication.

In Vienna, the golden age of opera portraiture came when the photographer Setzer married Marie Gutheil-Schoder, one of the stars of the Mahler era, and gained privileged

photographic access to the period's main stars, who would routinely sit for him, or for his rivals, Mme d'Ora and Franz Löwy. Germaine Lubin first found sumptuous photographic immortality under the lights of Löwy's studio in Vienna, then in the Paris studio of the brilliant Laure Albin-Guillot (later Harcourt). Whether on film or on vinyl, the offering is total and absolute. Just as there are photogenic faces that draw light and look good on film, there are phonogenic voices whose inflexion and tone are boundlessly eloquent. Wherever I am sitting when listening to opera records, theater settles in and takes over the space. Tosca and Isolde slip into the room, speaking for only me, and their gaze has me transfixed. This is when opera attains the supreme magic of theatrical illusion, a magic replicated by those pictures of opera singers in which a gesture or a smile makes you believe that the air is about to vibrate, that marble has come to life and that a song will soon burst from the eyes staring back at you from a black-and-white picture.

We could have selected to show other divas. The ones we've chosen aren't necessarily the most beautiful or famous. But without exception, the women we chose lived exceptional lives. Their stories could fill endless volumes of fiction. And whether it's through a face, an expression, or a pose, every one of these singers shimmers with an indefinable something that is everything and more: personality. Today, their voices are available to us, they are known, no matter how imperfect the recordings may be. Throughout this book, you will discover the women who tore up the stage at the beginning of the twentieth century, who lived under the reign of hypnotic black and white, with its incredible nuances of light gradation. Divas have now left the global spotlight to other stars, and Maria Callas may have been the last singer to live a life in opera that resounded beyond the stage. It's no surprise that the vast majority of these singers came from Europe, for Europe was where opera lived creatively, where fashions were launched and artists were discovered. At the time, America was satisfied to sit back and applaud singers in their pretty Parisian gowns as they sang their repertoire made in Europa. That time is long gone, in every way, but this book will make it possible to stop talking about lost divas as if they had been mirages. The recordings remain, and now the photos are here, in your hands, filling in the picture and bearing witness.

# Fanny Heldy

## (1888/1973)

If there ever was a singer who was irresistible onstage, it was Fanny Heldy. Devilishly beautiful, no matter what she did, her interpretive ability knew no limits. In *La Traviata,* she made the audience cry with her poignant realism, yet in Maurice Ravel and Franc Nohain's *L'Heure espagnole,* in which she remains unmatched, she drew the audience into her game with the brassiness of a chorus girl captain. She brought an inventive fancy to the stage that was sometimes worrisome and always captivating. In fact, Heldy was living proof that opera did not wait around for Maria Callas to discover creative freedom! Of course, it's difficult to imagine Fanny Heldy in some of the passive roles she chose to play, such as Elsa in *Lohengrin,* Mimi in *La Bohème,* or the title character in *Manon,* to which she contributed her own costumes, which remain legendary. She transfigured the role of Louise through the pure sensuality of her desire and the frenzy of her audacity. As Rosine in *Il Barbiere di Siviglia,* her singing may not have been unforgettable, but she was unmatched in making eyes and using her fan as an eloquent prop. And though they may be forgotten today, Fanny Heldy's heroines in *Esclarmonde* (the opera by Jules Massenet) and *Gismonda* (composed by Henry Fevrier) had astonishing impact in their time. Heldy's costumes, her hairdos, her jewels, and her aura combined in a semi-magical, semi-evil whole that fascinated as much as it haunted. Arturo Toscanini brought her to La Scala, a rare French exception, to play Louise and Mélisande—roles associated with Mary Garden, whose stage composure and social prestige Heldy rivaled with. Another connoisseur, the composer Reynaldo Hahn, wanted her to play Portia in *The Merchant of Venice.* Her rich attire in Raoul Laparra's *L'illustre Fregona* revived the memory of Sergei Diaghilev's splendors, whereas for her rendition of Carmen, a part hardly lacking in opportunities to shine through virtuoso acting and singing, she staked everything on her eyes and her sober approach. In 1937, she played a cross-dresser. Wearing the white uniform immortalized by Edmond Rostand, she created Jacques Ibert and Arthur Honegger's *L'Aiglon* with a slenderness and physical composure that cast her shadow over the memory of the great Sarah. She eventually married Marcel Boussac and left the opera from one day to the next, leaving her old rose taffeta dressing room at the Opéra to be resurrected by Maria Callas some years later. After she left the opera, Fanny Heldy reigned over the racetracks where her husband was a regular winner. She was splendid, friendly, and always adored.

Fanny Heldy: in *The Barber.* No matter how she hid herself, those eyes always gave her away.

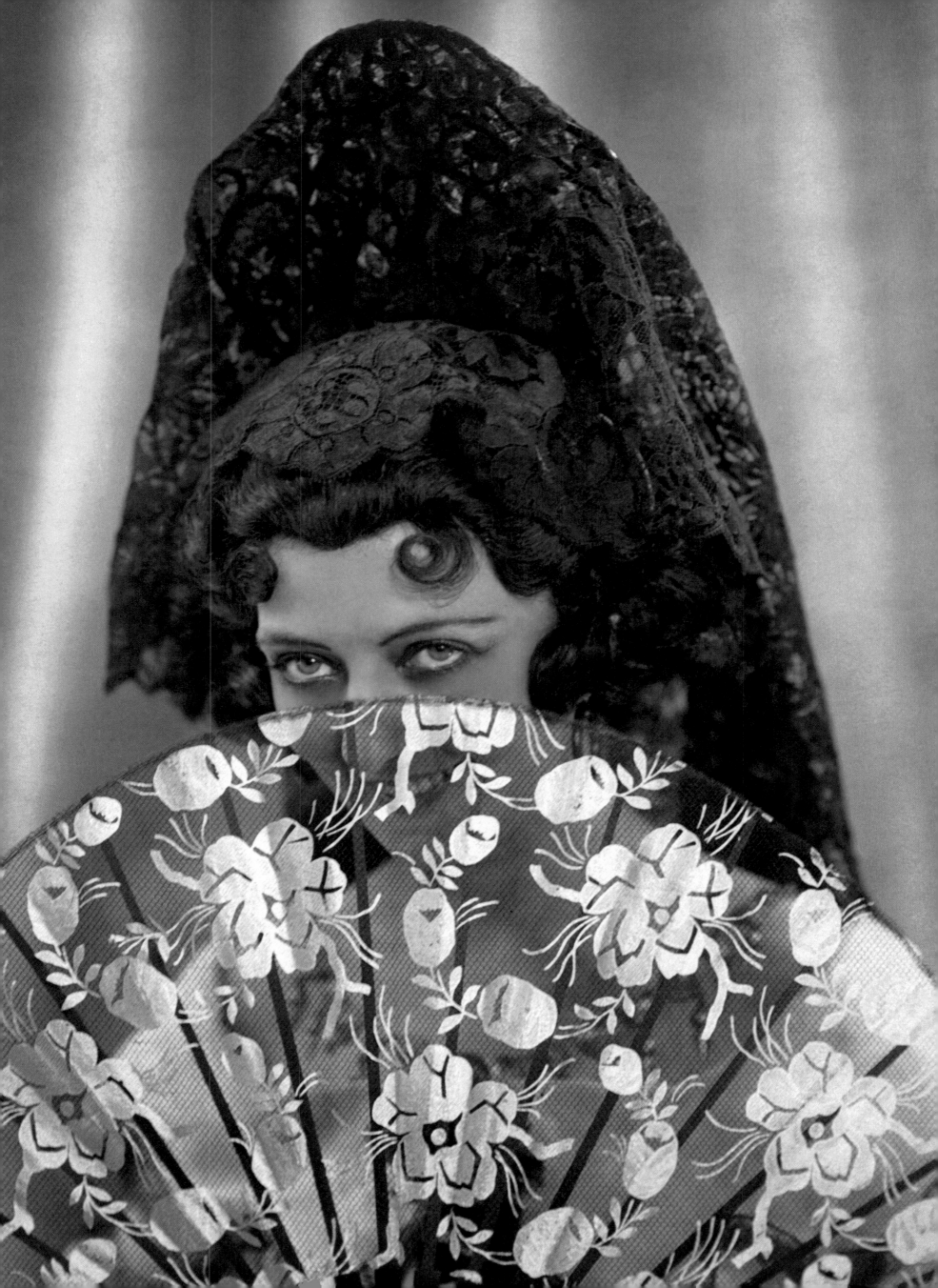

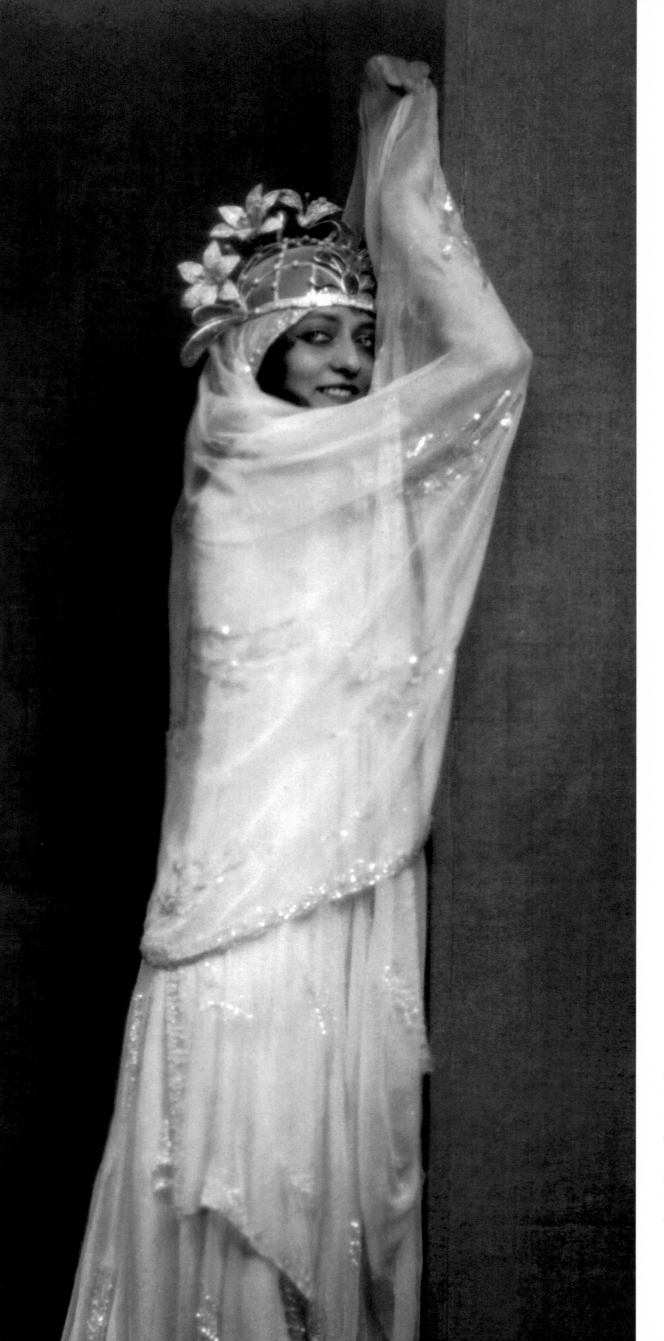

LEFT:
Fanny Heldy creates an incredible
magical silhouette as Gismonda,
as iflifted from a fairy tale.

RIGHT:
Heldy in *Paillasse*, the defiance
of a devouring, brilliant smile.

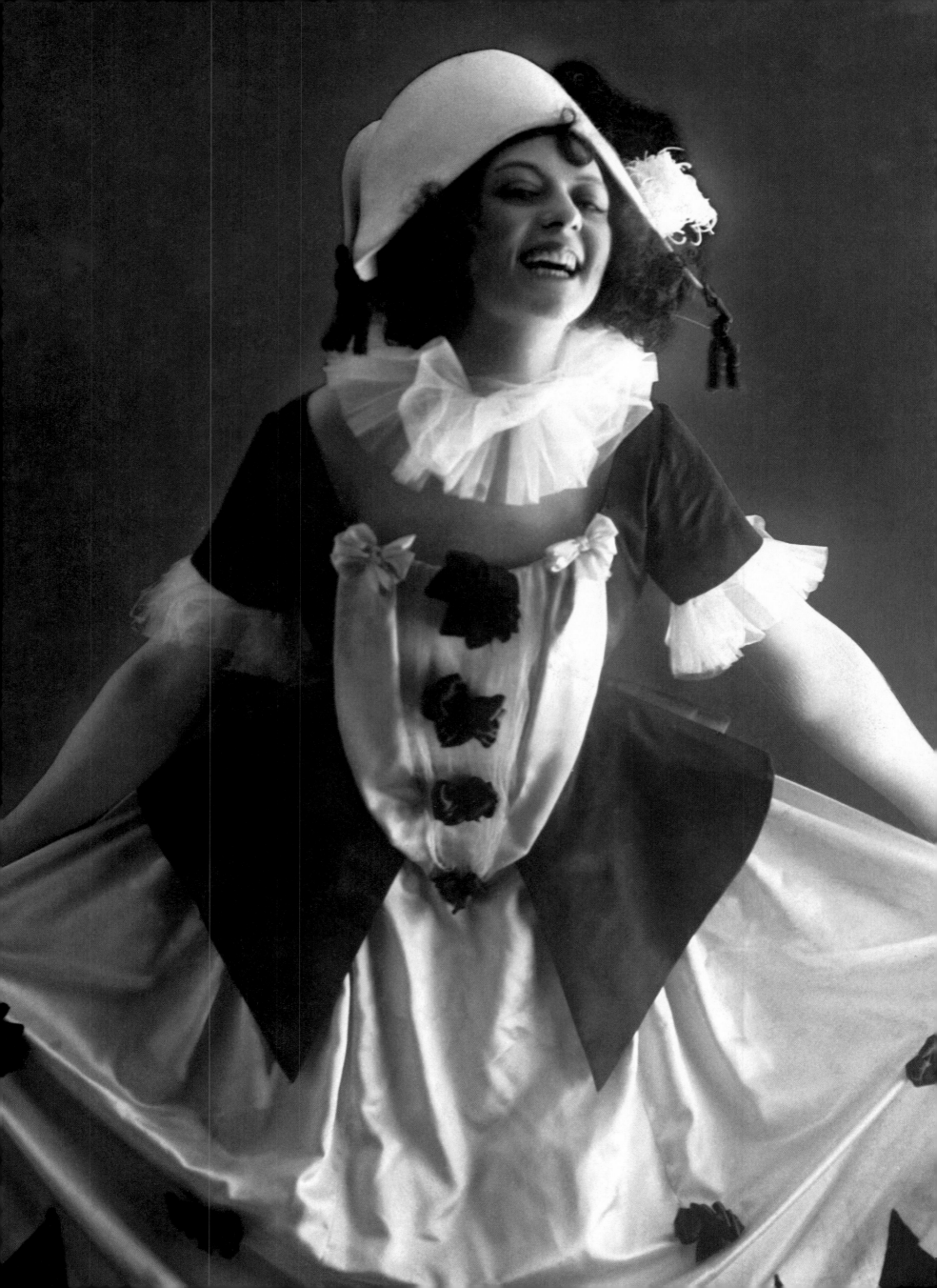

# Maria Jeritza
## (1887/1982)

Her nickname was Mizzi, but soon enough no pet name could fit this tall, thin Slovenian blonde. She was *die* (the) Jeritza, the one, the only beloved singer of Vienna and, especially, of Emperor Franz-Josef. After discovering her in *Fledermaus* in Bad Ischl, he despairingly asked why the opera singers were so fat! She was only 25 when she broke out with a sensational double tour de force: a Belle Hélène produced for her by Max Reinhardt, and the world premiere of the first version of Richard Strauss's *Ariadne auf Naxos*. She went on to create other Strauss parts: the version of Ariadne with a Prologue, produced in Vienna in 1916, the Empress in *Frau ohne Schatten,* Salomé, and Ägyptisch Helena. And thanks to her, Leos Janacek's previously disdained *Jenufa* was accepted and acclaimed in Vienna, then in New York. Composer Erich Wolfgang Korngold wrote the fabulous double role of Marie/ Marietta in *Tote Stadt* specifically for her, and proudly watched as the inextinguishable power of her high notes and her stunning appearance entranced Vienna and seduced New York. Her daring onstage caused some scandals and much adoration. In *Tosca,* as a dazzling blonde, she sang "Vissi d'arte" prostrated on a rug; at the end of *Carmen,* she let herself fall down the stairs of the arenas with a knife in her stomach. An adoring Giacomo Puccini asked her to create his *Turandot*. Though she wasn't able to play the role at La Scala, she made up for lost time at the Metropolitan Opera. She was famous in the opera world for getting into furious free-for-alls. A less celebrated fact is that, during a long absence from the stage (she had indignantly refused the pay cuts imposed by New York following the Wall Street crash), she headed a pro-Nazi lobby in Hollywood. She was married to low-ranking aristocrats and millionaires. When the war ended, she sent Richard Strauss innumerable food packages, which he thanked her for by dedicating "September," the most beautifully of his *Vier letzte Lieder* (Four Last Songs), to her. He even offered her a fifth *lied,* "Malven", which she kept secret. After staying away from the stage for twenty years, she made a sensational comeback in Vienna in 1952, triumphantly reprising the risky roles she had played at 30, Salomé and La Fanciulla del West. Later, when *Ariadne* was produced in New York, a recording date was organized for Jeritza to sing with her lifelong Viennese rival, Lotte Lehmann. Both women were 80, but Jeritza was still blonde, wearing a breathtaking hat and huge black sunglasses. Worn down and discouraged, Lehmann suddenly felt old and made the legendary comment: "What can you do about it? She is the sun!"

Maria Jeritza: Salomé doesn't need to remove her veils. Her face is all she needs to get what she wants.

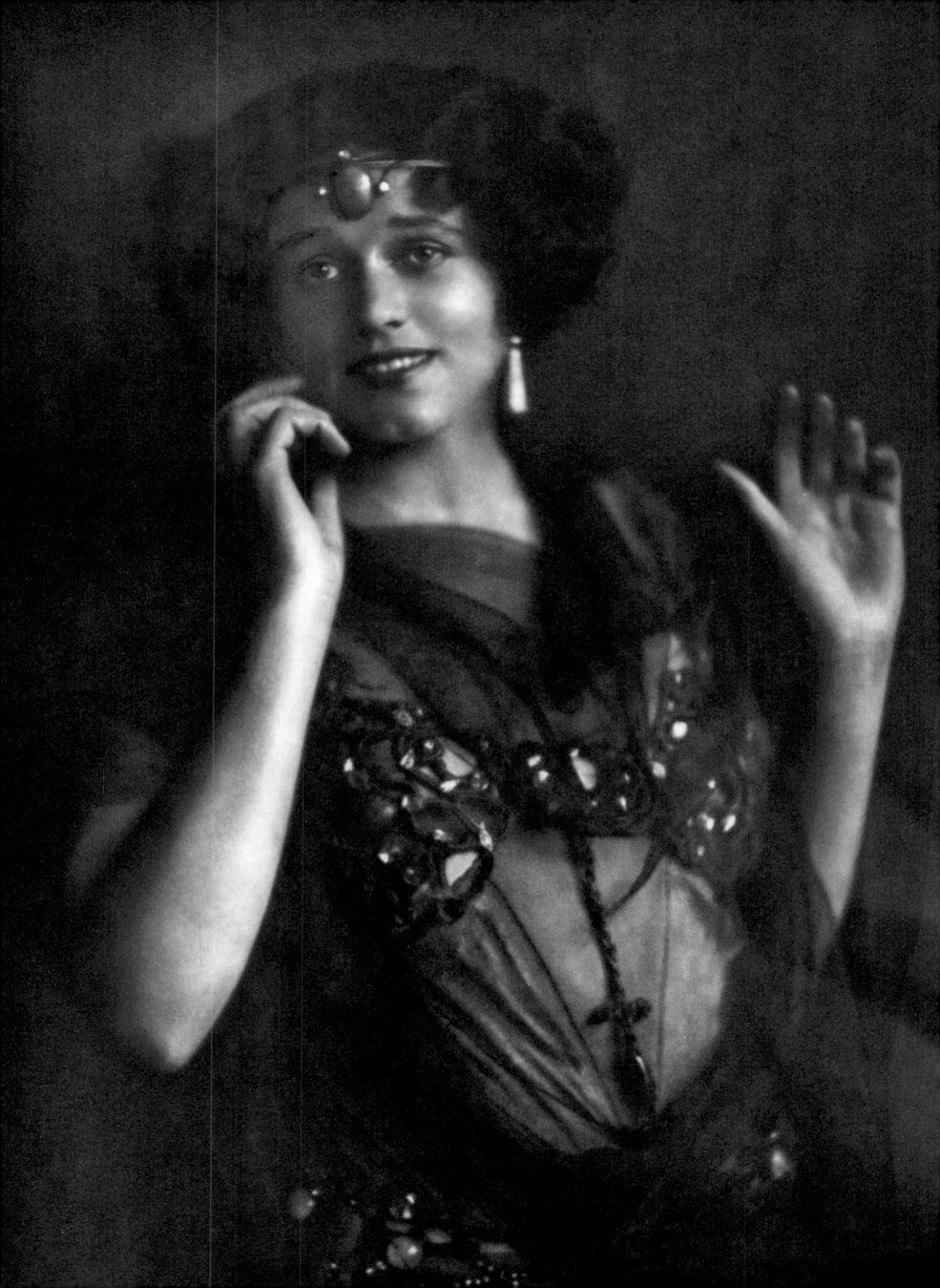

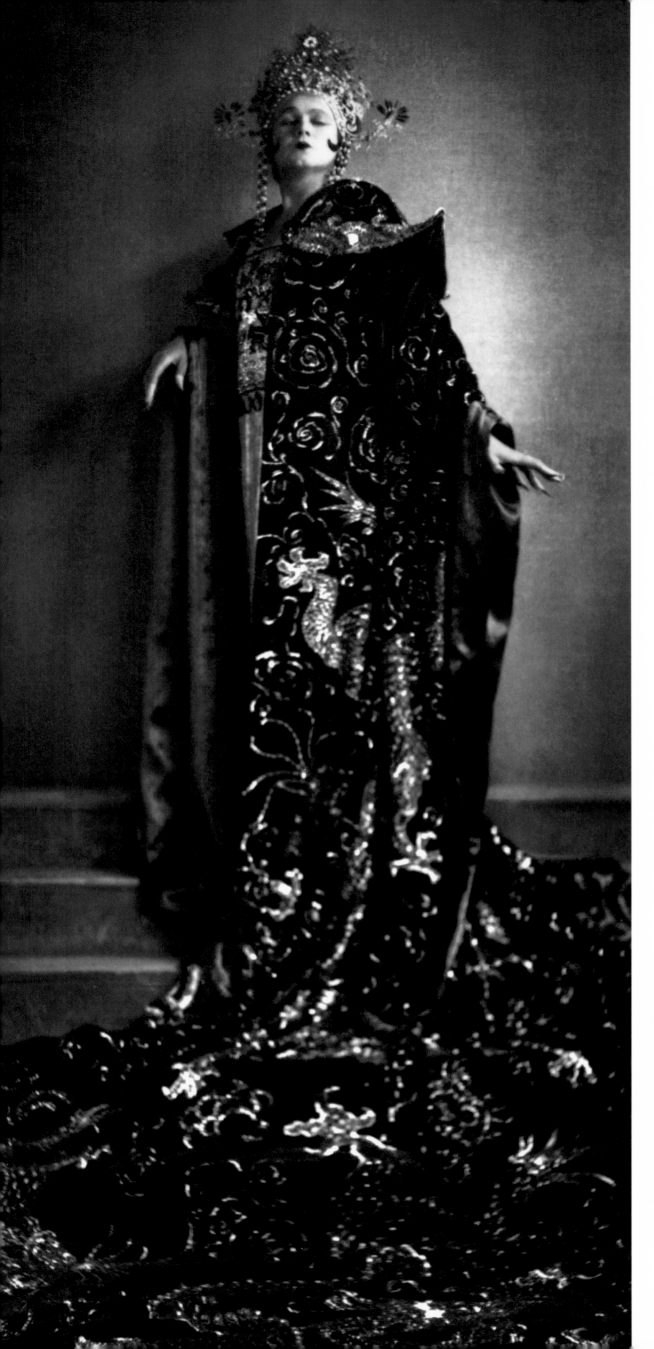

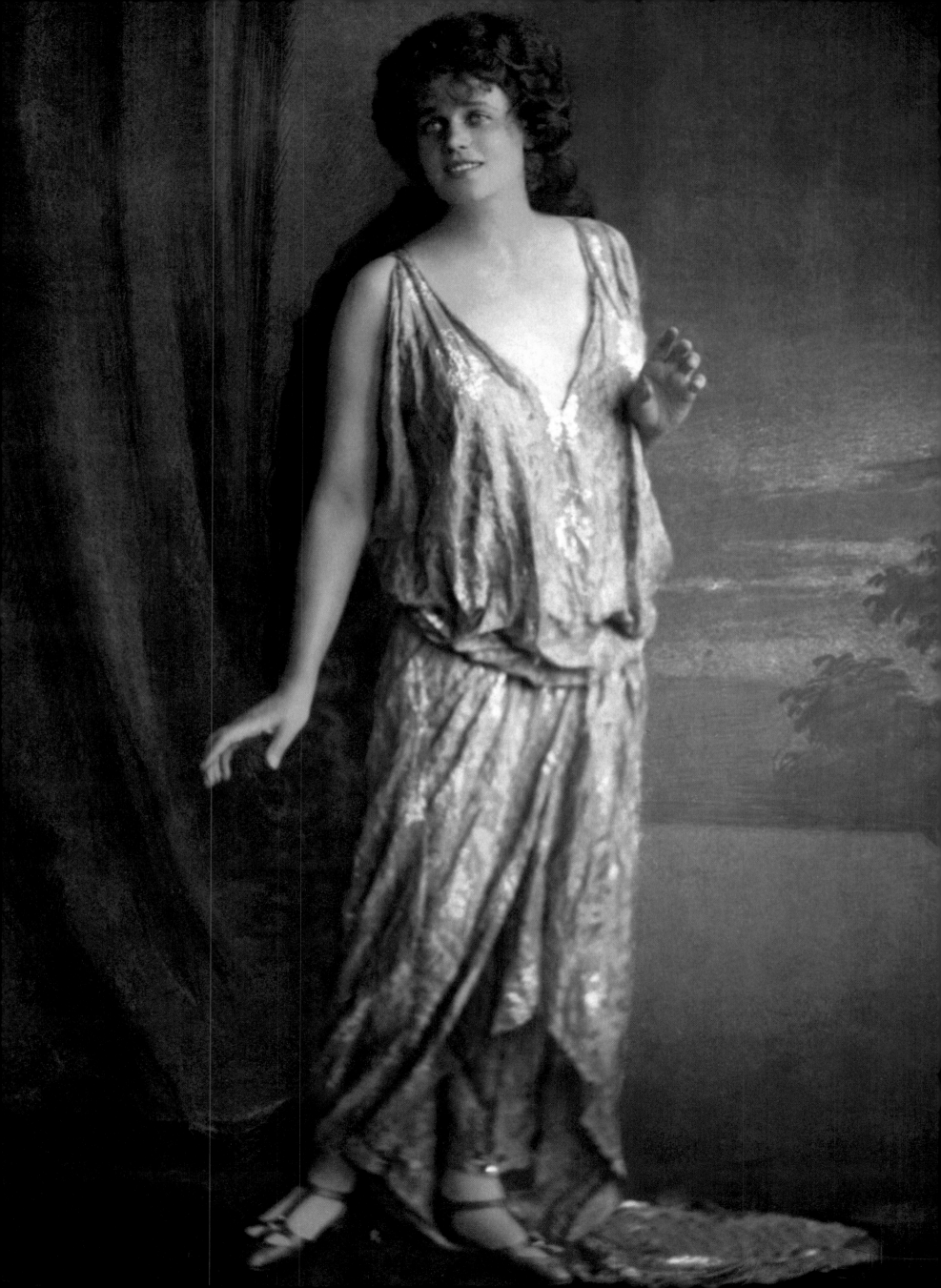

# Lina Cavalieri

## (1874/1944)

She was a supermodel before the job existed. Only the word "supermodel" properly conveys Lina Cavalieri's global prestige and the innumerable times she appeared on the front page. Even when she was still a simple café concert singer, her postcards flooded the market. It must be said that her beauty was enough to make a monk forget his vow of chastity. She had milky skin, fiery eyes, distinct features, and a remarkably slender waist, particularly given the norms of her era. And though she looked like a Madonna, she was no saint. All she had to do was bat her eyelashes and she had rose to the top of the opera world, opening the New York Metropolitan Opera's season with the idol of Saint Petersburg, Enrico Caruso. In fact, Caruso had met her some years earlier, when she was only a second-rank singer, but was already wearing the fabulous pearls and emeralds belonging to the family of Prince Baratynski (whom she probably never actually married). Propelled by her new status as an opera star among American tycoons, she nearly caught herself a Vanderbilt. She made up for her near miss with a Chanler, from the Astor clan, and got him to agree to a contract by which he left her all his belongings in exchange for a legal marriage required to last only eight days! Next, she married Lucien Muratore, a handsome tenor she acted with in the first silent film opera adaptation. Though her film role as Manon Lescaut didn't allow her to be heard, she could be seen, which was sufficient for the thousands of aficionados who would never have dreamed of getting anywhere near her in the theater. The tag of "most beautiful woman in the world" followed her wherever she went for several years. Even the famous painter and illustrator Erté, who dressed Cavalieri for the opera and had seen a few beauties in his time, agreed that she was indeed the most beautiful. Cavalieri was also a businesswoman and a redoubtable shopper. She gave her name to her own line of beauty products, and was known to leave the jewelry and clothing stores on rue de la Paix empty whenever she came looking for theater gowns or jewels such as the ones she wore in Fedora. *Romance,* a play that attributed her many loves and scandals to the transparent character of Rita Cavallani, was played thousands of times over. Eventually, the movies also got hold of her story with Greta Garbo as Cavalieri. Cavalieri finally married a Campari heir and retired to her palazzo in Fiesole. She offered the church in her mother's native village two sumptuous theater costumes, which were refit for two statues of the Madonna. Her death was in keeping with her melodramatic life: she died in 1944, in bed, killed by allied bombs.

Lina Cavalieri. The best advertisement for her line of beauty products? Cavalieri herself.

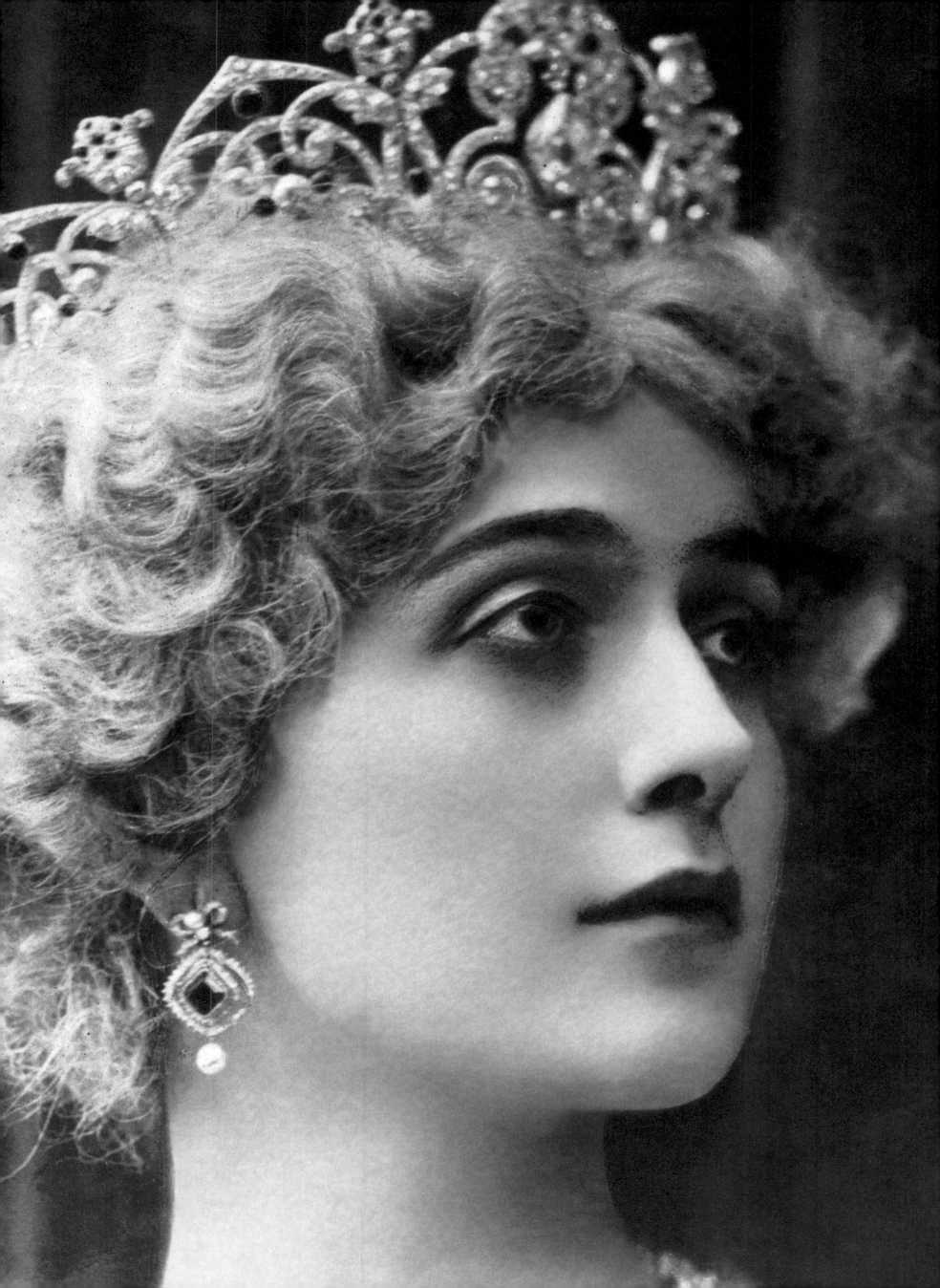

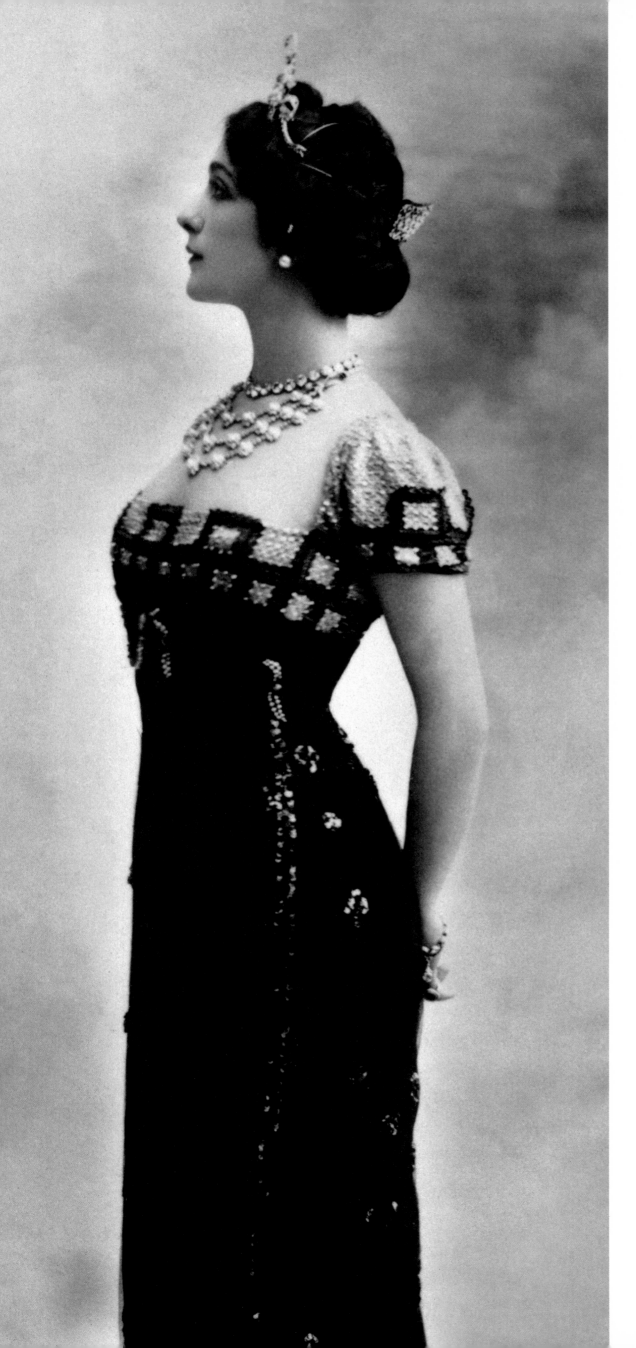

Lina Cavalieri: a style icon.

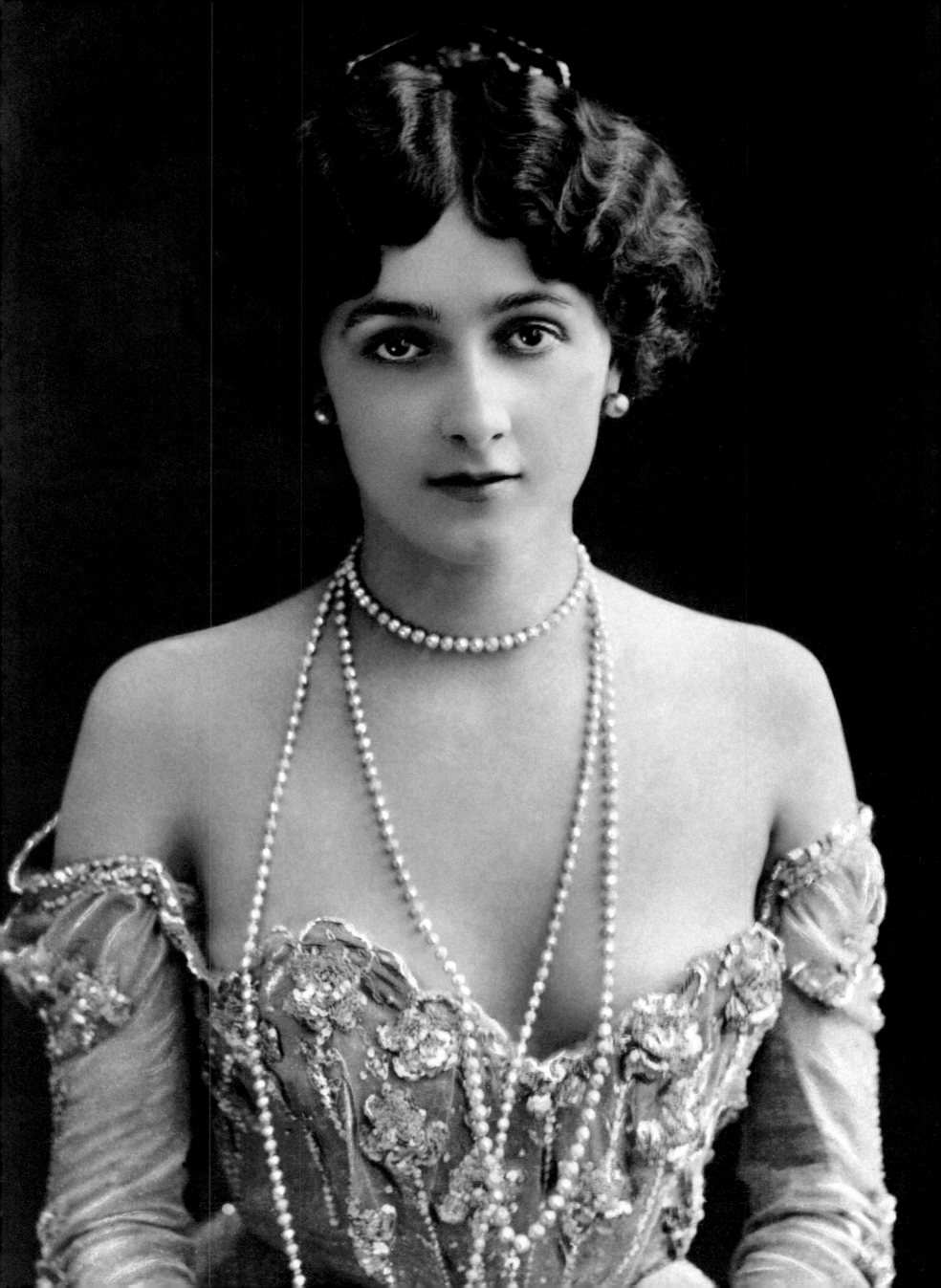

# Claire Dux

## (1885/1967)

No other diva can boast of having had her portrait painted by one of the greats of her century—Salvador Dali! Her tone was made of honey, gold and light, and was possibly the most delicate ever heard from a German soprano. Her phrasing seemed to be guided by Mozart. She herself was precocious: at 12, she was playing and singing Gretel in Engelbert Humperdinck's magical children's opera. She made her official debut at 21, as Pamina, then as Agathe, immediately stepping into the archetype of the German maiden. She stuck it out for a while, until the role of Sophie in *Der Rosenkavalier* allowed her to break from the mold. She played Sophie in Berlin in 1911, then in Covent Garden, where she conquered London. The English audience remained faithful to her: For many years, no Sophie, no Pamina, no Eva in *Les Maîtres-chanteurs* was considered up to the standard set by Claire Dux. More elegant than beautiful, and a favorite of the Kaiser's (she sang the operas he liked, such as Georges Bizet's *Pêcheurs de Perles* and Étienne Méhul's *Joseph*), Dux could have seen her career stagnate in the impoverished, traumatized Berlin of the postwar period. She tried playing *Hollandweibchen,* an operetta Eimmerich Kalman wrote specifically for her, and after having gone through two husbands (Signor Imperatori, a forgotten writer, and the highly prestigious actor Hans Albers), she decided to relocate to the United States. The Chicago Opera welcomed her with open arms, and the king of corned beef, Charles Swift, fell for her charm. In 1926, at 41, Dux became a billionaire and one of the queens of Chicago's very exclusive high society by marrying Charles Swift. Her public singing appearances became quite sporadic, and Europe only ever saw her again in Salzburg, still sublimely elegant.

Claire Dux: a silhouette of light that could easily be mistaken for a fashion print.

# Emma Calvé
## (1858/1942)

Along with Rose Caron, Calvé was the ranking diva of her era. She was also a pioneer whose work verged on the revolutionary. Calvé brought temperament into the opera house and it was said that her Carmen, her most famous role, did not consist of one interpretation, but of thousands, depending on her mood the day of the performance. To play Carmen, she fully explored the contradictory possibilities of moving at will between the dark opulence of the contralto and the adamantine brilliance of the high-pitched soprano. Her versatility could nearly pass for a lack of discipline. She enraged George Bernard Shaw, who was furious that such an exceptional musical and vocal organization could go to pieces for a Carmen capable of doing anything at a moment's notice, as if she had been carried away by her own realist folly. Yet behind this facade was the iron discipline of a little girl who spent seven years as a boarder with the Sisters of the Sacred Heart and studied with the inflexible Marchesi. Calvé's voice was unhindered by her extravagances onstage and in life. She stunned everyone by developing what she called her fourth voice, a new "voice" that she claimed to learn from the last castrati and which can be heard to magical effect on some of her recordings. She debuted in *Faust,* in Brussels, in 1881, but it didn't take her long to find her way to London's Covent Garden and New York's Metropolitan, where she was a sensation in *Cavalleria Rusticana.* She drew her inspiration for Santuzza from Duse herself. She often said that she owed the hardiness and phenomenal purity of her voice to the silence of her peasant ancestors as they breathed the pure air of the Causse plateaus. Her voice was so extraordinarily healthy that, following her return from the United States (where she had toured the country singing the *Marseillaise* wrapped in a French flag to raise money for the French war effort) and her retirement from the stage, she continued to record past her 60th birthday, releasing a mind-boggling series of records that covered the most unlikely repertoire, ranging from *Norma* to *La Périchole* and even *Dixie.*

Calvé in *Carmen,* reading the cards: "Death, for both of you!"

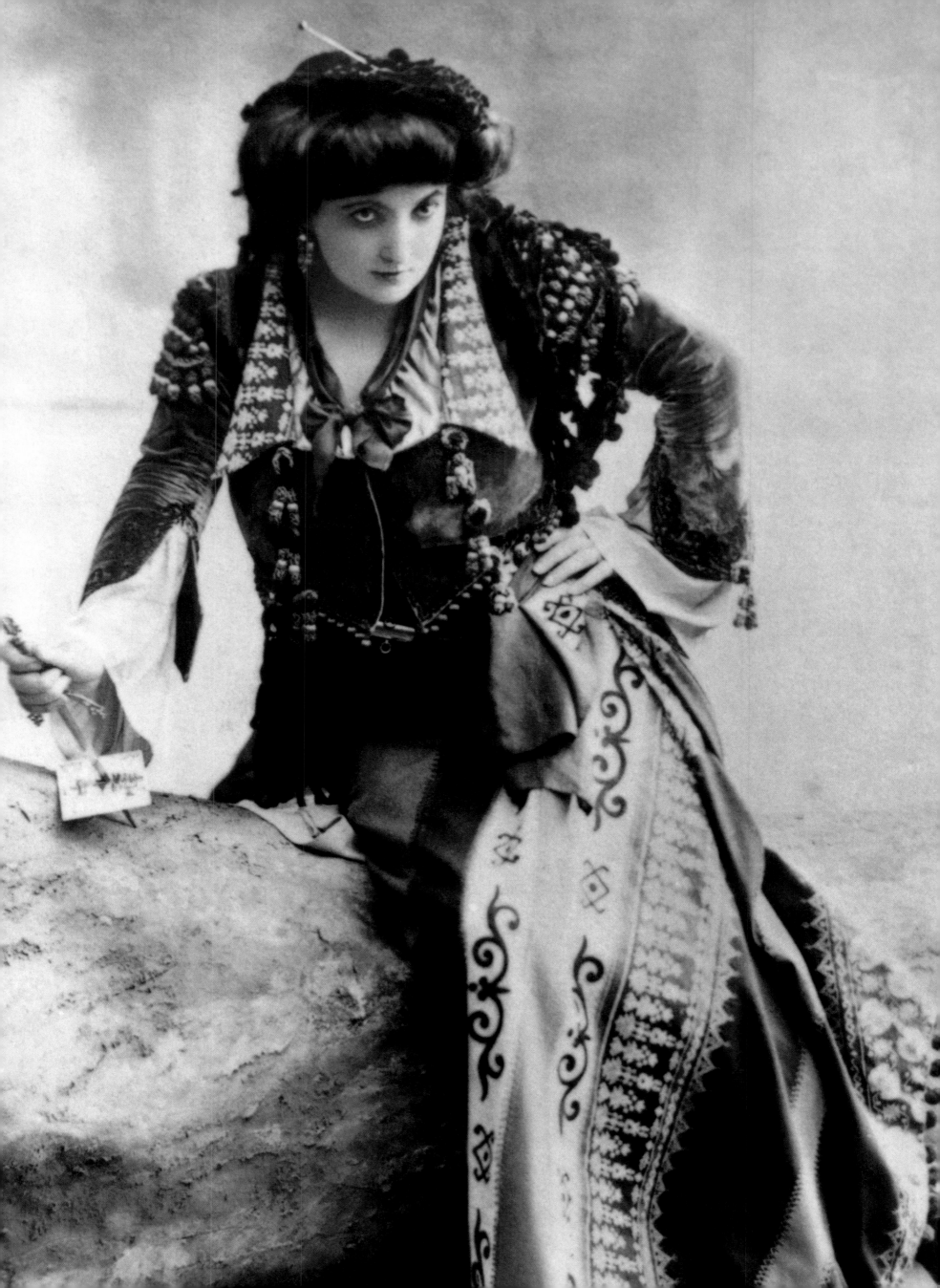

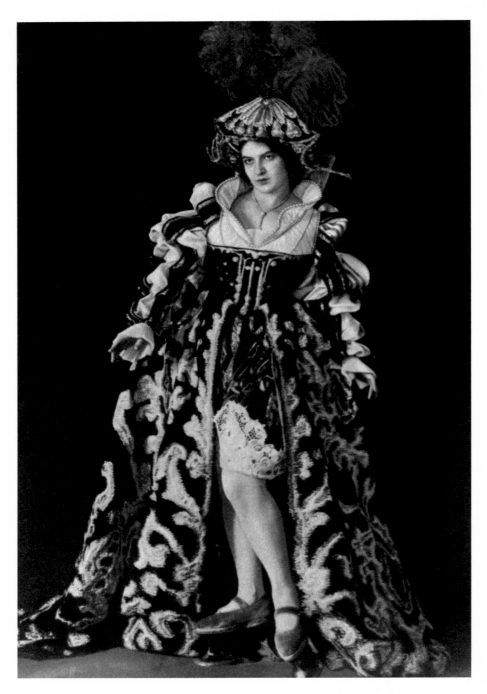

# Maria Kousnezoff
## (1869/1941)

She was born on the steps to the throne. Her father Nicolas, the Court painter, created the only portrait of Piotr Ilyich Tchaïkovsky. The tsarina took an interest in little Maria and organized her initial training as a dancer with Preobranskaya, the illustrious ballet teacher. And many years later, when Maria was a celebrated singer and a regular guest at the Tsarkoie Selo palace, the tsar allegedly enjoyed her favors. She was faithful to the Romanovs to the end, escaping from Cronstadt disguised as a ship's boy (which was believable thanks to her slender figure) and smuggling the Grand Duchess Olga's jewels out with her. By this point, she had become a tremendously cosmopolitan, incredibly versatile

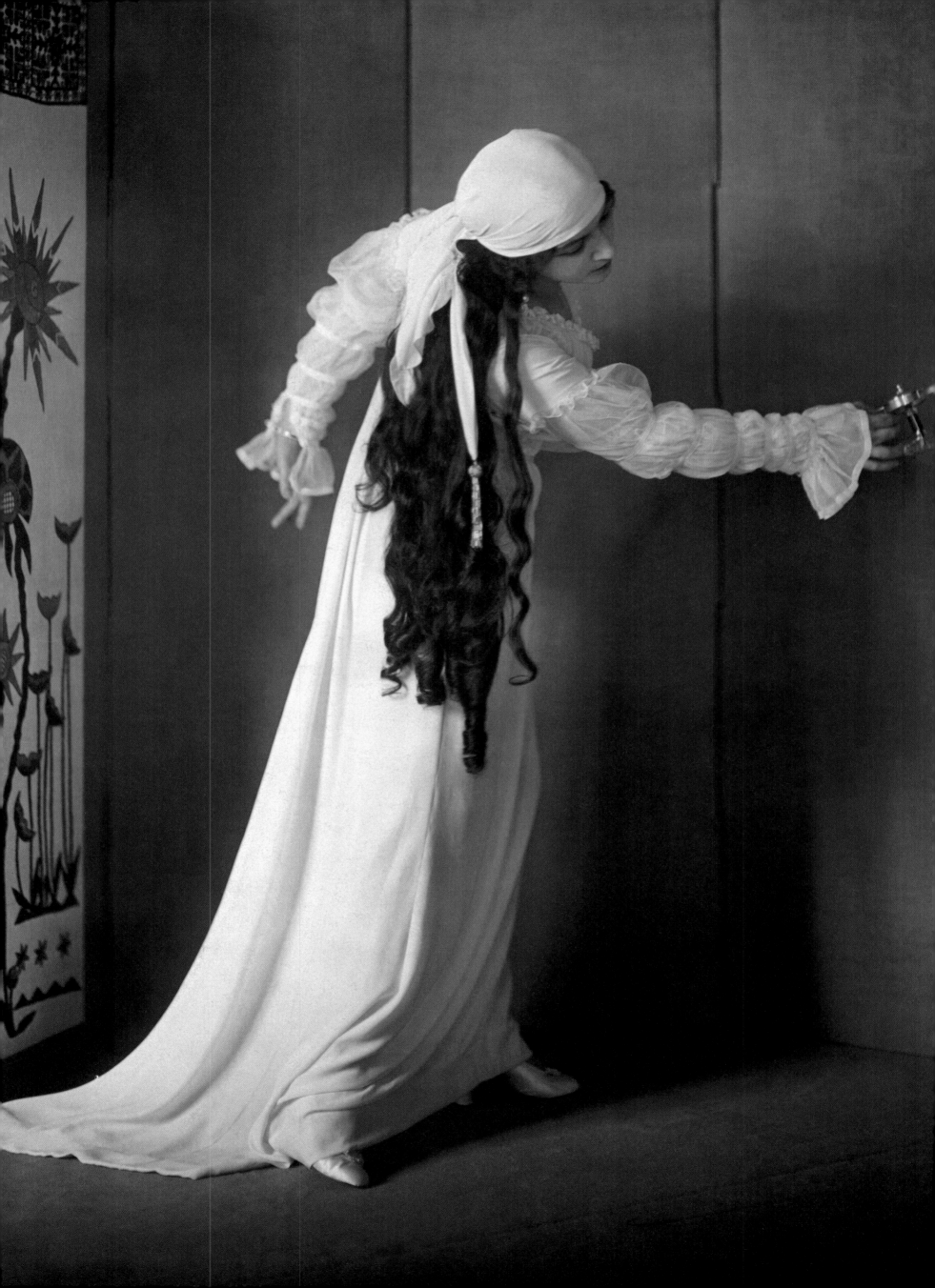

singer who had created Rimski-Korsakov's *Kitezh* at the Marie Theater in St. Petersburg
before settling in Paris, where she played Roma and Cléopâtre, two of Jules Massenet's last
works. She revealed her talent as a dancer to the public at the world premiere in Paris of
*The Legend of Joseph,* a ballet Strauss wrote for Sergei Diaghilev, and in which Kousnezoff dan-
ced and mimed but did not sing. She had already experienced Strauss's subtle rhythms in
*Salomé,* in a production for which she had forgone the double generally used by singers for
the Dance of the Seven Veils. And though Ida Rubinstein had initially been considered for
the role of Madame Putiphar, Léon Bakst convinced Kousnezoff to take the part by promi-
sing to open up the front of the marvelous Veronese dress intended for Rubinstein.
Standing tall in her incredible clogs, Kousnezoff could now show off the legs she was so

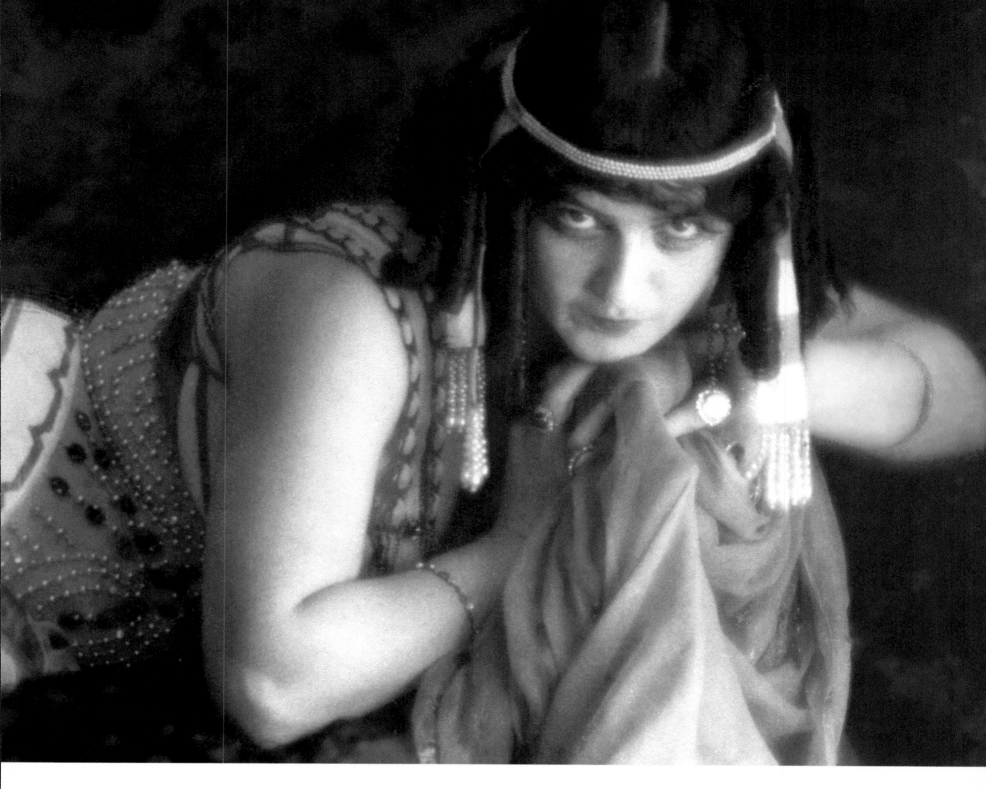

Maria Kousnezoff: Thaïs the sinner, the seductress, already a vamp.

proud of. After the First World War, she attempted to revive the Diaghilev style by putting her talent, her energy, and her fortune behind a Russian Opera in Paris. She trotted *Sadko, Russlan and Ludmilla* and *Kitezh* from Paris to Buenos Aires, but her project proved to be an impossible dream. The beginning of the thirties found her singing *Manon* in Japan and presenting her own ballet evenings in which Spanish dance numbers shared the stage with more realistic tableaux of the Parisian underworld. Film could hardly pass up such a personality. Kousnezoff first appeared as the title character in a version of *Thaïs* filmed in Moscow, then in several Jacques de Baroncelli melodramas. She lost just about everything during the Second World War, but her indomitable drive remained, along with a slew of international memories that make us regret that she never wrote a memoir.

# Berta Morena

## (1878/1952)

It is far from incidental that it was Franz von Lenbach, a painter and a regular guest of Richard Wagner's in Bayreuth, who first noticed the talent of this young Jewish beauty auditioning to enter the conservatory. Indeed, image played a crucial part in the life and career of Berta Morena. Yet whether she was in Munich (her home base during the thirty years of her career) or traveling to New York, she was never able to erase the vivid memories of her illustrious predecessors, the first heroines of Bayreuth. As far as appearance, however, she was night to their day! The glorious Amalie Materna had always been very simply dressed onstage, whether she was playing a witch or a queen. The great Lilli Lehmann used corsets to barricade herself. Morena, on the other hand, was an authentic creature of the theater. She was probably one of the first to play the great Wagnerian characters comprehensively, down to the smallest scenic and pictorial details. She also played a very realistic Santuzza in *Cavalleria rusticana* and, especially, a stunning *La Juive,* which her swarthy complexion, her splendid dark eyes, and her oriental beauty seemed to predestine her to play. She was never honored with an invitation to Bayreuth, as she was the queen of its dangerously close rival, Munich, but, all things considered, Munich was good enough for her. And no singer who so diligently avoided travel was so well rewarded. A sumptuous luxury volume, published in a minuscule print run, immortalized the iconography of this rare singer who always knew how to penetrate her roles by truly looking like them. Is it worth mentioning that the book also contained Franz von Lenbach portraits of Morena as Isolde and Kundry?

*Le Vaisseau Fantôme's* Senta seems to be born by the wind Berta Morena.

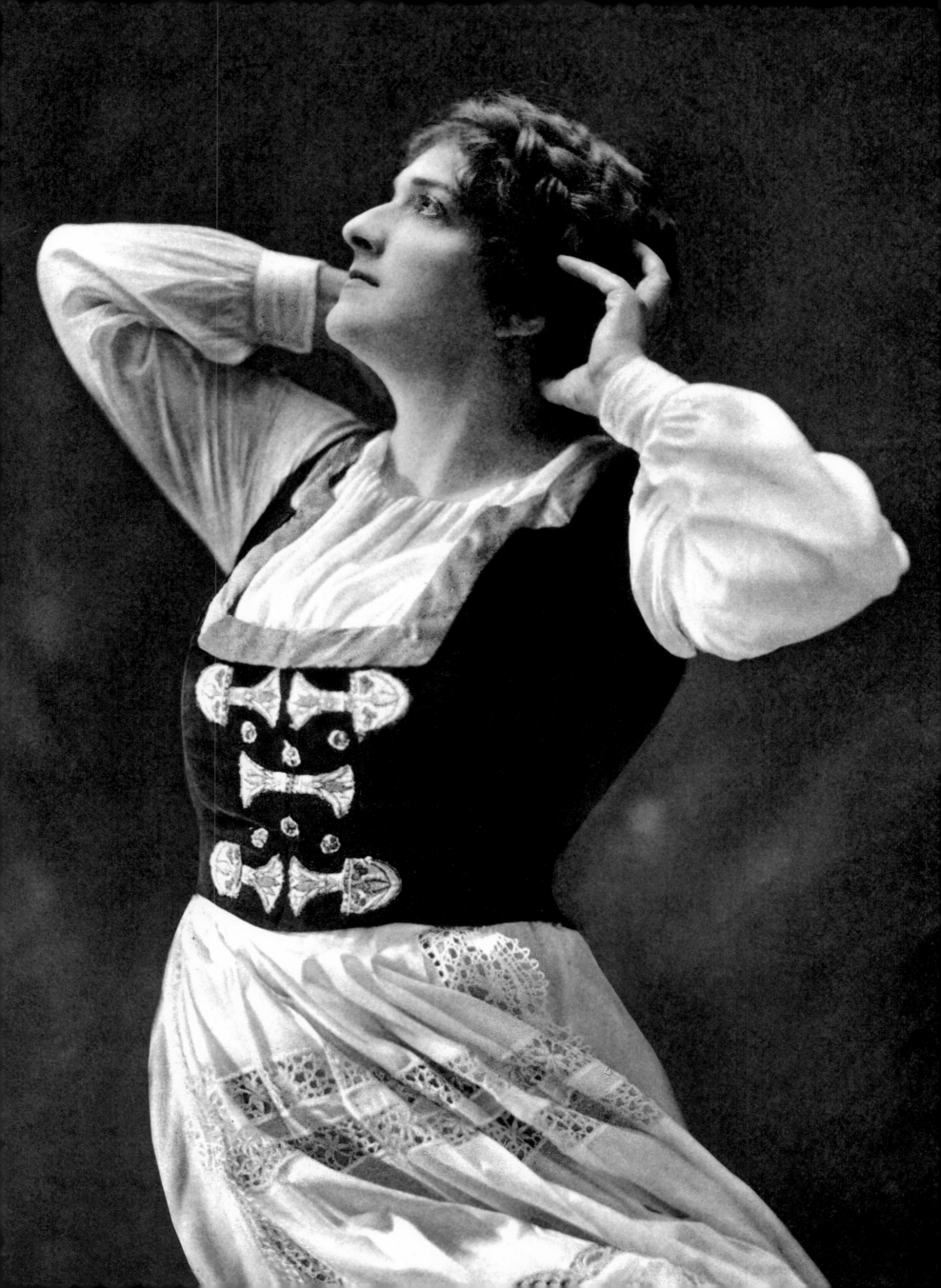

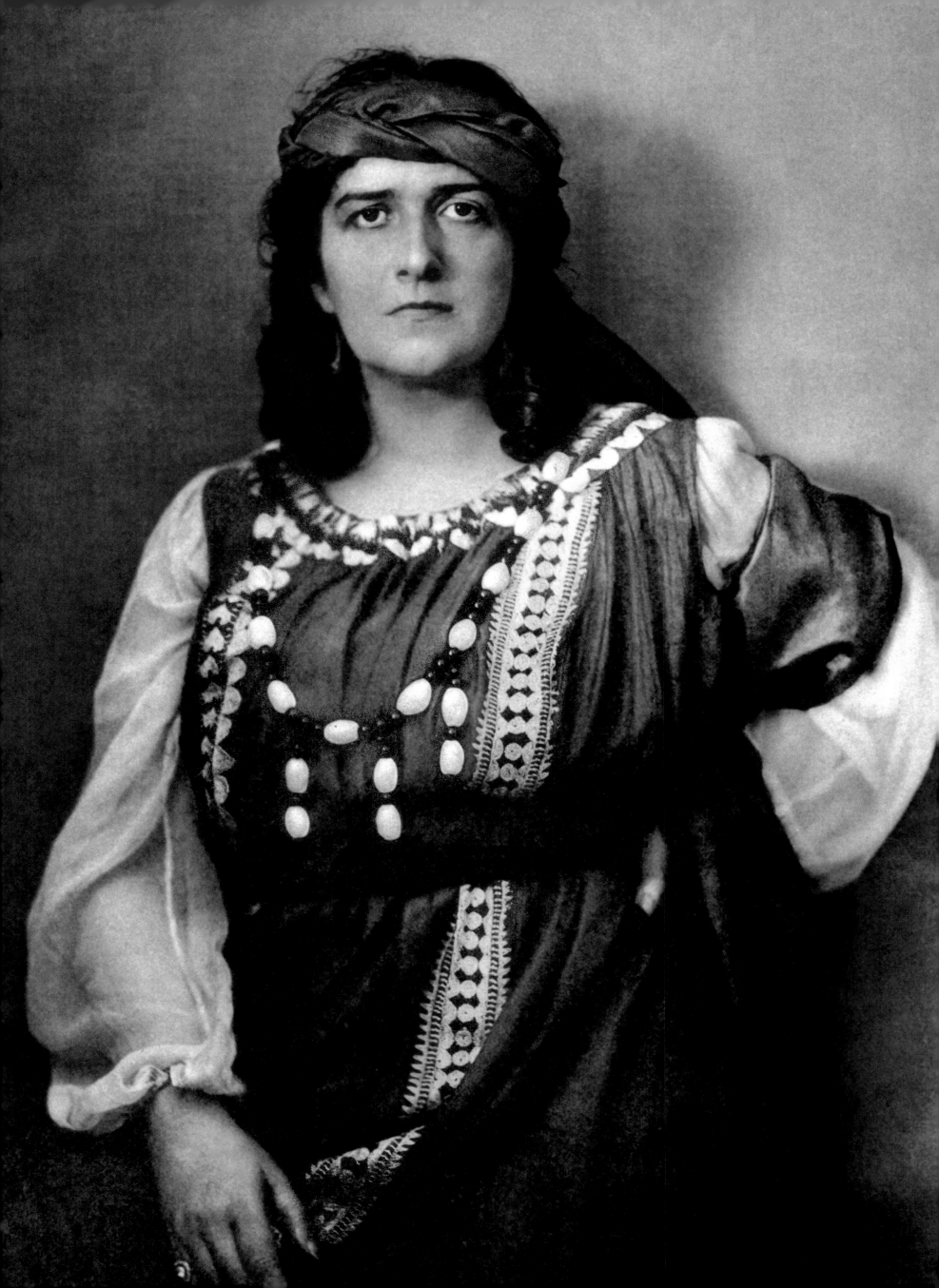

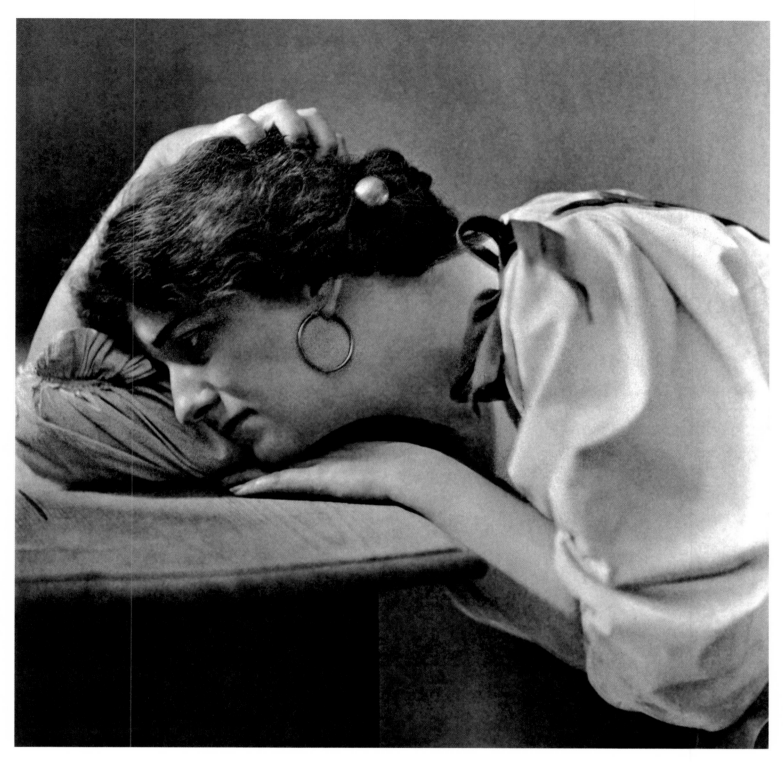

Berta Morena displaying her uncanny beauty—Rachel in *La Juive*.

Kundry repenting? No, Santuzza prostrate. Berta Morena knew
how to bring tragedy down to street level.

# Eidé Noréna

## (1884/1968)

A butterfly from the Great North, as light as a breeze, and pure as a clear mountain stream, Norena began her career near Oslo, of which few recordings remain. Once she married the great Norwegian actor Egil Eide, she changed her name, and the metamorphosis was accomplished. She did a brief stint at La Scala, in Milan, and worked with the opera singer Nellie Melba for a while, but really only took off at 40. This diamond-voiced virtuoso had a skier's long breath, which allowed her the most robust sustained notes and supported the ethereal, luminous truth of her sound. Norena was also blessed with that strangely poetic and highly moving warmth that fits only ostensibly cold, even glacial, vocal tones. She could make the public melt, captivating everyone with her poetic face and her Ophelia eyes. The future dancing star Yvette Chauviré, who was still in ballet school then, never missed a single one of Norena's appearances, and greatly admired her striking posture, her graceful movements, her beautiful clothes. Back then, the lion's share of advertisements in the Opéra's programs went to fashion spreads for the couturiers responsible for the divas' appearances. In a theater graced by supreme beauties such as Lubin and Heldy, it was nevertheless Norena who was regularly given a full page photo to display a Jean Patou hair-do. Gounod's Juliette was never so young, so gracious or so fine as when played by Norena. And yet she was close to 50 when she played the part! As Ophelia in *Hamlet,* and as the queens in both *Les Huguenots* and *The Golden Cockerel (Zolotoy Petushok)*, her beauty, her voice and her outfits created a harmonious effect that seemed superhuman. But hadn't her technique already rendered her superhuman? Take her final record, Georg Frideric Handel's "Care selve", recorded when she was 55. Her voice accomplished such marvels of phrasing and of breathing technique, such leaps into the high register that her entire audience was left speechless, spellbound. Yet she was not superhuman. She was simply possessed of the supreme art of singing, possibly inherited from Nellie Melba, but with an added charm and vocal softness that Melba never had.

Marguerite's real costume: but, more important, the authentic light of her eyes, thanks to Eidé Norena.

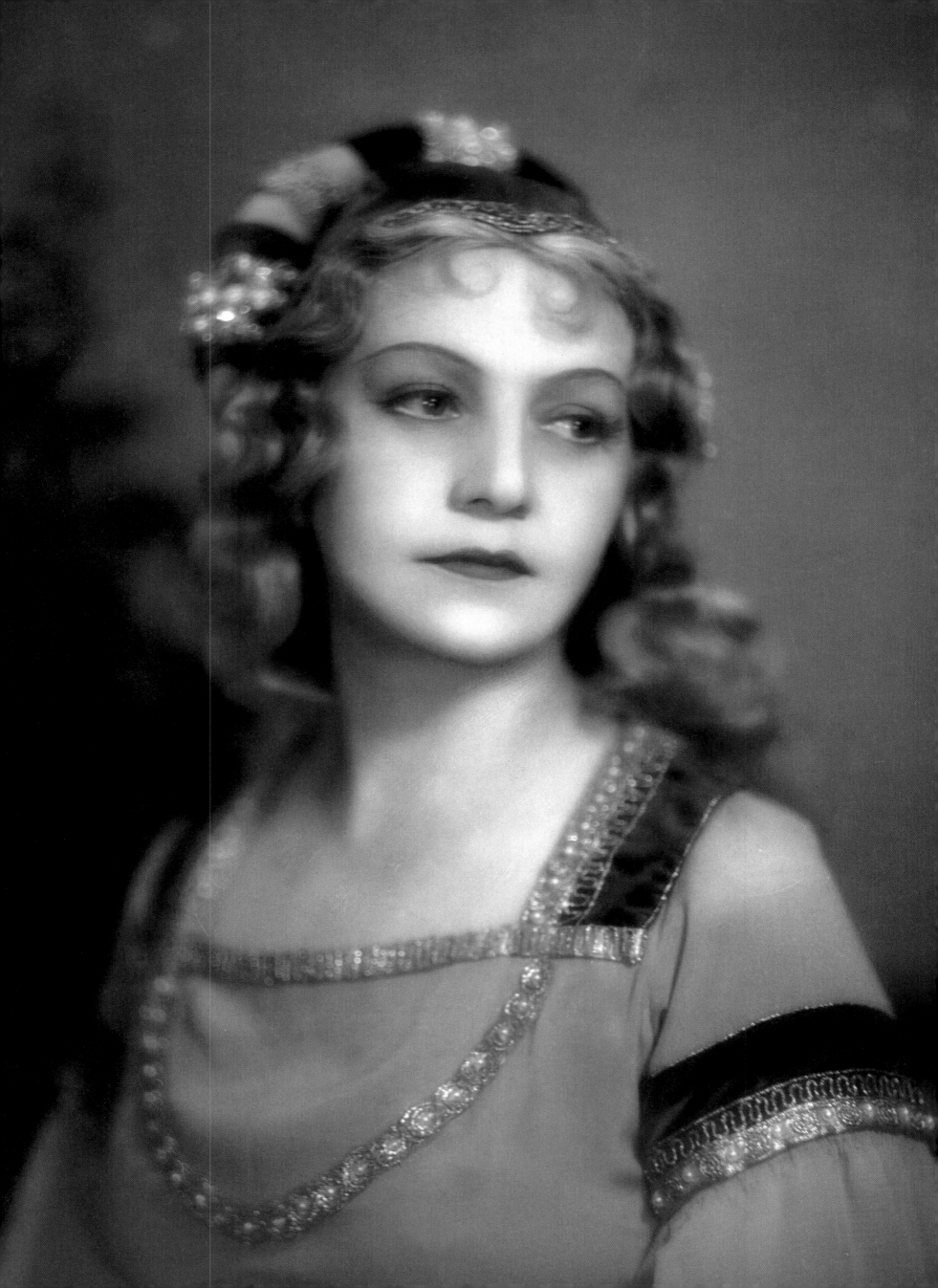

# Rose Caron

## (1857/1930)

The composer Reynaldo Hahn referred to her as "the dear damaged voice." Damaged by use, by wear and tear? Toward the end, yes, there was some of that, but this great proud voice was bruised from birth. At a time when the heroic roles called for ample shapes and immobile acting, Rose Caron never really had the epic Wagnerian powers. She was frail, slender, and visibly fragile. Her great parts were not as victorious heroines, but as sacrificial victims. She sang Wagner's Elsa, his Elisabeth, and, especially, his Sieglinde, the radiant sacrificial heroine who guaranteed her place in history. She also played Salammbô, and Brünnhilde, in Reyer's *Sigurd*. These para-Wagnerian heroines were the flavor of the period and seemed to be written for her captivating voice, which was just a little smoky and raw, her beautiful, expressive arms, and her gray-green eyes with an intensity that wiped out the memory of any other color. In Paris, she played Desdemona in an *Othello* that moved Verdi to say that he had finally found a singer who not only could sing his notes but was also a creative artist capable of performing on the level of Shakespeare. Next, she realized Christoph Willibald Gluck's dreams with a graceful, noble Iphigenia. Some mocked her for being thin at a time when having a little meat on your bones was fashionable. In fact, she was just born too soon: she would have been perfect in Chanel! When she was thrown in to her basin of boiling water at the end of *La Juive*, old regulars sniggered that she would make for a pretty thin broth. To which the true connoisseurs replied, yes, but it will have beautiful eyes.

Rose Caron in *Sigurd*: beautiful finery, but a bare face. And what eyes!

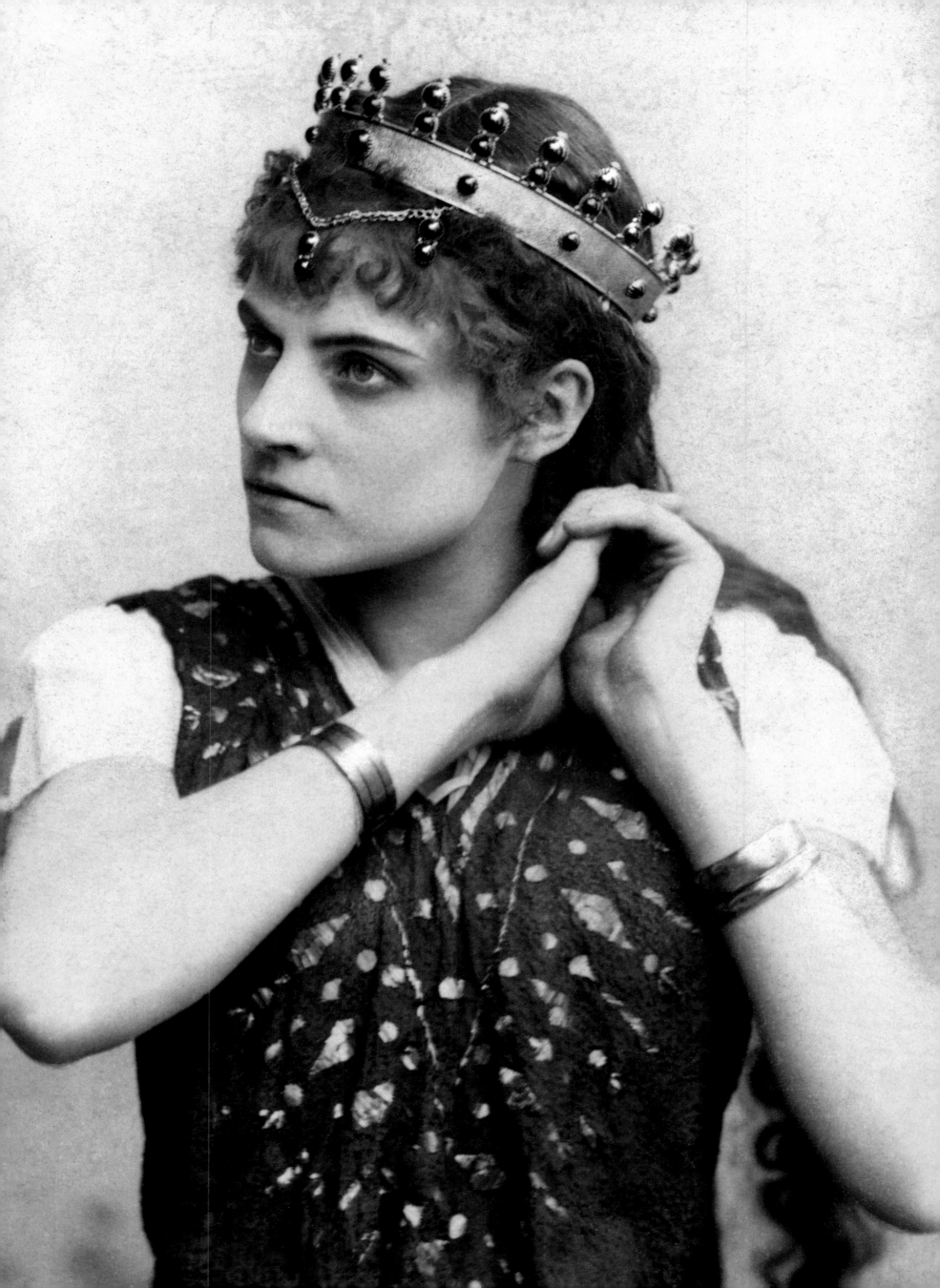

# Fritzi Jokl

## (1895/1974)

With a silver fox over her shoulder, a string of pearls over a décolletage, a cloche hat, and a tight-fitting satin sheath dress, Fritzi Jokl personified the charm, style, and intangible beauty of the Jazz Age. She exuded the easygoing joie de vivre of one blessed with everything: a striking smile, beautiful dark eyes, slenderness and grace, marvelous theatrical roles (especially in Mozart), and the admiration of great conductors such as Bruno Walter, Karl Böhm, and Hans Knappertsbusch. She started off on the right path—born and educated in Vienna, dividing her time between Berlin and Munich, she was already invited to Salzburg to play Despina in Cosi. There was only one problem: She was Jewish, a fact that her warm and inimitably melancholy eyes projected clearly. And as a Jew, she was required to be silent. So, for several years, she remained confined to a theater world strictly reserved for Jews (both onstage and in the audience), a Berlin theatrical underworld provisionally tolerated by the Nazis to keep up appearances. Luckily, she fled Nazi Germany and reached New York in the prime of her beauty and voice. She managed to save her life but faced the bitter realization that in the United States, her European status, appearances in Salzburg, and few recordings were absolutely meaningless. The United States already had Lily Pons, and Bidù Sayao was on her way. Instead, Jokl's passionate love affair with Jack Siegel, a young journalist, became her main reason for living. She was ten years older than he was, though, so she chose to hide her age, thereby keeping her track record and her past glories a secret. When some of her old records were rediscovered, the word got out that Fritzi's voice would finally live again. Yet Fritzi did not want the records to be reissued, in fear that she would have to tell her story and reveal dates. Eventually, the records were released, but they did not include any biographical information. It wasn't until after Fritzi died that her husband learned who she had been and what she sacrificed for him. Even her intimate New York friends, who were singers in their own right, had never suspected a thing. When I told her friend Regina Resnik the whole story and played her the stark, simple "Last rose of Summer" from *Martha,* she burst into tears. She had never had a clue that her friend for a quarter of a century had been an opera legend of the first rank, a singer of the highest quality, an artist who had projected the most intense emotion. If Fritzi had only shown Regina her photos from that period, the look in her eyes and her bearing would have said it all. But she didn't have any.

Fritzi Jokl: the most astonishing fate, the most fascinating gaze.

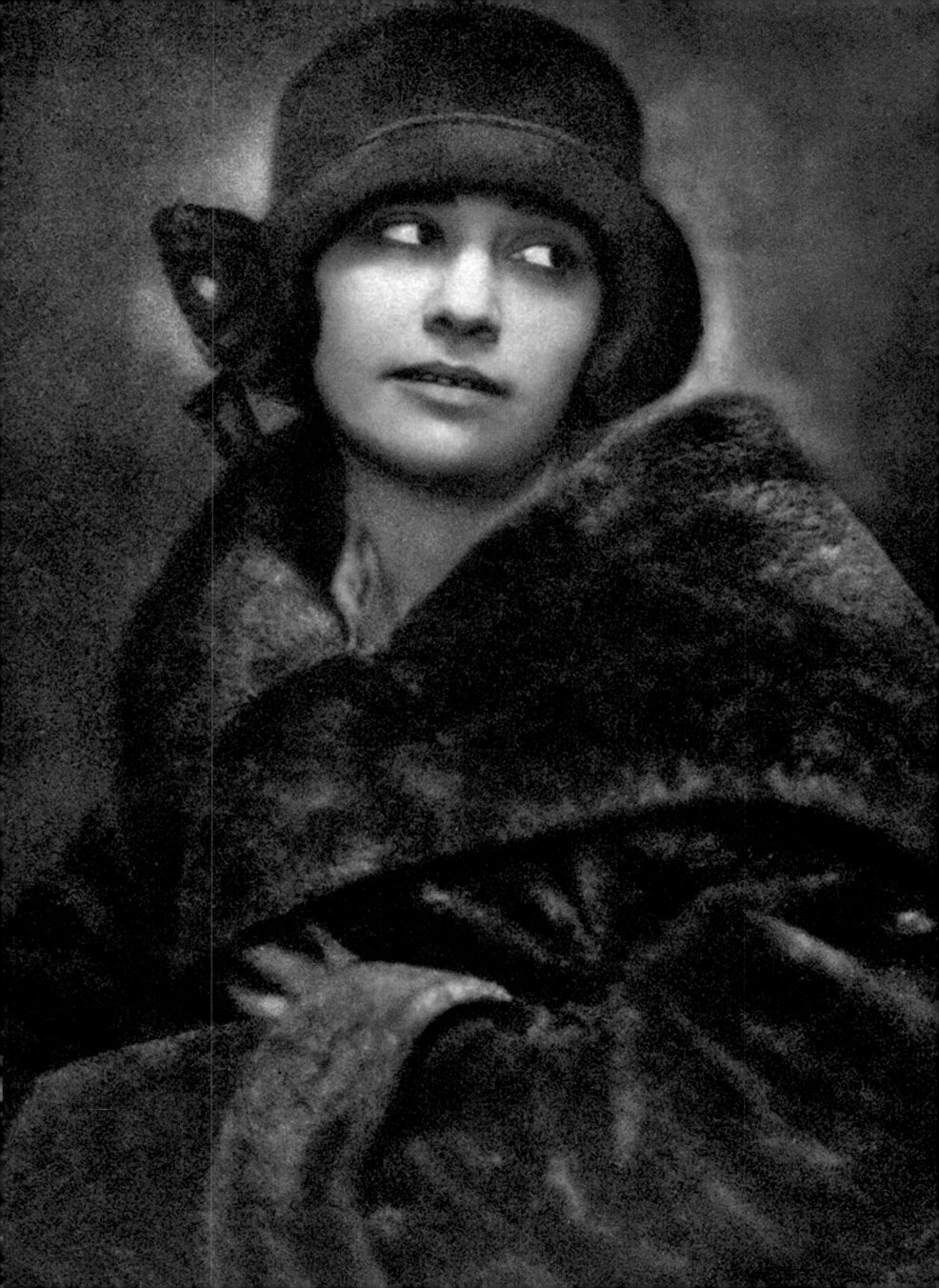

# Jarmila Novotna

## (1907/1994)

Rarely has the stage encountered a more ravishing beauty, or a more precocious success story. At age 19, Novotna was propelled to the very top: *La Traviata* in Prague, *Rigoletto* in Verona, then in Berlin. Born Czech and a baroness by marriage, she remained passionately attached to the homeland from which she was initially banned by the Nazis and then again by the Soviets. Her album for martyred Lidice, with Tomás Masaryk at the piano, is at the heart of her sadly limited discography. In Berlin, she debuted at the Kroll Oper in *L'Heure espagnole.* Director Max Reinhardt then recruited her unmatched charm and beauty for a production of *Die Fledermaus,* which was presented in Berlin, then moved to Paris. Vienna even transgressed an unwritten law for her (and Richard Tauber) by allowing an operetta by Franz Lehar, *Giuditta* to be produced in the august halls of the opera house with her in the title role. Yet her personal career peaks came thanks to Mozart, in Salzburg, with the roles of Cherubino and Don Elvira (with Bruno Walter), Fiordiligi and Comtesse (with Felix Weingartner), and, the ultimate consecration, Pamina (with Arturo Toscanini). It was thanks to Toscanini that she was able to find the American roles necessary to allow her to flee Europe with her children and her interpretations of Mélisande, Manon, and Mimi made her into one of the authentic wartime stars of the Metropolitan Opera. She made quite a convincing dip into cinema in Max Ophüls's *Die Verkaufte Braut* (which borrowed so little from the Bedrich Smetana opera that it left Novotna with nothing to sing). She also played Melba in the film *The Great Caruso* (with Mario Lanza), once again without singing. But above all, she played a particularly poignant Czech mother searching for her lost child in *The Search,* the film that brought Montgomery Clift to public attention.

OPPOSITE:
Jarmila Novotna in *Giuditta*, Franz Lehár joined the Vienna Opera for her.

FOLLOWING PAGES:
Twenty-year-old Novotna at home. The picture is from 1930, but it could have been taken yesterday.

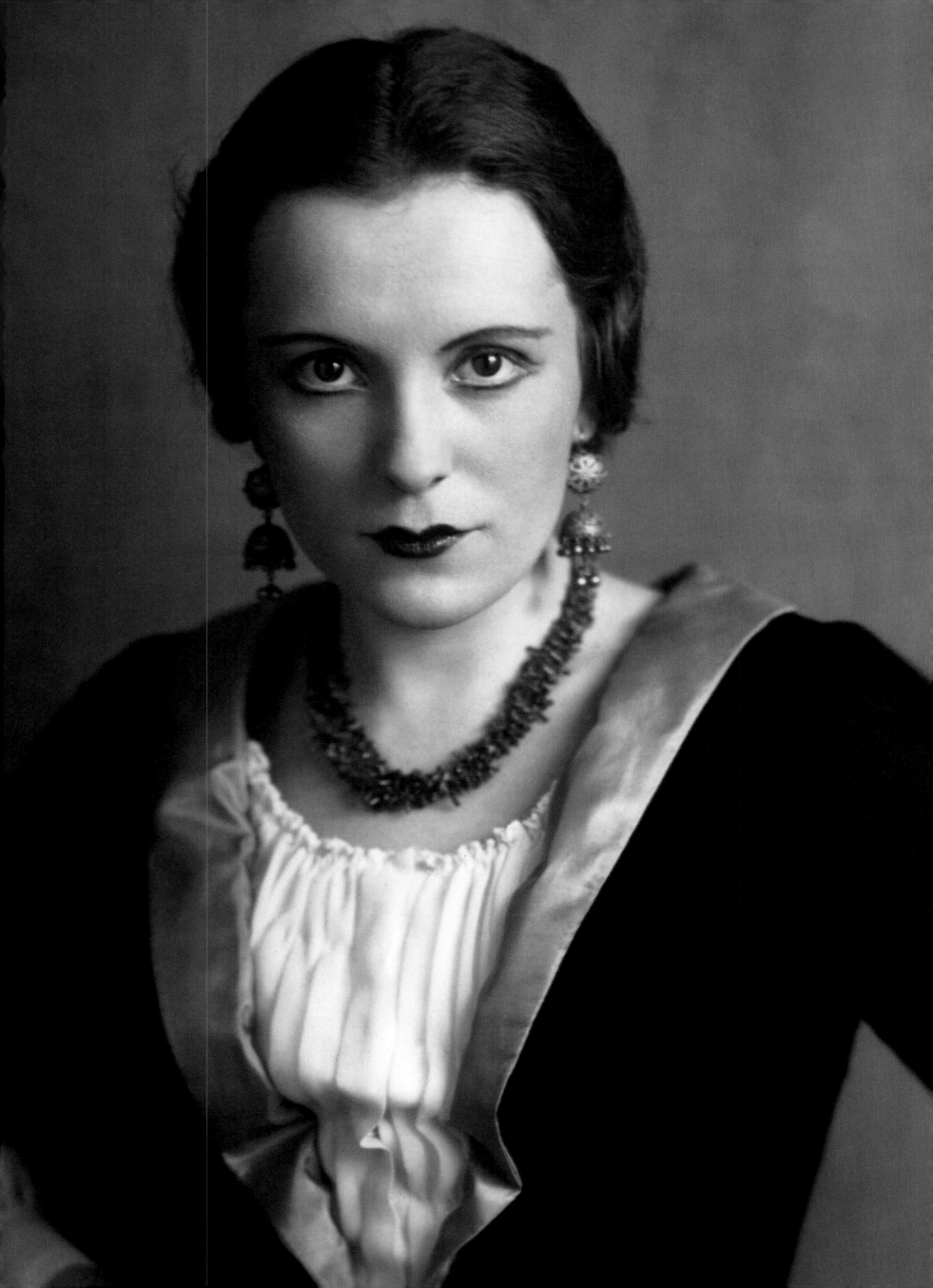

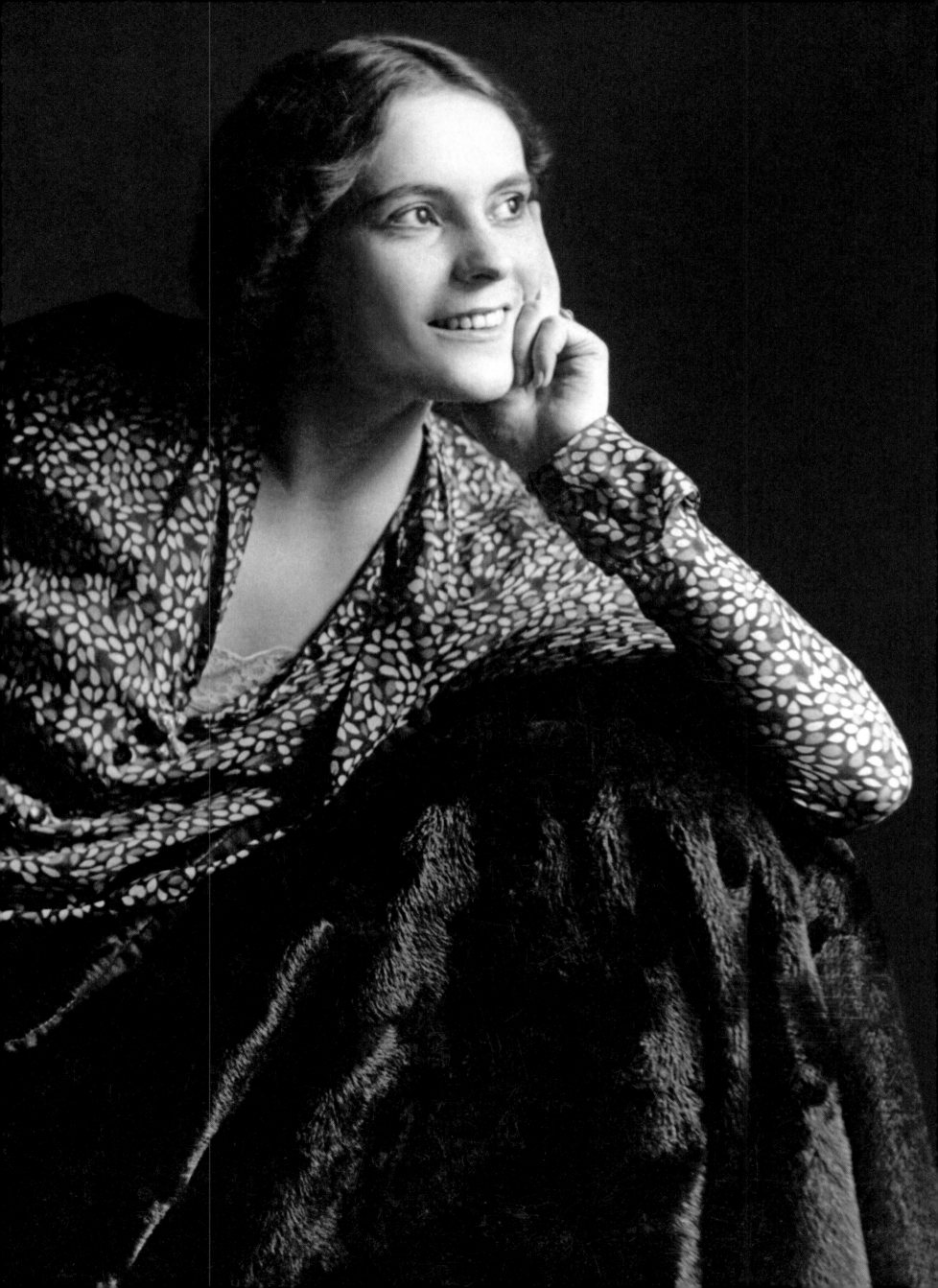

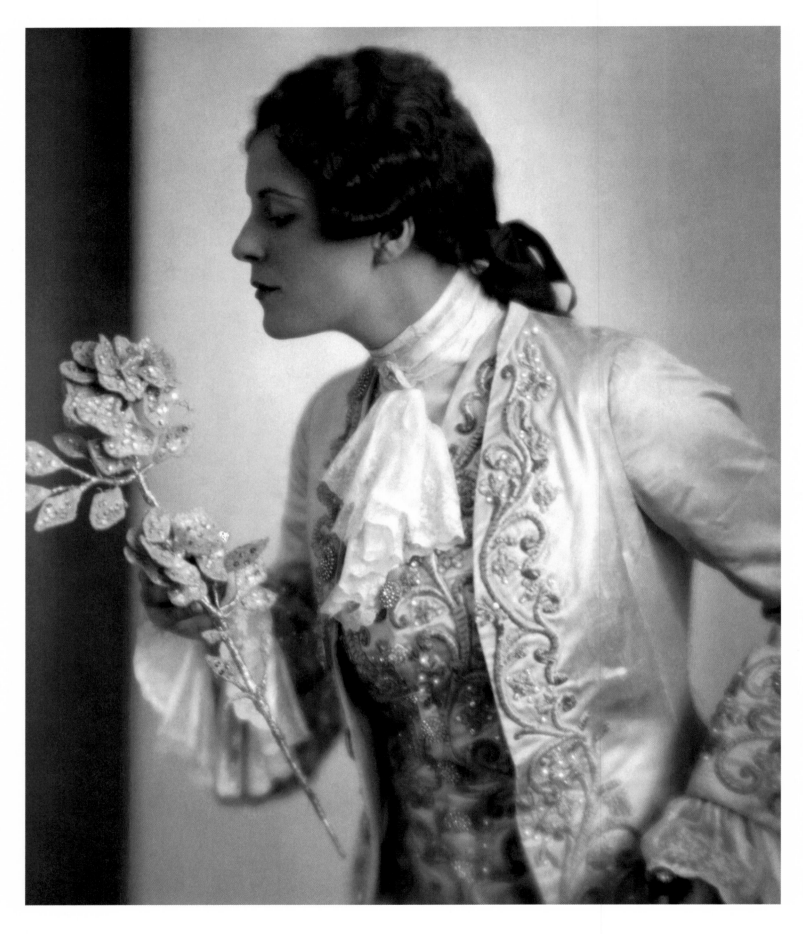

ABOVE:
Jarmila Novotna with her silver rose in Salzburg: portraying Quinquin, as Richard Strauss and Hugo von Hofmannsthal dreamed for her.

OPPOSITE:
Jarmila Novotna in *Manon*: the epitome of *femme fatale*.

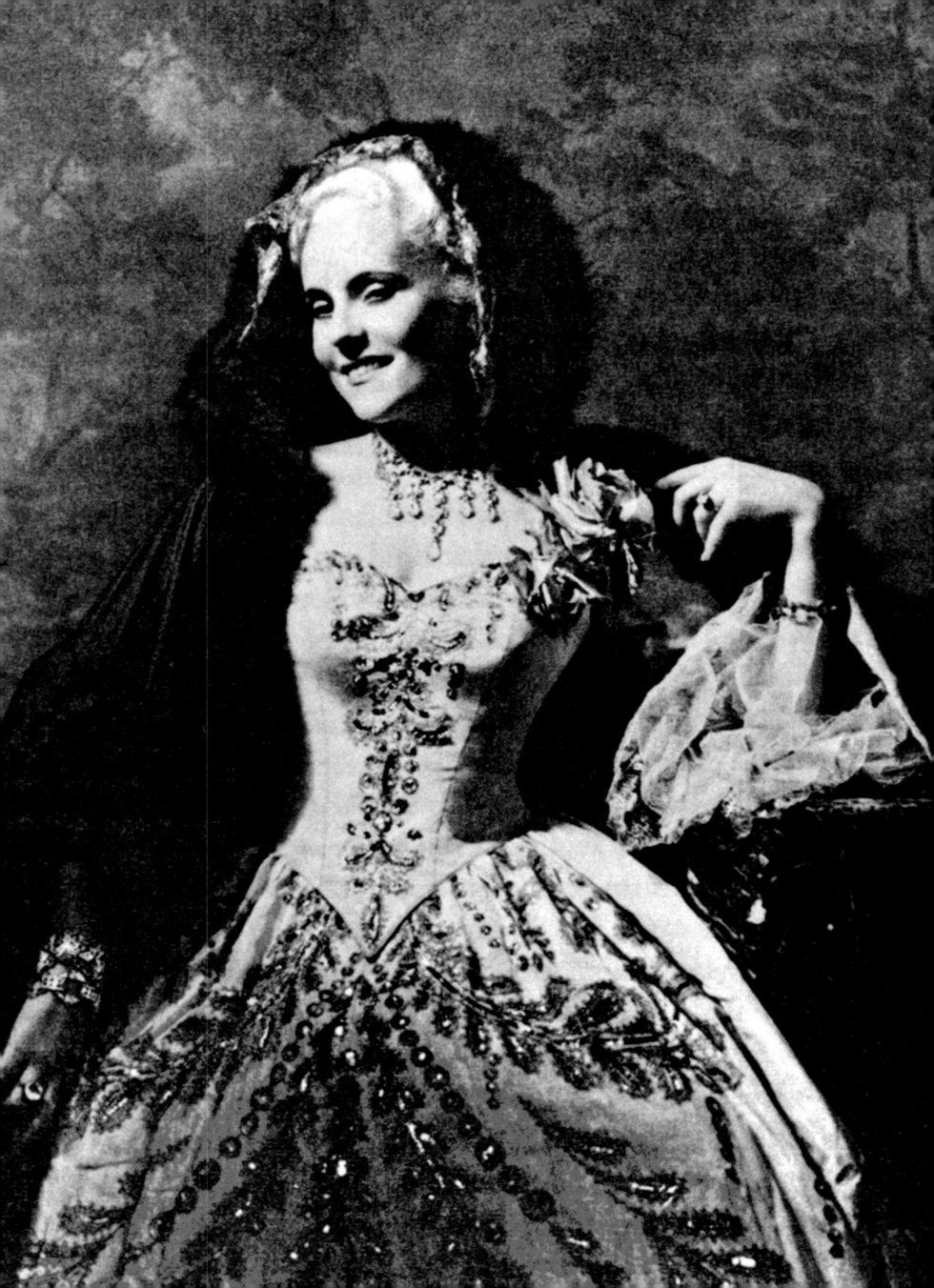

# Sigrid Onegin

## (1889/1943)

Born the French-German daughter of an embassy attaché to Stockholm, she was raised in Paris high society. Initially a natural soprano, she saw Mrs. Charles Cahier sing Carmen in Stuttgart and had a revelation: She would be an alto. The second epiphany came when she met a classmate at the conservatory, the delightful and fragile Russian baron Boris Lvov Onégin, a marvelous pianist and composer who would become her husband. She started at the top, with *Carmen*, in Stuttgart, then as Dryade in the world premiere of *Ariadne auf Naxos* with Maria Jeritza, and as Zerbinetta with the soprano Margarethe Siems. But when the First World War broke out and her beloved Boris risked imprisonment as a Russian, she decided to hide him, braving police searches and holding out two and a half years until she managed to obtain a pardon for him by throwing herself at the feet of the king of Württemberg. Unfortunately, this was only a brief respite: Boris, as a result of his long confinement grew gravely ill and died. Onegin turned back to her work. Munich welcomed the splendid alto for other triumphs, while Margarethe Siems helped her to master the agile singing and magnificent trills that few equally opulent-voiced altos have ever rivaled. She continued to scale the heights of greatness by performing the incredibly difficult *Prophet,* singing Wagner in Bayreuth, and appearing in the most sculptural *Orpheus* ever produced. Finally, she brought the Metropolitan Opera's audience to its feet, debuting there with a shattering Amneris in *Aida,* and surprising everyone by physically basing her character on Nefertiti. In truth, she was single-handedly responsible for the rebirth of Marie Malibran and Pauline Viardot's golden age of singing. And like Viardot, Onegin was not afraid to sing astonishing literal adaptations for voice of Chopin's *Impromptus*.

Sigrid Onegin, the profile of a Greek goddess to play the Wagnerian gods.

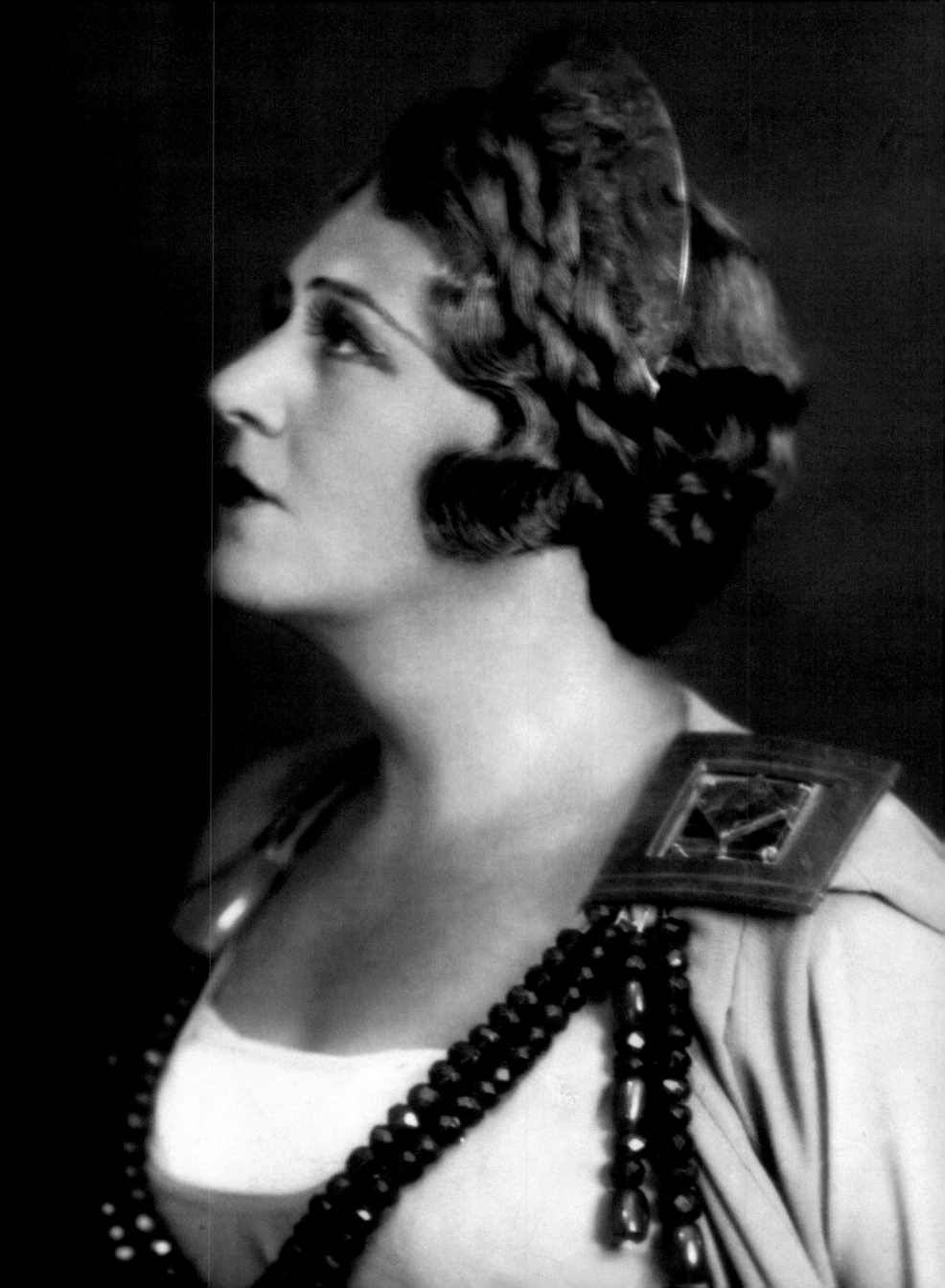

Onegin as Carmen, with her festive outfit and her deadly gaze. She had become an alto to play this role.

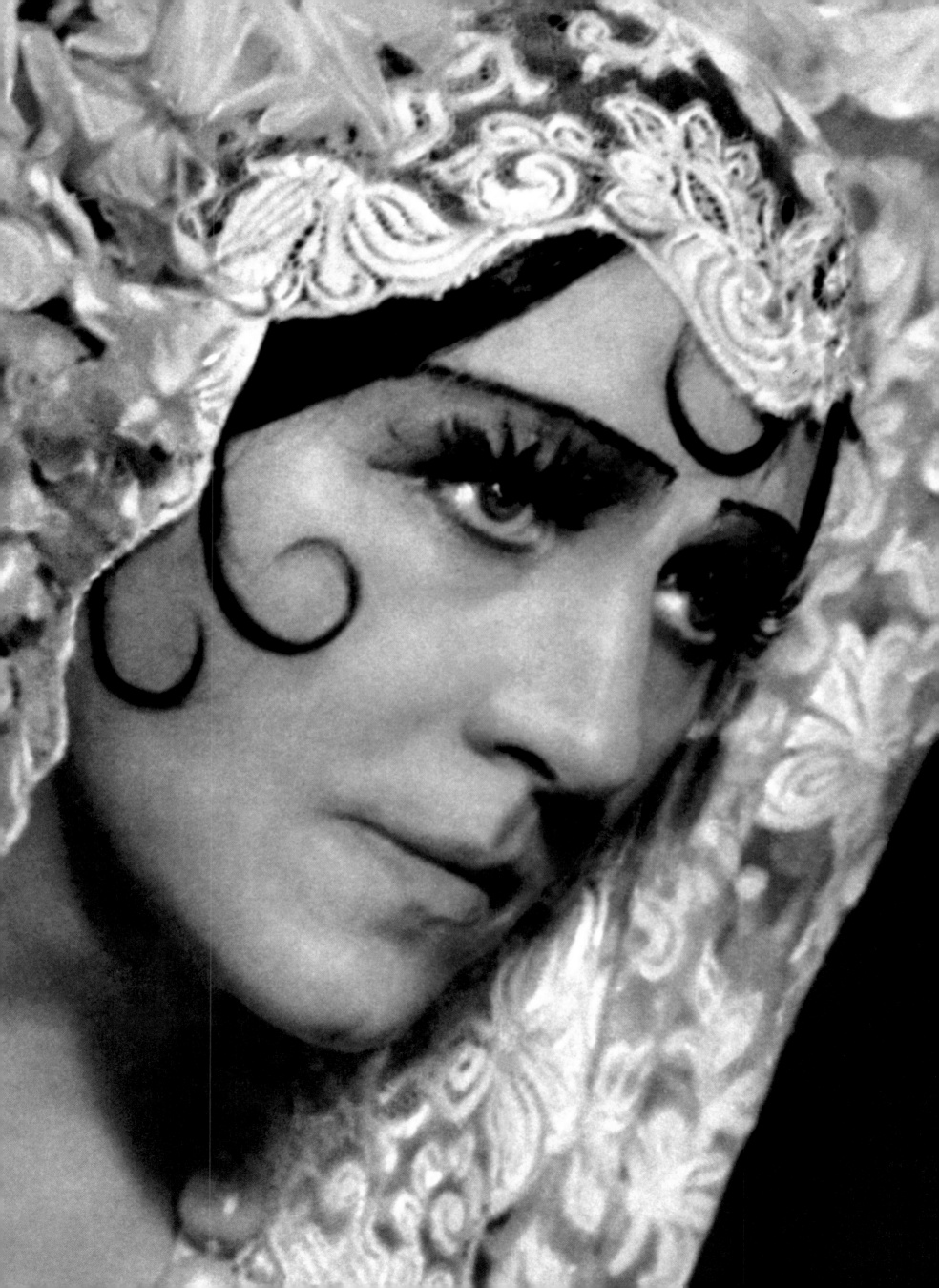

# Aino Ackté

## (1876/1944)

Born in Finland to a musical family (her mother and her sister, Irma Tervani, were singers), she could have stayed in her little corner of the world, but the call was too strong. The city of lights was to reap the initial benefits of her remarkable vocal talent and beauty. Look at these pictures of Aino Ackté carefully. She may very well have been the first to make a crucial transition. At the beginning, she was just a luminous beauty with a very good voice, playing the roles that fit her type (Juliette in *Romeo and Juliette,* Marguerite in *Faust,* maybe Elsa de Brabant in *Lohengrin*). All she had to do was lift up her beautiful white arms and open her mouth to sing, and recognition was hers. But when Richard Strauss offered the world his Salomé, lightning struck: Ackté was exposed to a darker perspective, an entire facet of her personality that was more opaque, more deadly. She followed her inclination and made Salomé her warhorse, playing it in Germany, then in London. American audiences, however, were not as receptive to her, preferring throatier Italian voices. She returned to Finland and tirelessly fought for opera (with the powerful help of her husband, a senator), beginning with her creation and direction of the Savonlinna Festival. Though the recording is primitive, it is her voice that best captures the "Jewel Song" from *Faust,* an aria that was sadly to become the territory of the most pompous singers. A very young Aino Ackté had approached the piece by projecting her awed emotions into the night, singing like Charles Gounod had taught her to, with trills and impeccably sustained sound.

Ackté at her beginnings, playing a virginal Juliette, and already in good hands...

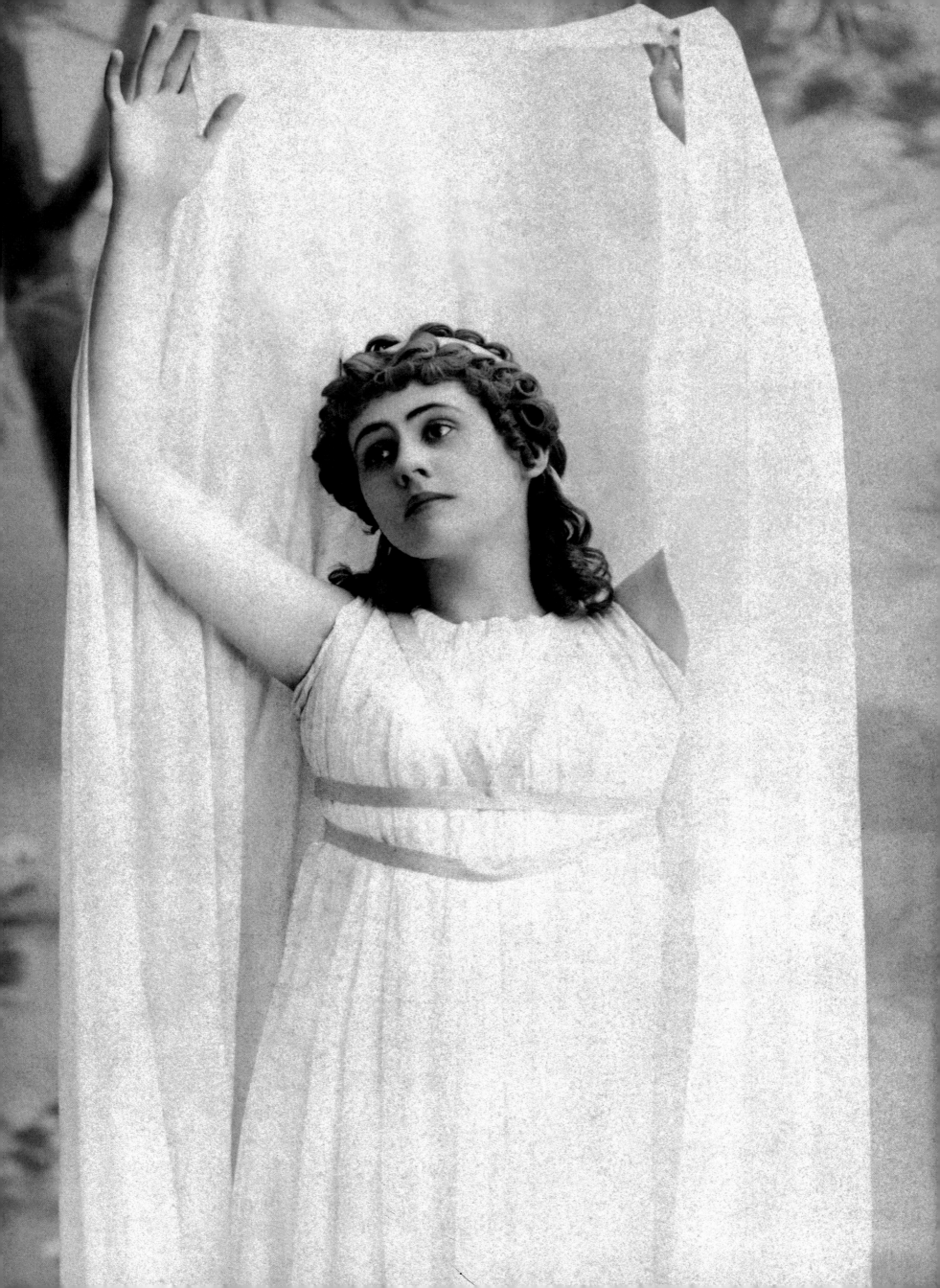

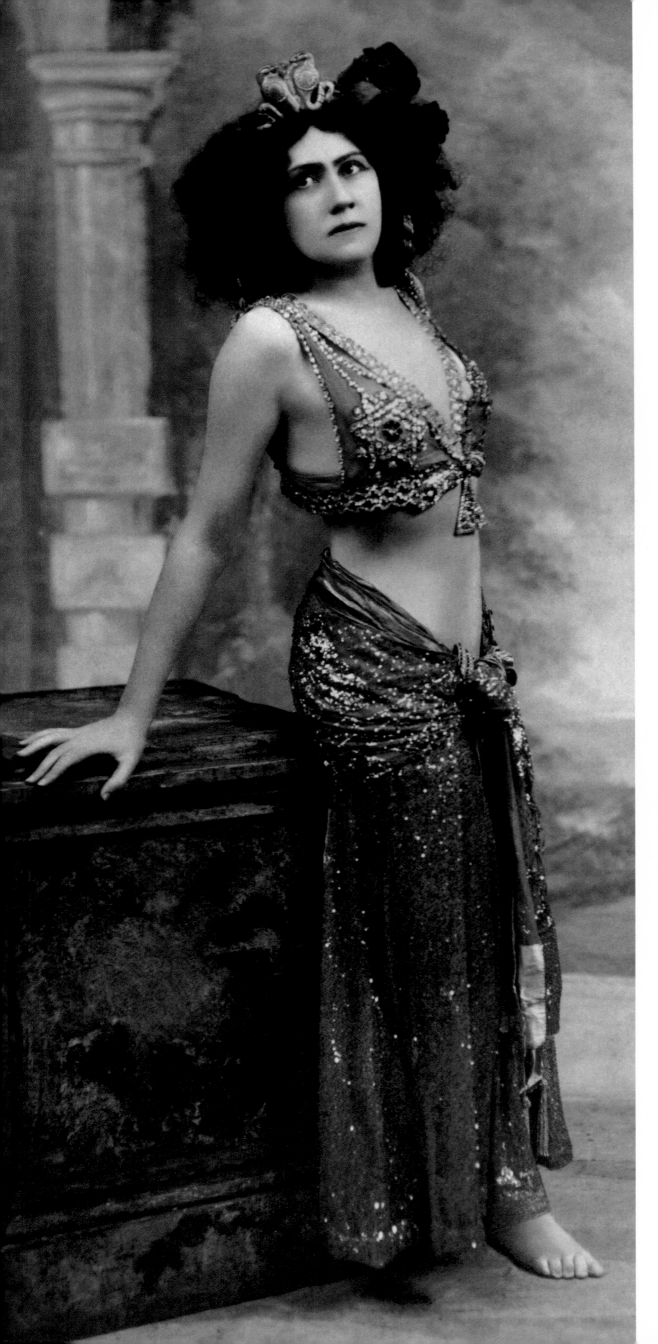

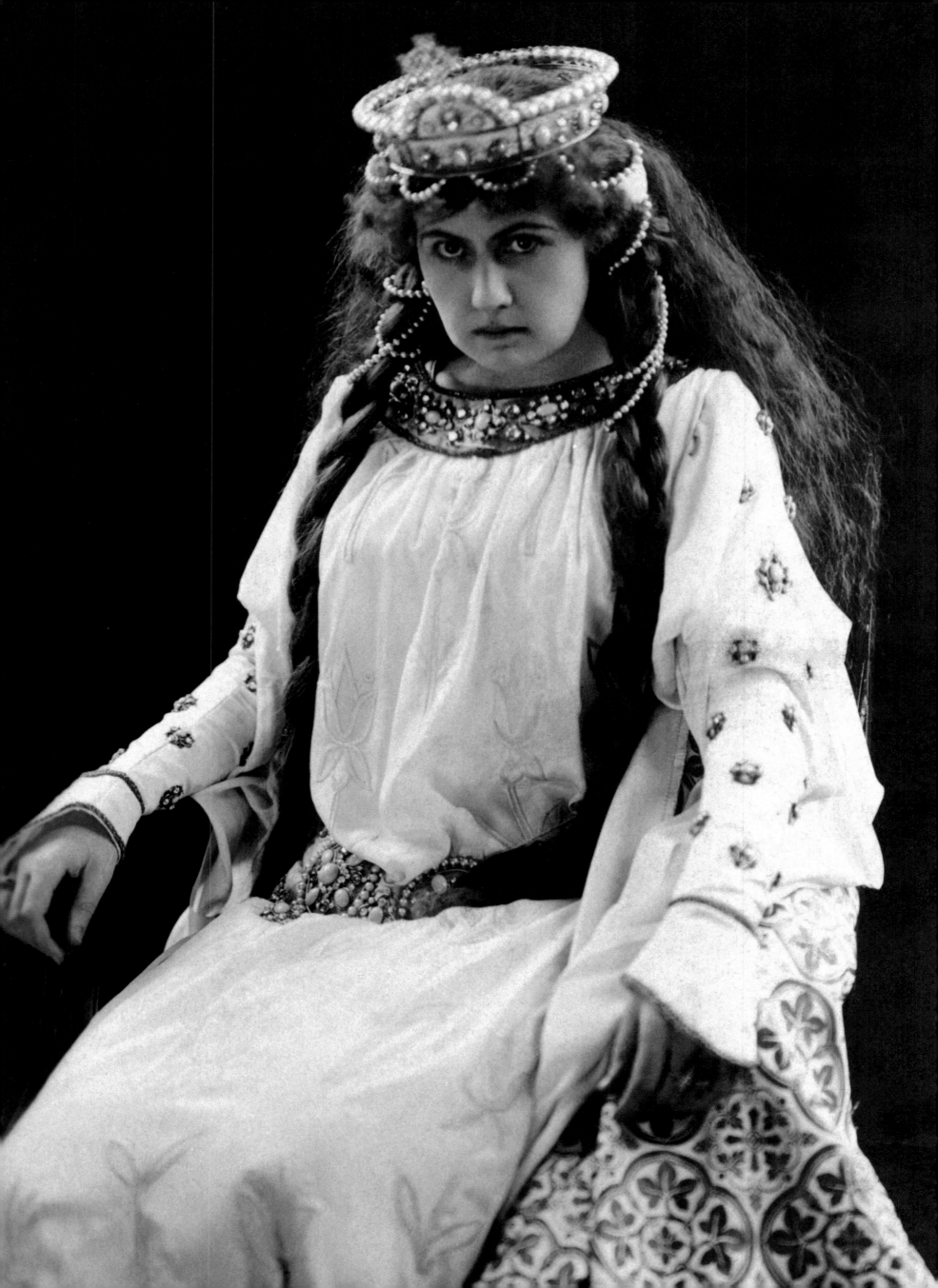

# Lotte Schöne

## (1891/1977)

Better than a beauty: a dream! The venerating public called her *die schöne Lotte*, the beautiful Lotte. Few singers are blessed with such vocal charm. Her numerous recordings of arias from Viennese operettas bear witness to her honeyed tone and her virtuoso vocal range. Offstage, she wore the most exquisite outfits: furs and strings of pearls that made her a walking fashion plate. Onstage, her first master was Mozart. With time, she added light, humorous parts such as Norina in *Don Pasquale* and Puccini's painfully tender little women: Mimi, Butterfly, and, especially, Liù, from *Turandot* (which, according to her colleague Delia Reinhardt's recollections, was the most beautiful Berlin had heard in fifteen years of opera). She was the first to give a Richard Strauss recital in Salzburg, where she was a regular and essential guest, and performed an incomparably graceful and mysterious Mélisande in Berlin, and then in Paris. In June 1933, she realized it was time to leave Berlin. Her devoted audience wanted to keep her so badly that at her last performance she was called back for twenty curtain calls, until she was finally left standing in front of the steel fire-curtain. Yet she managed to intuit that the same people begging her to stay might turn into the ones throwing rocks at Jewish businesses. So she took her children and made a new home for herself in Paris. Though Bruno Walter continued to invite her to Salzburg and Florence, the 40 year-old Schöne lost all the previous momentum of her career. War soon caught up to her in France, and she and her son were forced into hiding in the Alps for three years (her husband and their daughter hid elsewhere). After the war, she attempted a brief comeback but quickly chose to return to her family, where she could be indulgent with life, living out her days with the radiant charm and kindness that eventually outlived her beauty.

RIGHT:
Lotte Schöne: so aptly named *die schöne Lotte.*

FOLLOWING PAGES:
Schöne's Mélisande at the fountain.

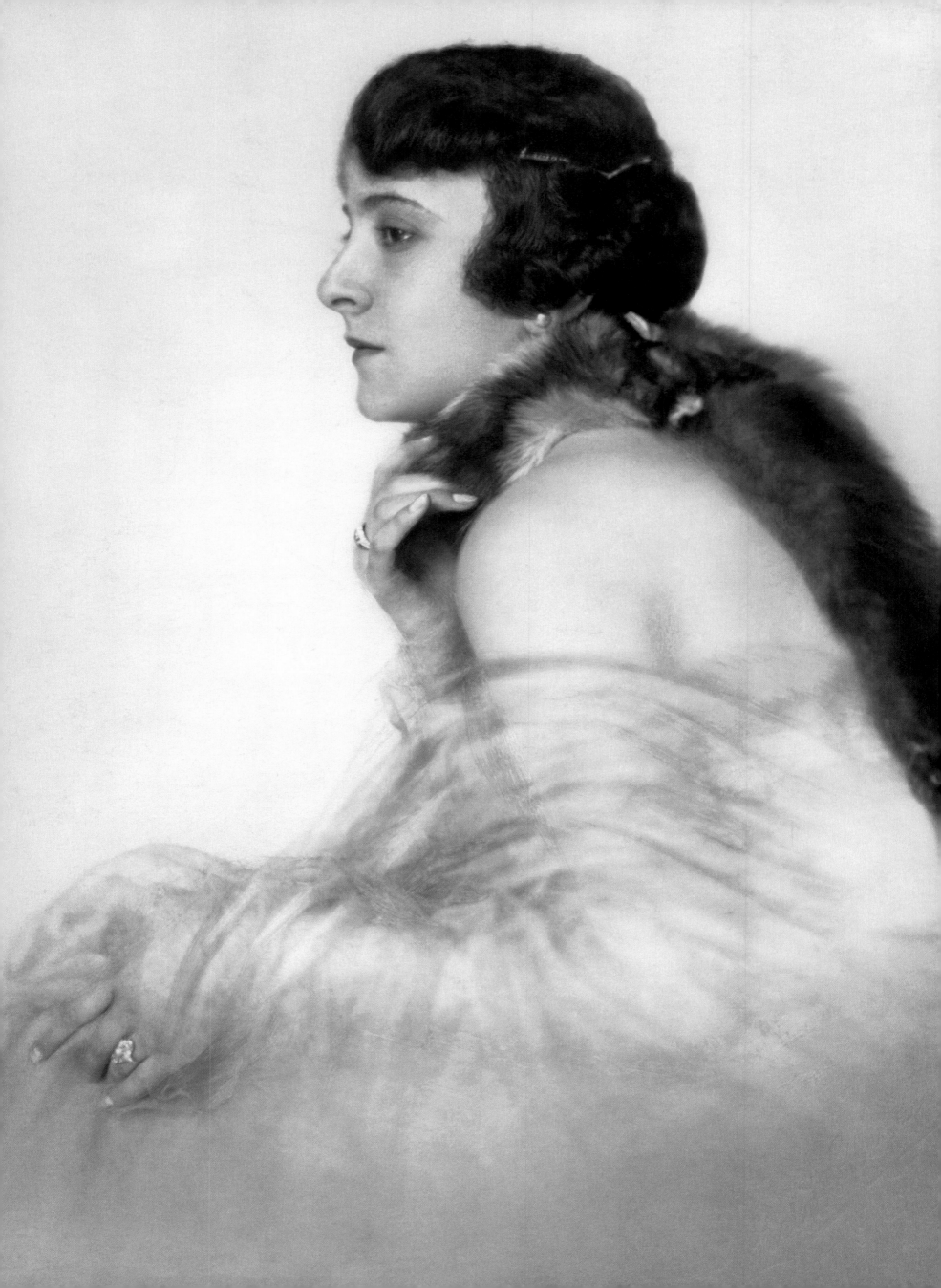

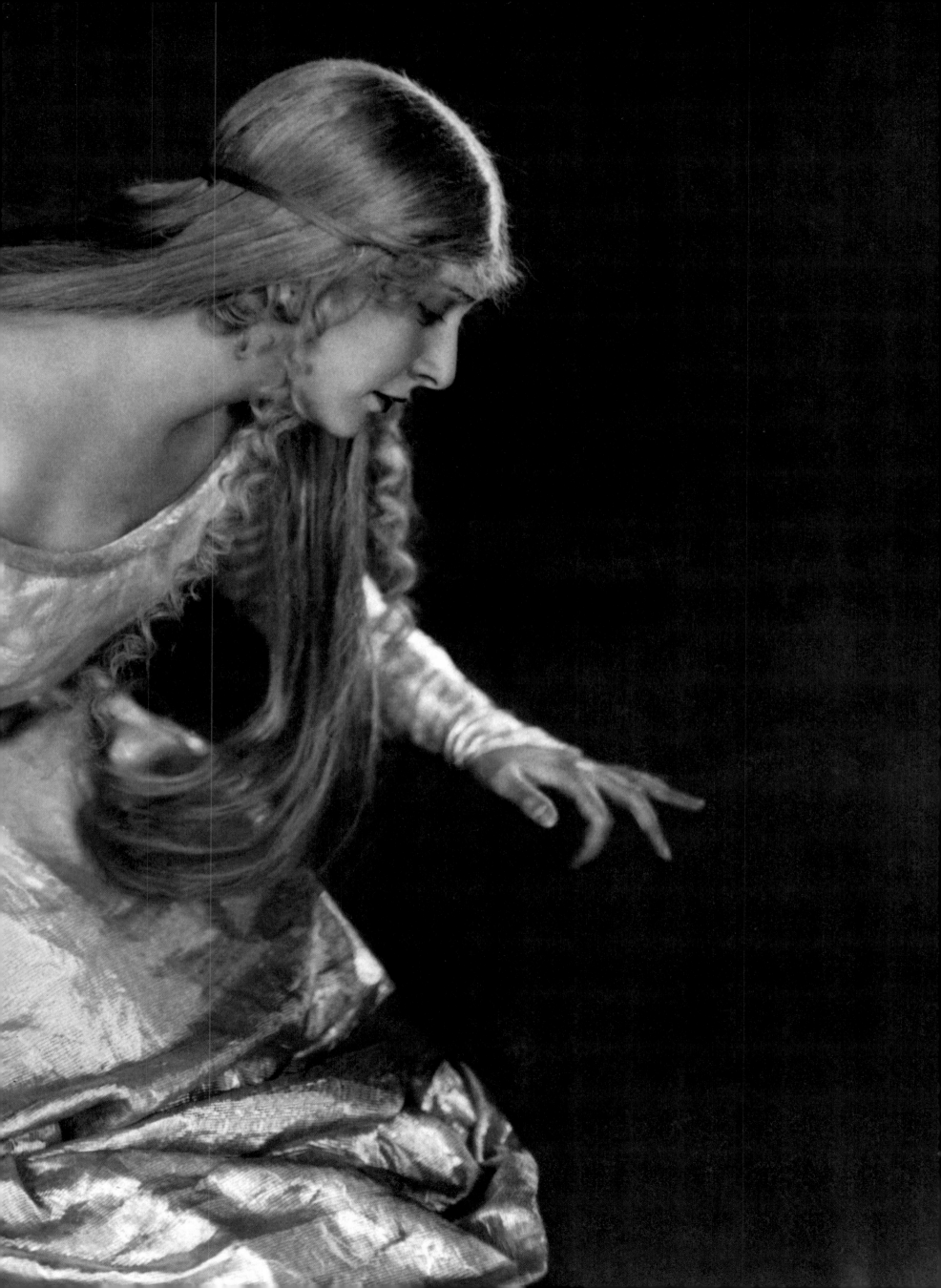

# Zinaida Jurjevskaya

## (1896/1925)

Zinaida Jurjevskaya's eyes brimmed with Slavic melancholy and the pain of being exiled and uprooted. Despite the revolution, a very young Jurjevskaya made her debut at the Mariinsky. This brief initial phase of her career came to an abrupt end when her husband, a Baltic baron, was taken hostage. Berlin opened its arms to the 25-year-old darling, acclaimed her, and found the most beautiful roles to fit the incurable sadness in her eyes. She was sent to the Paris Olympiads, with Sergei Prokofiev at the piano. Her beauty and her voice had such a stunning effect on the French audience that one critic was moved to write that Berlin sent her "as war reparations." Russian roles were well-suited for her strange, touching tone, the virtuosity of which allowed her to be at ease both in the frivolity of *The Golden Cockerel* (*Zolotoy Petushok*) and in the grand costumes of *The Tsar's Bride*. Yet it was really when she played a victim that she was most truly herself, without any need for costumes or finery. She was a victim of sickness as Mimi in *La Bohème*, of duty as Iphigenia, and of crazed passion as Lisa in *The Queen of Spades* (*Pikovaya Dama*). And when she sang her miraculous rendition of Sophie in *Rosenkavalier* (as one of the first to sing it in Berlin), it was as if she couldn't resign herself to success. She certainly wasn't helped by her pursuit of an impossible offstage love for her poetic costar, Delia Reinhardt. Yet when Erich Kleiber offered Jurjevskaja a production of *Jenufa* under ideal conditions—with sufficient rehearsal time, attention to detail, and a cast to guarantee triumphant acclaim—one would have thought she would finally find serenity. But it was not to be. She did not take the role of the child-mother with a slashed face and drowned baby lightly. During the following summer holidays, while walking in the area of Andermatt, Switzerland, she dove into a river and drowned herself. She was barely 29. Jurjevskaya left only a few magnificent pictures of her most famous roles and a handful of heartbreaking records (including Jenufa's hallucinations and prayer), which, by some sort of divination, she had insisted upon recording against all trends in fashion and business.

*Zinaida Jurjevskaya in* The Tsar's Bride *(Zarskaja Newesta).*

60

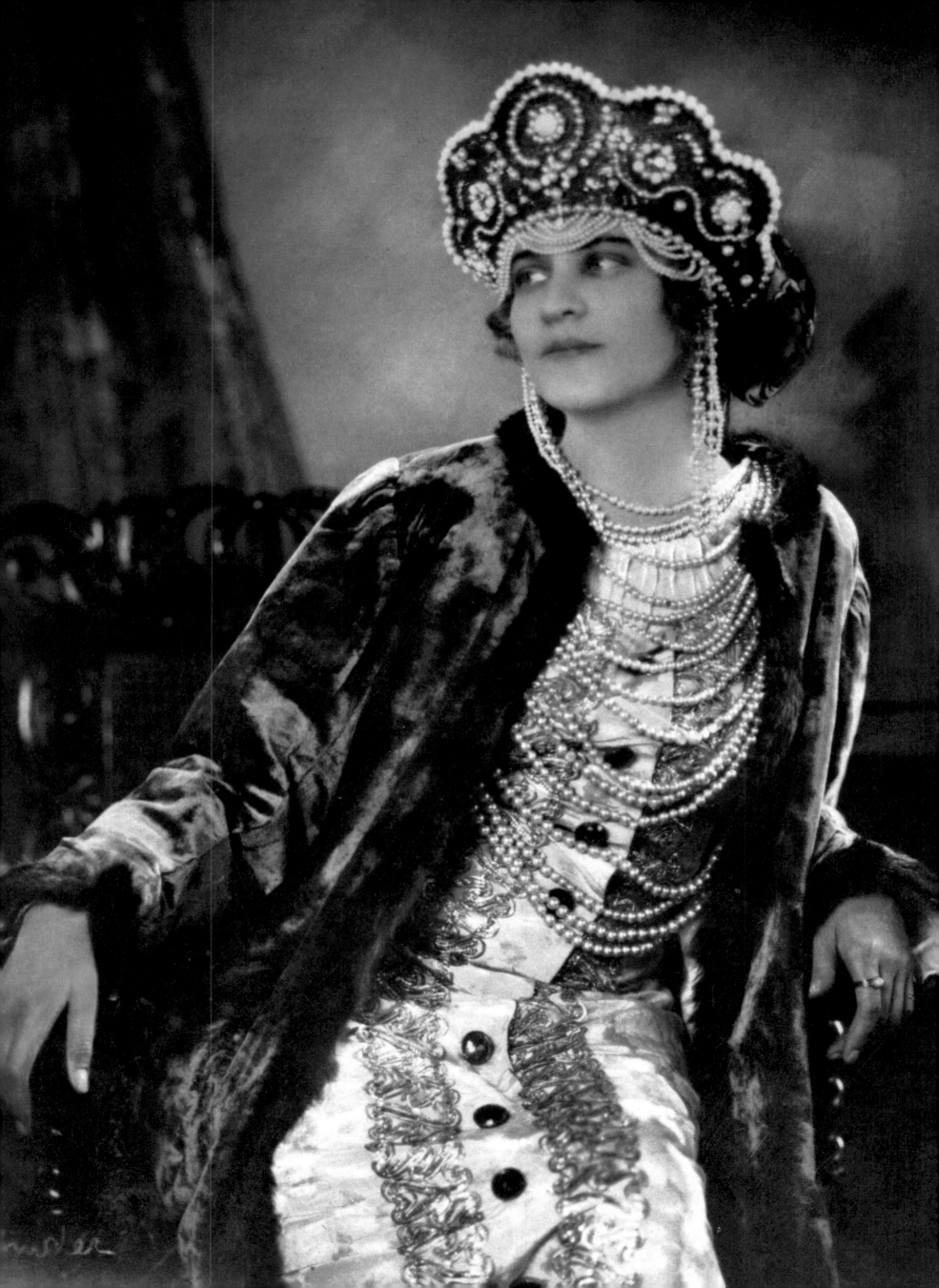

# Georgette Leblanc
## (1875/1941)

Despite the legend to the contrary, Georgette never became Leblanc-Maeterlinck. The eminent playwright Maeterlinck not only never married his muse, he left her for a much younger woman. If Leblanc's name referred to any writer, it was to her brother, Maurice, the brilliant creator of *Arsène Lupin.* Maurice Leblanc situated most of Lupin's adventures in Caux, the same area where his sister and Maurice Maeterlinck owned the abbey of Saint-Wandrille. It was here that she played Lady Macbeth, leading her audience from her gardens to the corridors she routinely sleepwalked through. She was 18 years old when she created Alfred Bruneau's *L'Attaque du Moulin,* based on Emile Zola. She followed this with an extended stay in Brussels, for which she turned down offers from many other theaters, in order to be on the scene to seduce Maeterlinck. He saw her play Thaïs and Carmen, then finally followed her to Paris, where she sang Schubert and Schumann, in translations he made for her, and which are said to be torridly erotic. But this unusual singer's illustrious career in the arts and letters doesn't stop there. Thanks to her role in *L'Inhumaine,* the celebrated, revolutionary film by Marcel L'Herbier, with sets by Robert Mallet-Stevens, she was one of the first heroines of silent film. Maurice Maeterlinck was probably thinking of her as Mélisande when he considered writing an opera of his Pelléas, but the project never went through. She was able to console herself some years later by playing Mélisande for the theater, opposite the great Sarah Bernhardt as Pelléas. And though Georgette Leblanc's opera career was marginal, probably by choice, she was no dilettante. Her role in *Ariane et Barbe-Bleue,* which Paul Dukas drew from the poem by Maeterlinck, will live for the ages. In fact, for those aware of Dukas's orchestration and his writing of the part, Leblanc's talent is clear as day. And though her insolent beauty led some to believe her voice was just an added bonus, Georgette Leblanc was a singer above all else.

Georgette Leblanc: Carmen the smuggler. You can see why she would be a success in the movies.

Georgette Leblanc as *Thaïs*.

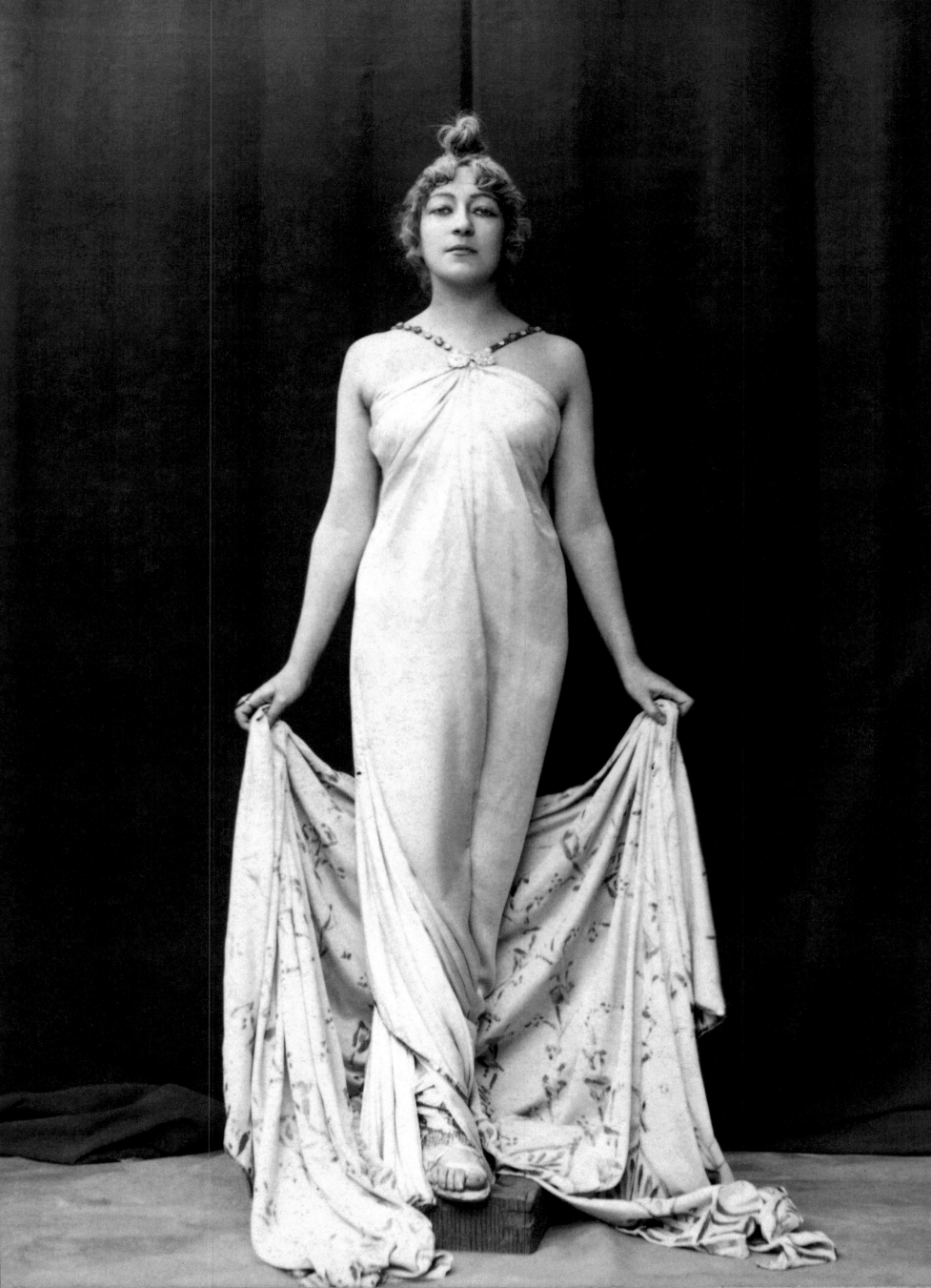

# Rosa Ponselle

## (1897/1981)

Purebred Italians but born American, the Ponzillo sisters started off as chorus girls. Though their voices swelled with a Latin richness, their ambition was entirely Anglo-Saxon. The outcome was astonishing: Rosa, the most ravishing of the two, and the most vocally gifted, started off at the top when she was barely in her 20s, opening the Metropolitan Opera's season on Enrico Caruso's arm, in the first New York production of *La Forza del Destino.* Surely, there haven't been any more impressive debuts, but then again there haven't been any other Rosa Ponselles. Tullio Serafin, the Italian conductor and vocal coach who knew voices better than anyone, had nicknamed Rosa the Caruso in petticoats. Even once he had conducted Callas, he continued to consider Rosa Ponselle one of the top three voices of the century, along with Enrico Caruso and Titta Ruffo. The sumptuous tone and richness of Ponselle's voice, and the absolute glamour of her silhouette, which remained Hollywood svelte to the end, guaranteed her a prestigious career. She appeared with Feodor Chaliapine in *Don Carlos,* then in *Oberon, La Vestale,* and, especially, *Norma,* which was revived for her in a production she made legendary. Terrified of sea sickness, she was the first American-born diva not to export herself. As it happened, she didn't require Europe to elevate herself to the level of a star: London had the opportunity to applaud her only three times, the summer festival Maggio Musicale in Florence saw her once, and that was it for Europe. Yet she retired from the stage quite early, disappointed that the production of Carmen she had lovingly created hadn't had the expected success and that her only operatic home, the Metropolitan Opera, was reluctant to stage *Adriana Lecouvreur* for her. Then Hollywood clamored for her. Screen tests were shot, yet in the end she decided to snub the movie business. She gave a few concerts as an opera idol, then opted for a peaceful life in her Villa Pace, near Baltimore. Secluded in her property, she nonetheless continued to treat her friends to recitals in which she appeared draped in satin and surrounded by toy poodles. Some twenty years after her retirement, a record made at Villa Pace carried her opulent voice, as rich and deep as it ever was, to the entire world.

Rosa Ponselle: Her overly studied Carmen did not please her era. We'd be happy to go see her today.

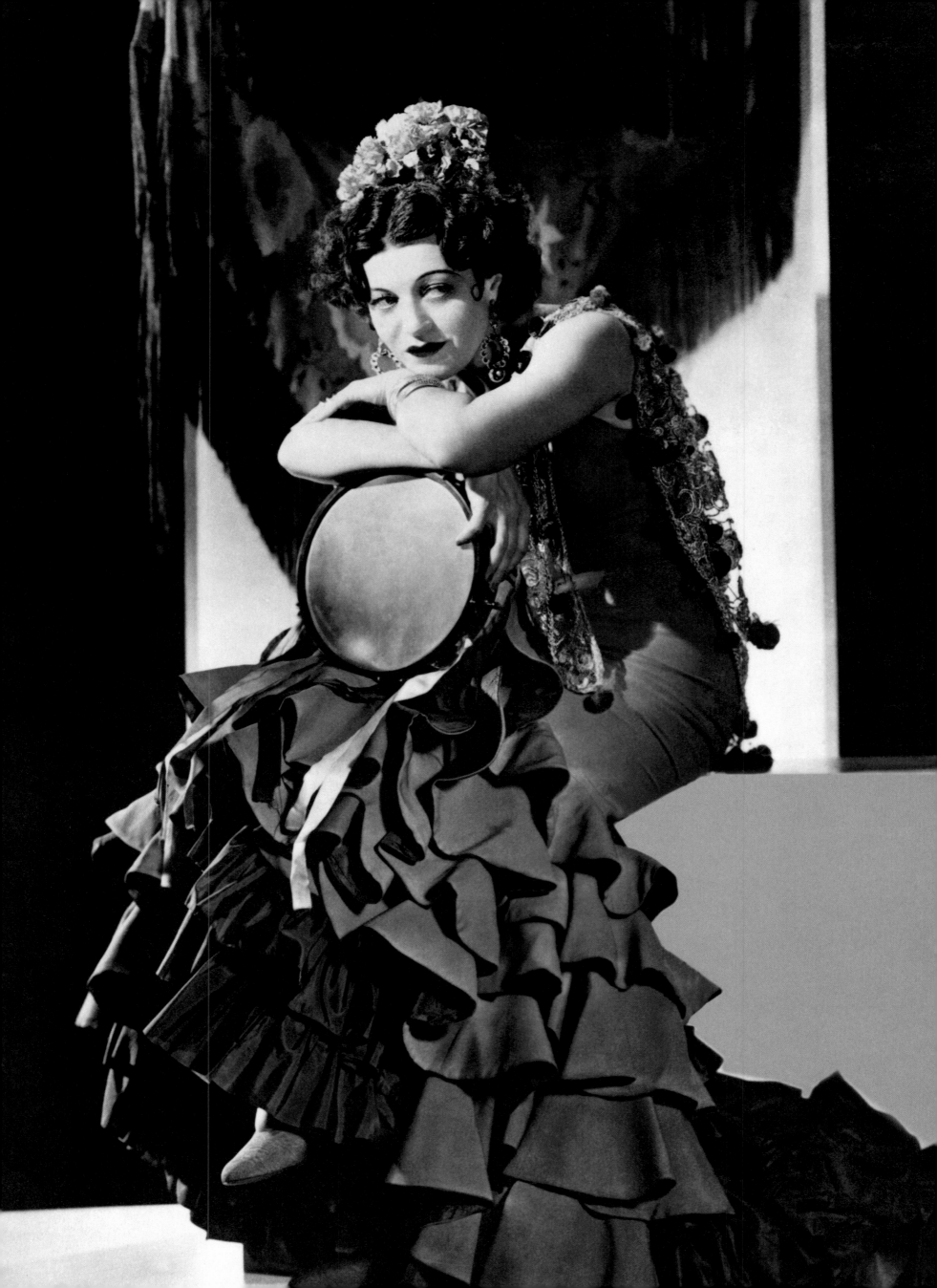

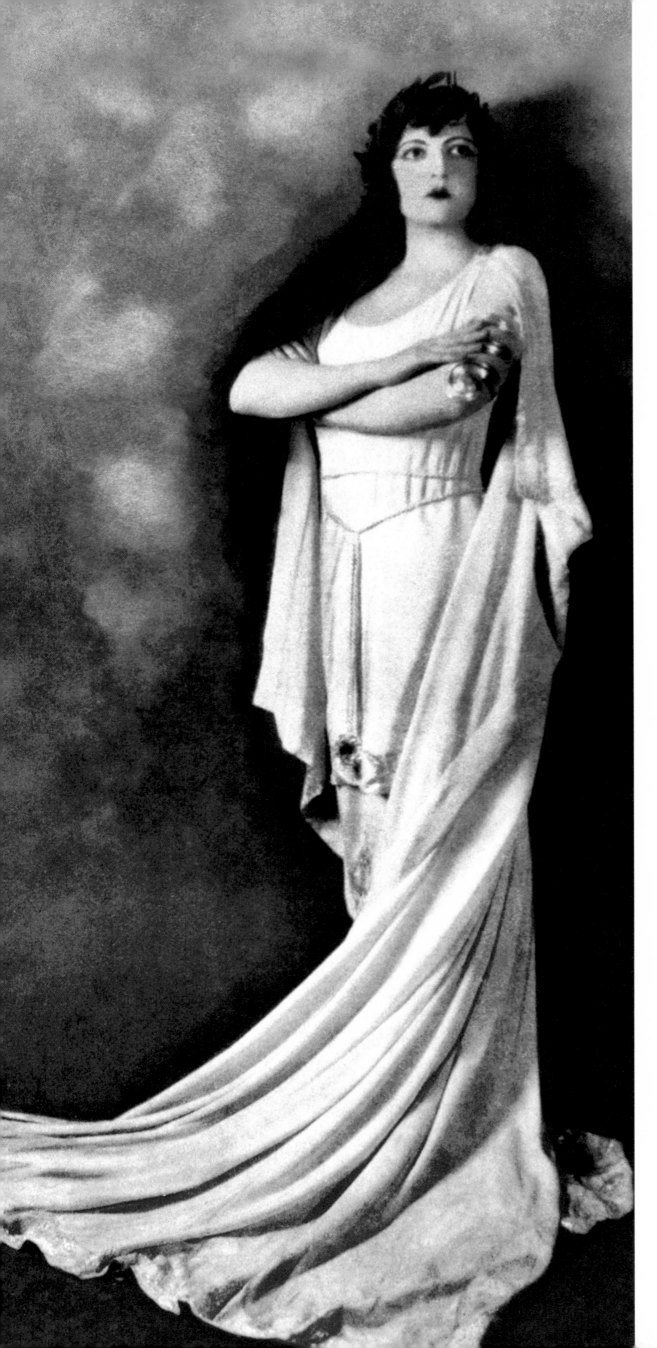

LEFT:
A unique silhouette and temperament:
Ponselle, or Norma re-created.

RIGHT:
This posed portrait of Ponselle reminds
us why Hollywood wanted this face so
badly.

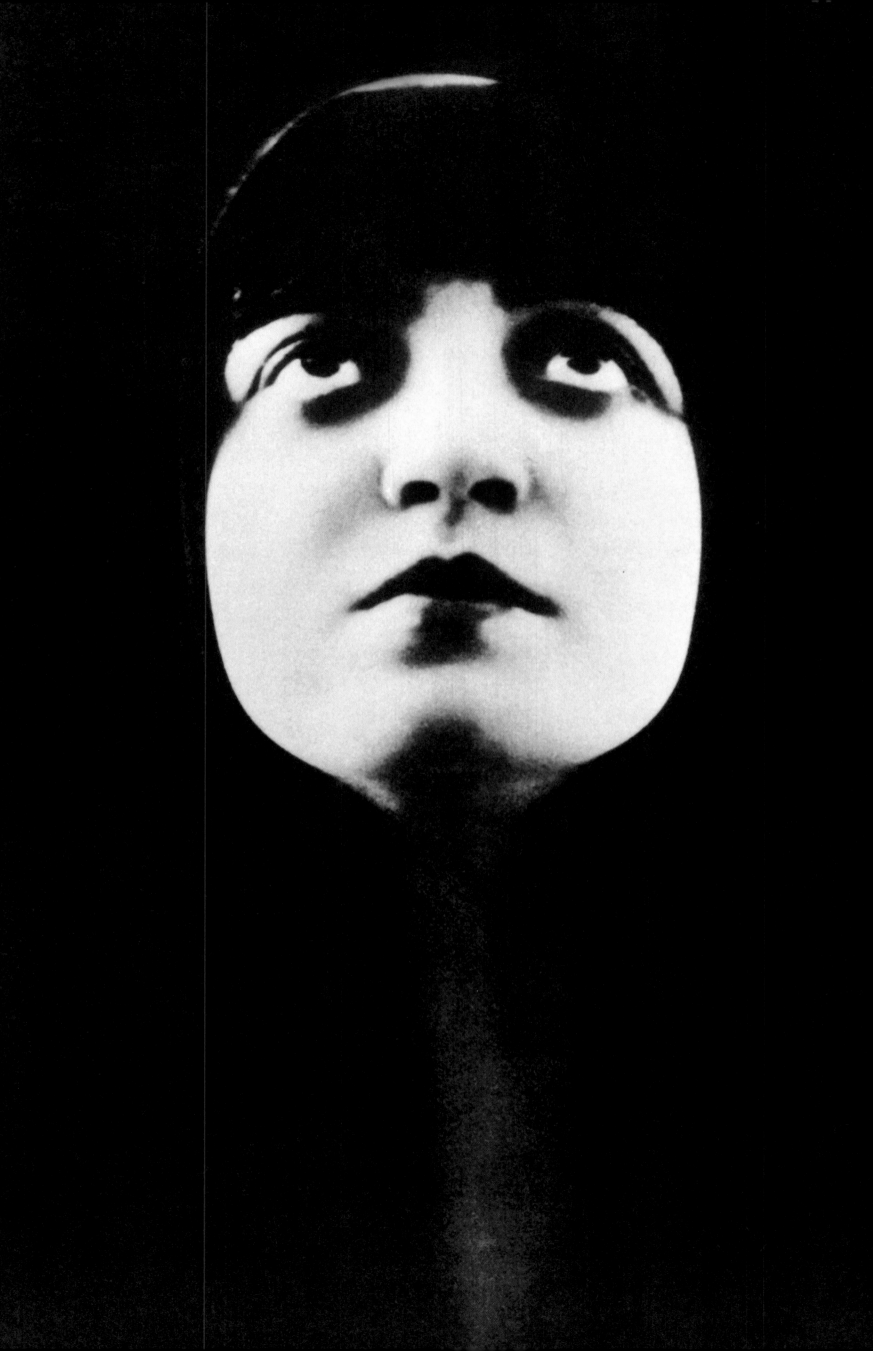

# Emma Eames

## (1865/1952)

Though she was American, and even something of a Bostonian, this lawyer's daughter retained a touch of exoticism thanks to her birth in Shanghai. Like many American girls, she studied abroad to earn her stripes, and spent two long years taking classes on rue Jouffroy in Paris with the illustrious and redoubtable Mme. Marchesi. It was Marchesi who allowed Eames to stride beyond a mere immaculate command of technique. Thanks to her lessons on rue Jouffroy, she acquired a quality and individuality of tone, a passionate vocal resonance and, especially, a singing ethic. Composure was primordial, occasionally at the cost of making her appear cold, distant, or overdressed. Onstage, it seemed she always wore Worth couture, and she never so much as ruffled her gowns. She made her debut at the Grand Opéra de Paris in 1889 at age 22, playing Juliette (she had been coached by Charles Gounod) opposite the great Jean de Reszké. This led to two solid years of Parisian successes, in *Faust,* then in Saint Saëns's *Ascanio.* After Juliette, she sang at Covent Garden in London, and the Metropolitan Opera in New York. She was the great star of the end-of-the-era aristocratic opera singing that had been ruled by the Reszké brothers and the French repertoire, tone, and style. At the turn of the century, Giacomo Puccini's increasing influence was eclipsing Charles Gounod, and the robust, energetic Enrico Caruso dethroned Jean de Reszké. Yet Eames reigned on, unaffected. Her Mozart and her Wagner were solid values, and were not threatened. Nonetheless, the French repertoire was no longer at the top, and Eames couldn't imagine herself wearing the worker's blouse worn by Louise, the new archetype. Instead, she played an imperial Tosca for Puccini. Only she could pull off a prima donna when the tide had turned to realism! She cordially detested the ubiquitous Melba (who returned her feelings in kind), another graduate of the Marchesi school who routinely played Mimi in *La Bohème.* Eames could be direct and cutting. She could make your blood run cold. George Bernard Shaw perfidiously described her Aida by stating that, "One could have skated on the Nile yesterday evening: Mrs. Eames was singing *Aida.*" Uninterest in the new Italian orientations of a Metropolitan Opera now ruled by Giulio Gatti-Casazza and Arturo Toscanini, she retired in 1909, at the height of her fame, and never looked back. Her first marriage was to the painter Julian Story; her second was to the baritone Emilio de Gogorza. Her beauty, which was frequently compared to a Donatello, did not fade, and neither did her timeless records. The astute listener can uncover the flicker of a strange, distant fire in her recordings.

Emma Eames: in *Lohengrin.* Cold? Perhaps, but royally so.

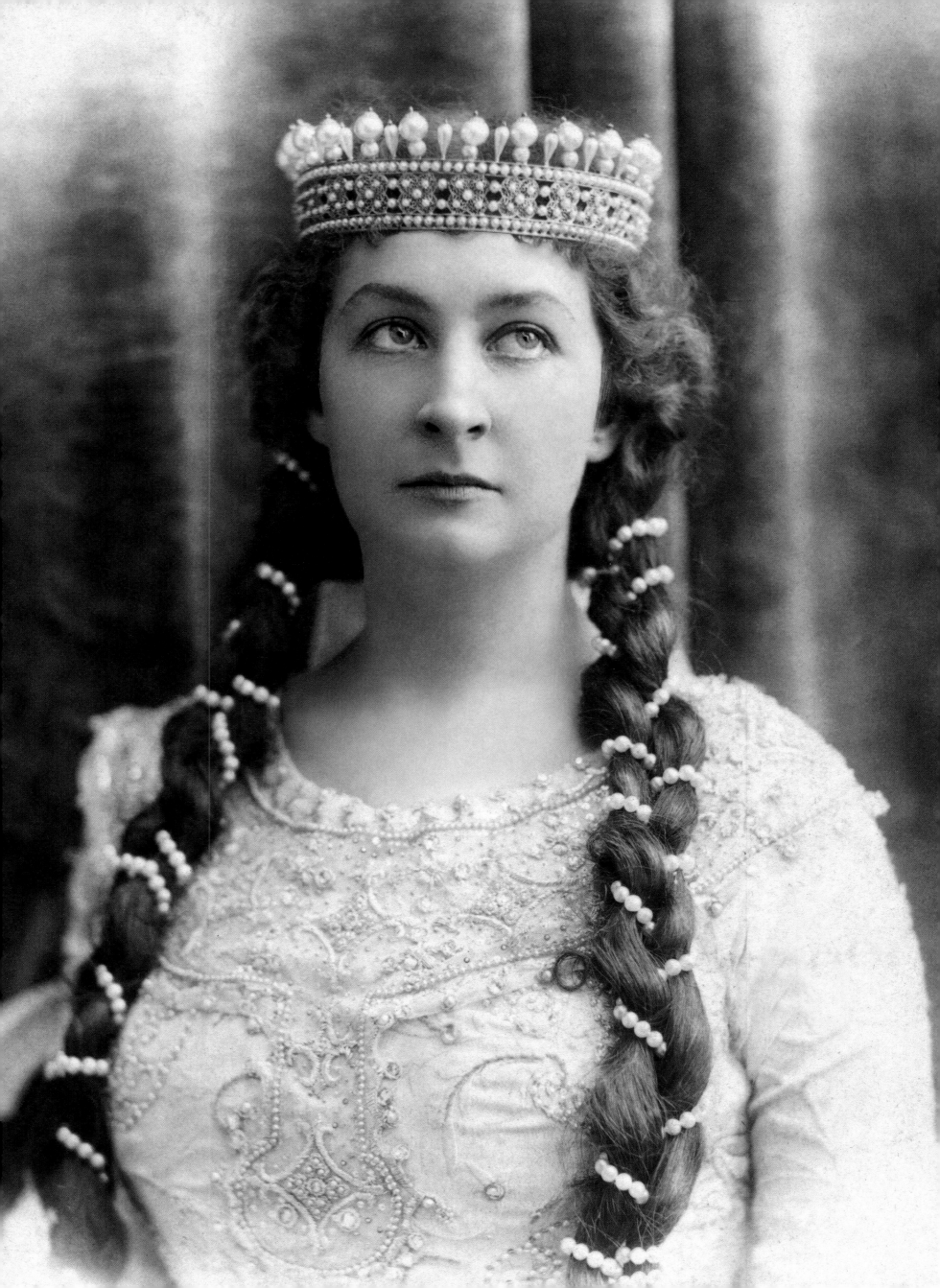

# Geraldine Farrar

## (1882/1967)

At the turn of the century, the Metropolitan Opera was offering European divas a fortune to grace its stage. Its top facilities and payment in dollars attracted every one of them. The most exclusive part of the room, the Diamond Horseshoe, where the richest industrialists had season tickets, wouldn't have given a singer born in the United States the time of day. But obviously this would eventually have to change, and Geraldine Farrar was the one to bring the winds of change. Her track record was exemplary, starting with the obligatory training abroad. She went for the very best, selecting the merciless soprano Lilli Lehmann of Berlin as her maestra. By sparing her nothing, Lilli trained Farrar's naturally beautiful voice perfectly. Yet like many of the great Lilli's students, Farrar's voice would be short-lived. She went straight from Lilli's studio to the Imperial Opera, whose regal stage had not been long in welcoming her insolent beauty and her pioneering, still exotic American spontaneity. A favorite and regular guest of the royal family, she had an affair with the crown prince, who had to be chastised when it was discovered that Farrar was wearing pearls and tiaras belonging to the Hohenzollern privy purse onstage in *La Traviata*. She followed her time in Berlin with numerous creations in Monte Carlo, a major stop on the singing star's circuit of the period. And when the time came to try her luck in New York, she made sure that the newest roles were all hers: Tosca, Butterfly, but also Juliette, all of which she snatched from stars on the way down. Manhattan was at her feet, Arturo Toscanini—the reigning conductor—was on his knees before her, and a brand-new breed of fans, the gerryflappers (i.e., "those who applaud Geraldine") swore only by her. Her voice quickly declined, but this consummate performer continued her ascent, adding Carmen to her list of triumphs. One of the most desired single women in New York, she eventually agreed to marry Lou Tegelen, a film and theater actor she allegedly stole from Sarah Bernhardt. They starred together in a silent version of *Carmen* directed by Cecil B. DeMille, who tapped into their previously established, unique prestige as opera stars and saved them the hassle of appearing on an actual stage. After *Carmen,* Farrar and Tegelen made *Joan of Arc.* Though she was a national hero, Farrar never allowed herself to make compromises. When she retired at the height of her fame, at 40, the gerryflappers harnessed themselves to her limo the way grand dukes had once harnessed themselves to Patti's coach.

Geraldine Farrar: Juliette, or the insolence of innocence.

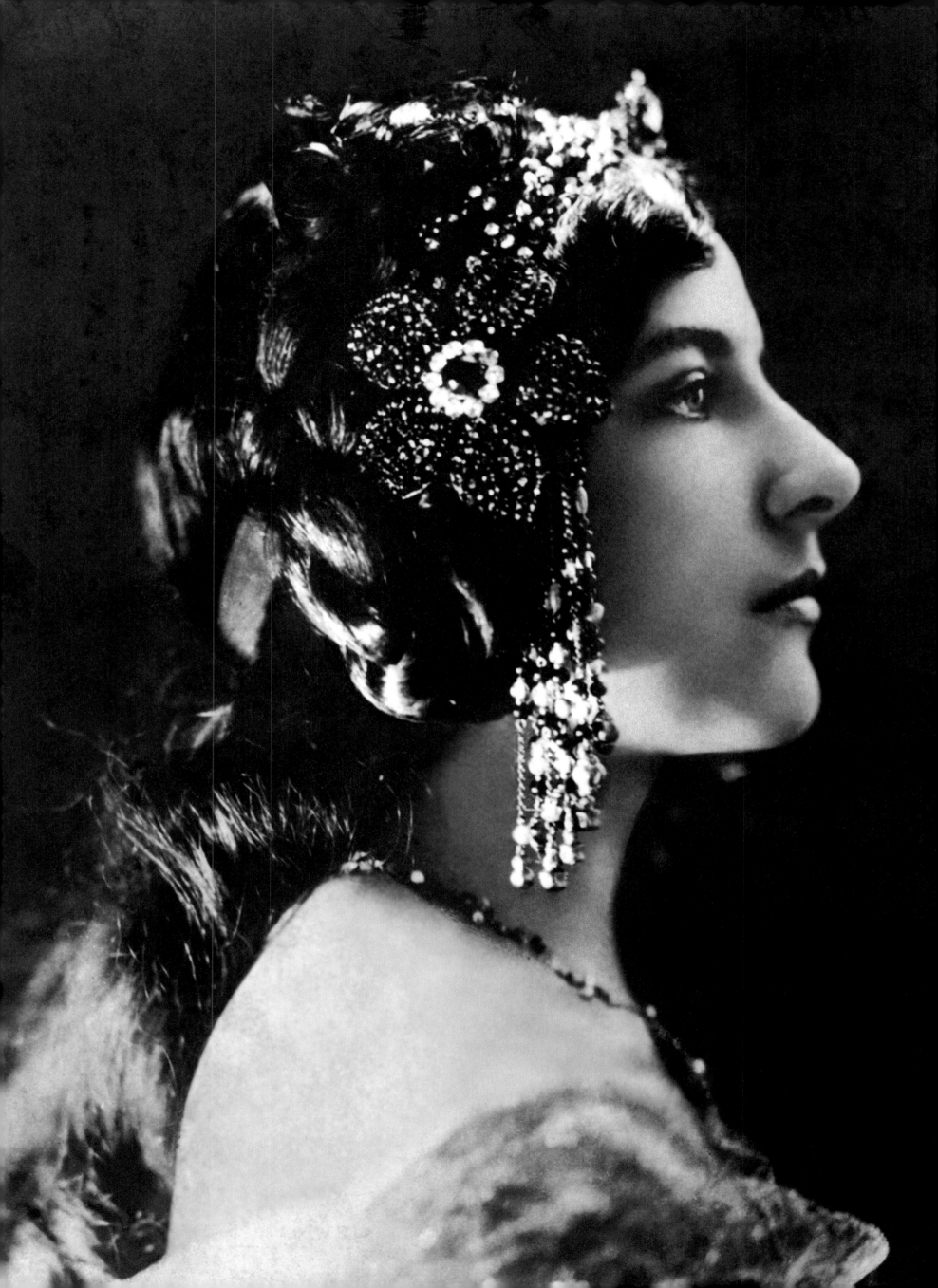

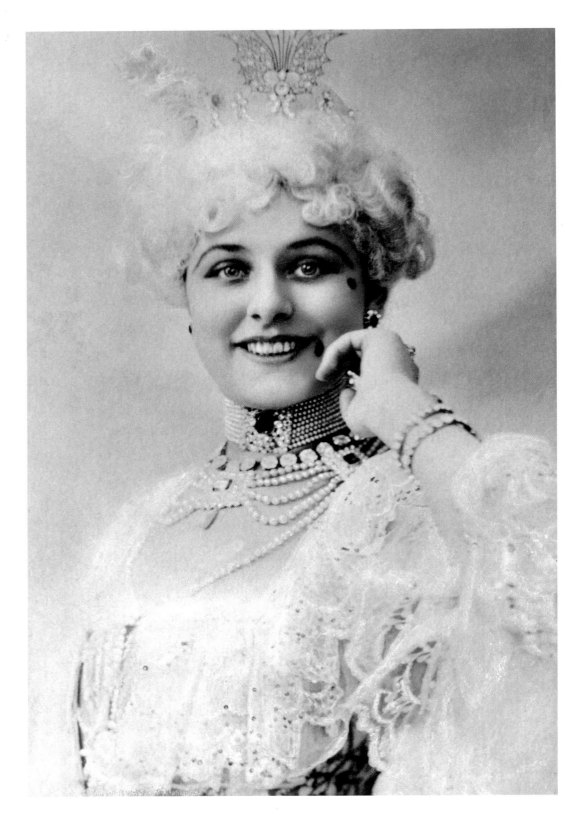

ABOVE:
Geraldine Farrar: bejeweled, pale, and powdered to look glacial.

RIGHT:
Farrar, with desire in her eyes, in her greatest role, Mignon.

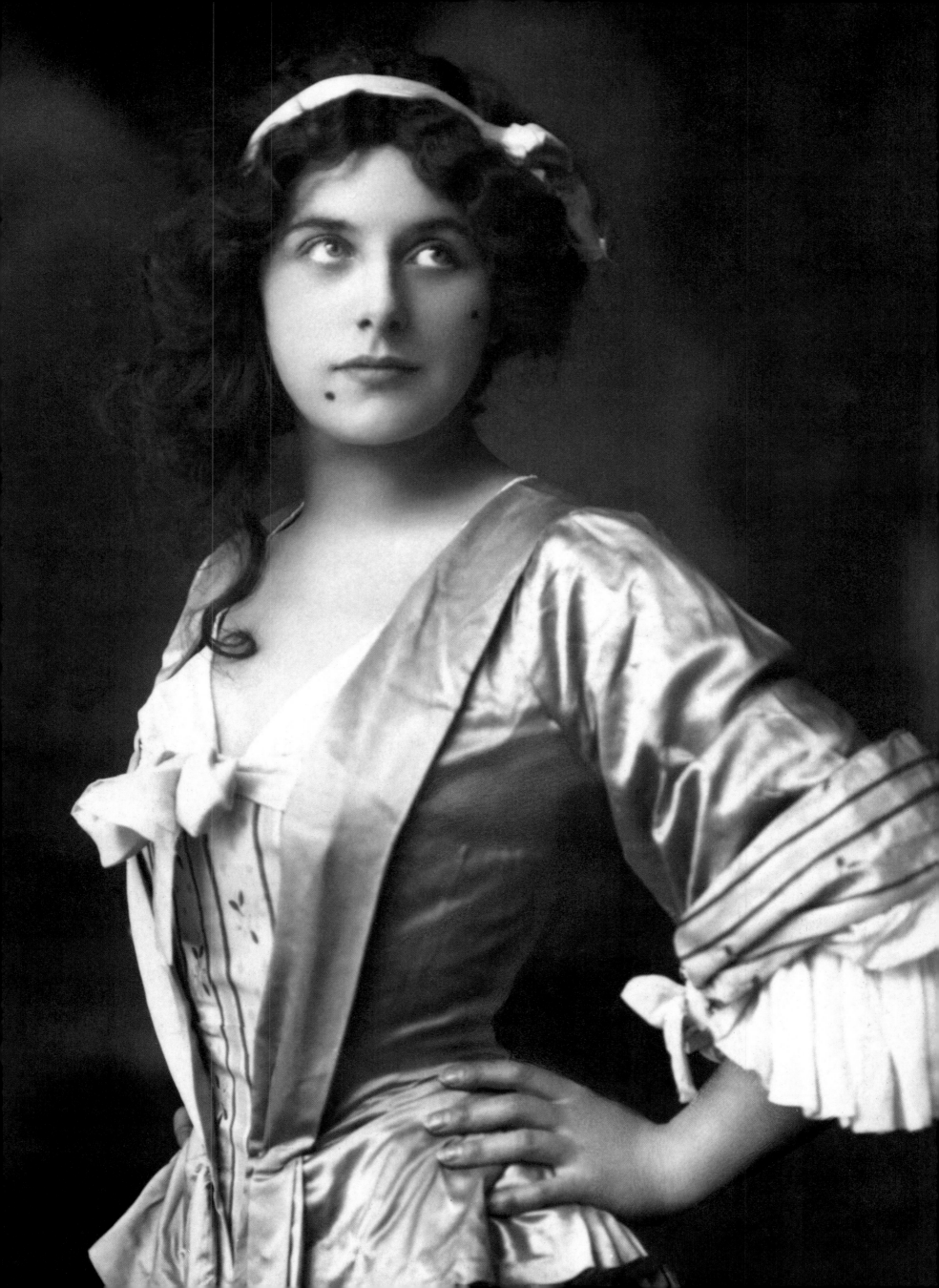

# Maria Cebotari

## (1910/1949)

Back in her native Bessarabia, her entourage was loathe to allow her to study music and singing, but nothing could stop her from following her future husband, the Moscow Art Theater actor Sascha von Wiroubov, when he came through on a tour. He took her to Paris, where he taught her to speak multiple languages and understand theater. In Berlin, she dedicated herself to singing, which was enough to get her a debut at the age of 21 in *La Bohème* under Fritz Busch's direction. Brimming with ability and talent, Cebotari was the most conscientious of divas: She took on dozens of roles and never missed a rehearsal. At 24, she was named *Kammersängerin* in Dresden, an unprecedented accomplishment for a young singer. She was the star of the world premiere of *Die Schweigsame Frau*, the Richard Strauss opera with a libretto by Stefan Zweig (who was already banned). She also played Strauss's Sophie, Daphne, and Ariadne. Salzburg wanted her to sing Mozart and the movies coveted her beauty (she appeared in Carmine Gallone's wonderful *Songe de Butterfly*). Her energy and her radiant disposition pushed her to try her hand at Carmen, Salomé, and even Turandot. Then in the middle of the Second World War, she lost her second husband, Gustav Diesel, the protagonist of Georg Wilhelm Pabst's *Westfront 1918,* and suddenly found herself having to provide for her two sons while keeping her distance from Berlin and Vienna, the scenes of her triumphs. But these misfortunes only led her to sing with even more passion and commitment. She continued to be celebrated and adored for her rendition of Comtesse at La Scala with a resurrected Herbert von Karajan, and for her devastating Salzburg creations of Gottfried von Einem's *Dantons Tod* and Frank Martin's *Le Vin herbé.* Yet she was powerless against the devastating cancer that cut her life short at 39, in June 1949. In a fitting tribute, her funeral train was followed by 40,000 Viennese mourners.

Maria Cebotari as Isot in Salzburg. The sublime mask of the tragedienne outshines the beauty of the woman, and it's for the best.

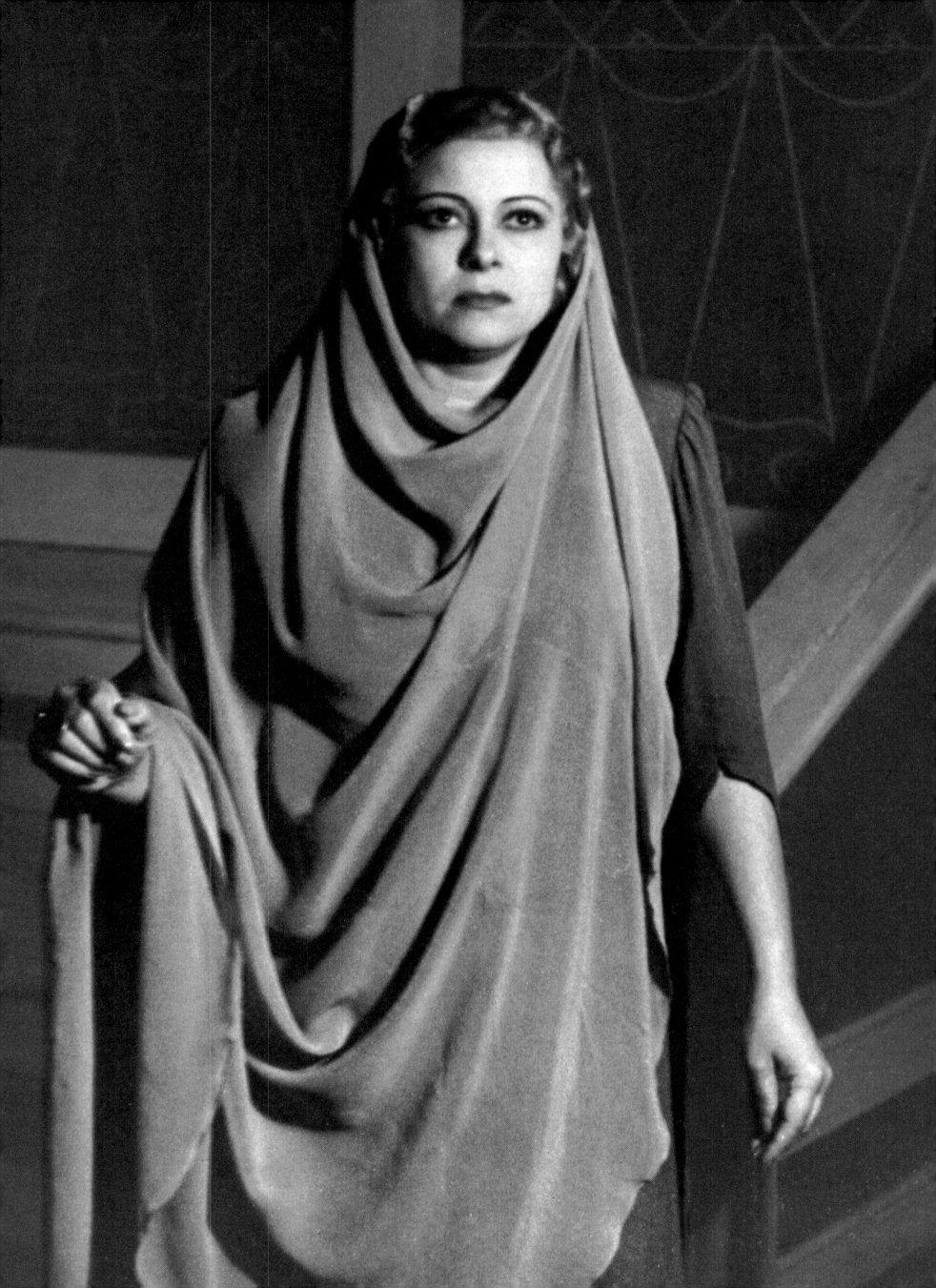

Maria Ceborati as Butterfly: Abandonment is death. Once radiant, the face is now lost in shadow.

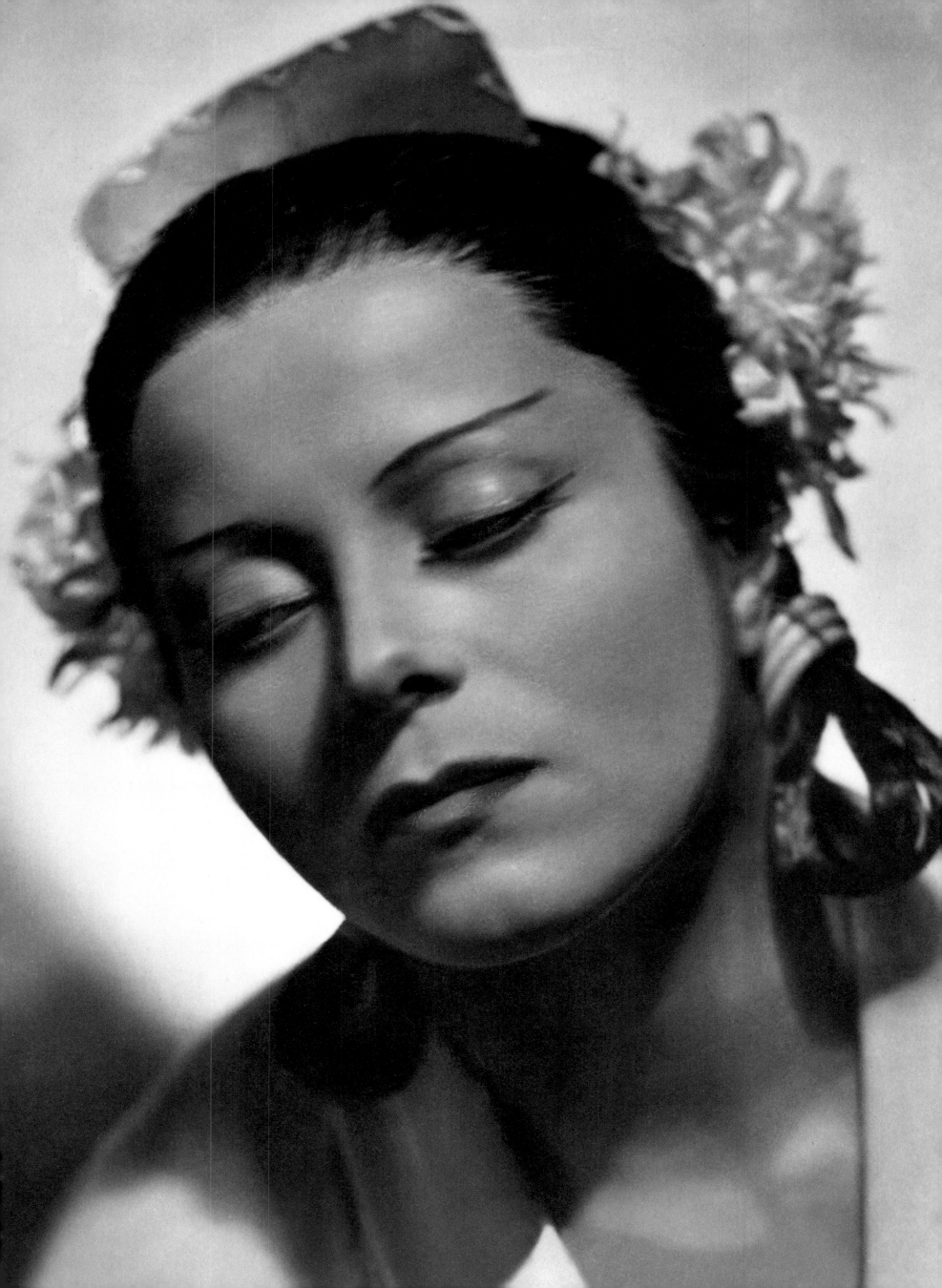

# Mary Garden
## (1877/1967)

Though she was born in Scotland and moved to the United States when she was just a child. Mary Garden spent most of her life as an ambassador for new ideas in French music and French fashion. By 26, she hadn't set foot onstage, but she had already assiduously followed the Paris rehearsals for the opéra comique play that in 1900 truly launched the new century: *Louise,* a story about real people, carnal desire, and free love. The production caused a scandal, and Mary Garden didn't miss a single performance. She later claimed that her decisive moment came on a Friday the thirteenth when in the middle of a performance, the main role, Marthe Rioton, completely lost her voice. André Messager, the conductor, immediately thought of the little Scotswoman who, by then, should certainly have absorbed the entire libretto. He didn't have to ask twice. In the blink of an eye, Mary Garden slipped on Louise's costume and found herself in the midst of the set representing Montmartre, launched into the great *Depuis le jour* before an astonished, impressed audience. Garden's is probably the sole career to have started in such a magical way. But then, French opera only brought her only luck: Her exotic and unusual charm and her slight accent seduced Debussy, and soon she was playing the first Mélisande, followed by Aphrodite, Reine Fiammette, Thaïs, Manon. If it was French and you could sing it, it was hers. She even carried off Hamlet and its vocal gymnastics. She peaked with two inimitably stylish and daring turns as cross-dressers: Jules Massenet's *Chérubin,* which she created, and the same author's *Jongleur de Notre-Dame,* which she appropriated from the tenors. Richard Strauss would have liked to see her pretty legs in *Der Rosenkavalier,* but she disdainfully refused. Make love to two women all evening? No thanks. So she stuck to French, imposing every conceivable French opera in New York. Her turf was not the Metropolitan Opera but its rival, the Manhattan Opera House, opened by Oscar Hammerstein in 1906 and ruled over by Mary Garden and no one else. Her success in Chicago was even more triumphant, where she spent a full season as director of an opera house (she was called directa), wielding power and losing millions. She tried Thaïs on the big screen, but her overacting led to a total flop. Next came *The Splendid Sinner,* another silver screen bomb. Yet her personality was so hypnotic, her prestige so colossal, that when her voice faded, she was able to lecture on fashion, politics, and morals. She died at 90, as impertinent, prestigious, and charismatic as she had ever been.

Mary Garden: What other Ophelia ever dared such flowers with her madness?

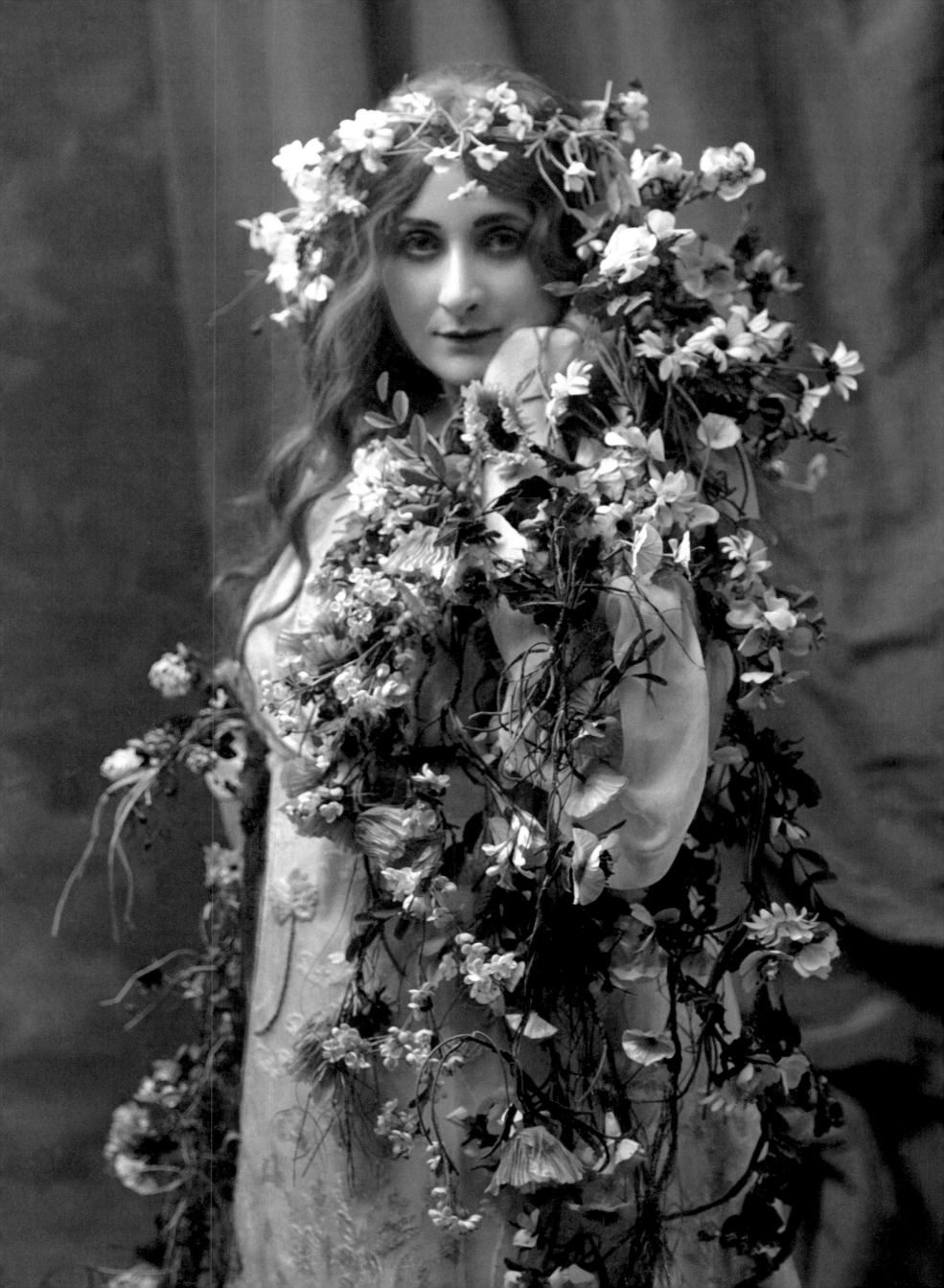

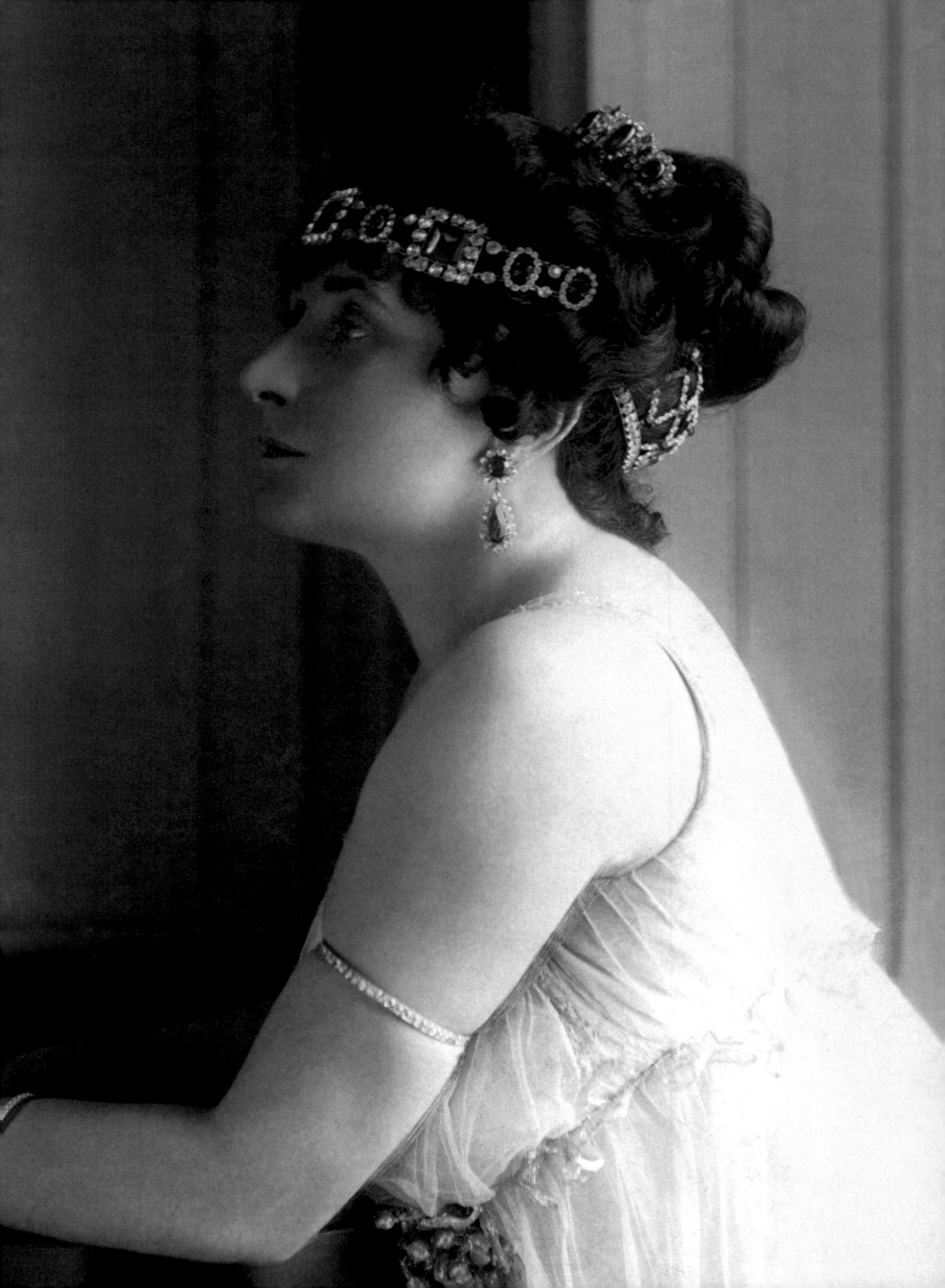

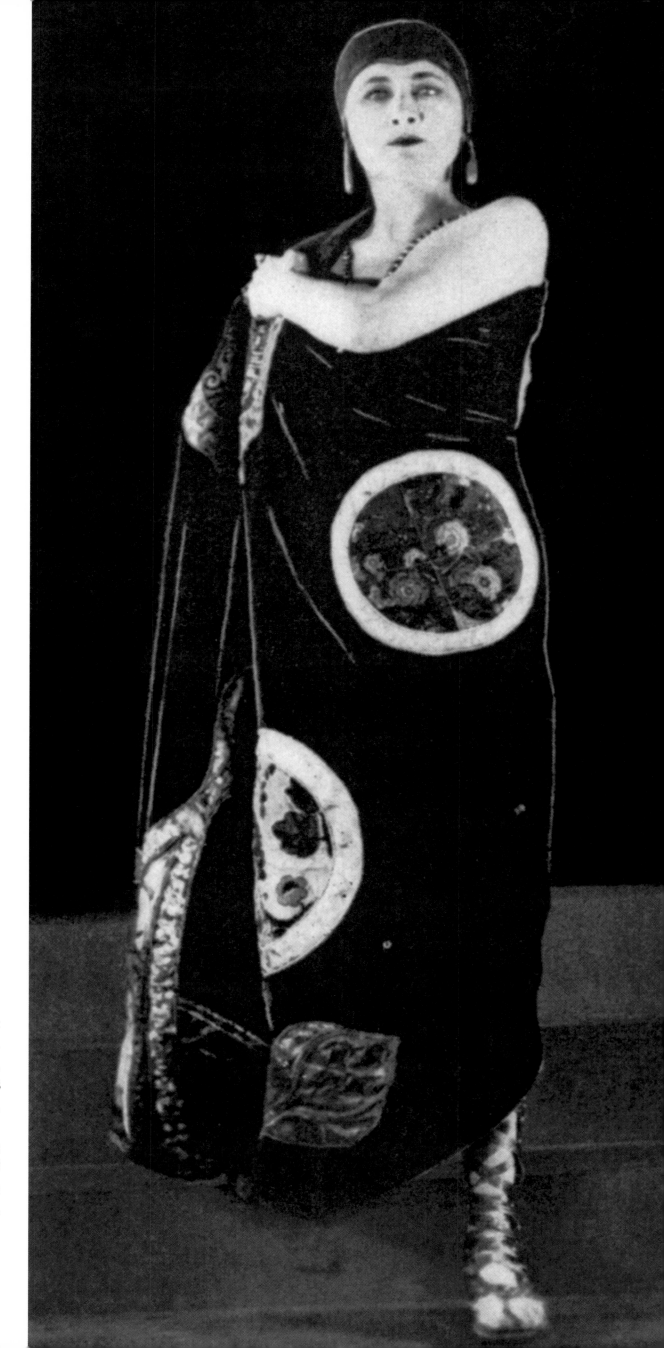

LEFT:
Mary Garden as Tosca.
Her profile, her bearing,
her tone. "Diva" means
personality.

RIGHT:
A fashion sketch?
No, here's Mary Garden in
her Aphrodite opera gear.

# Kerstin Thorborg

## (1896/1970)

Hers was the incarnation of the ideal Scandinavian voice: noble, ample, and deep. The dean of English critics, Ernest Newman, said that she walked "like a goddess and stood like a statue." Dense, haloed roles of classical antiquity suited her perfectly, beginning with Orpheus, whom she played in Salzburg, effortlessly erasing the memory of her eminent predecessor Sigrid Onegin. It was as if Richard Wagner had tailored his versions of the demigods of Scandinavian mythology, svelte and ardent creatures who were such a welcome change from the usual matrons, to her exact measures. She played Brangäne in *Tristan,* Fricka in *Die Walküre,* then the viper Ortrud in *Lohengrin,* in which her hell-bent imprecations sent shivers through the audience. Her Kundry in *Parsifal* was even more spectacular. Though she was Swedish and not directly threatened by the looming Second World War, she was disgusted by the rising tide of the Nazi Brown Shirts and chose to leave her home base of Berlin as early as 1933. She took refuge in the United States, where Wagner was more or less her bread and butter, though Amneris in *Aida* and Marina in *Boris* were even more effective at displaying her sumptuous tone and her dazzling high notes. She was the queen of Vienna and Salzburg and enjoyed such a powerful aura that she barely had to fall back on the theatrical: for Arturo Toscanini and Bruno Walter, the singer was enough. Toscanini conducted her in the most legendary renditions of Verdi's Requiems. Walter entrusted her with his first recording of his mentor Gustav Mahler's "Das Lied von der Erde." An absolute vocal equivalent of the Norwegian soprano Kirsten Flagstad and the Swedish tenor Jussi Björling, she was also blessed with dramatic genius and a powerful physical presence, both on and off the stage, which few mezzos ever displayed. Yet she preferred the wild swans and cold luminous skies of her native Sweden to the theater and its glories. She retired to Sweden quite early, before her voice had shown any sign of decline.

Kerstin Thorborg: A daughter of kings, or maybe even of gods, is watching us.

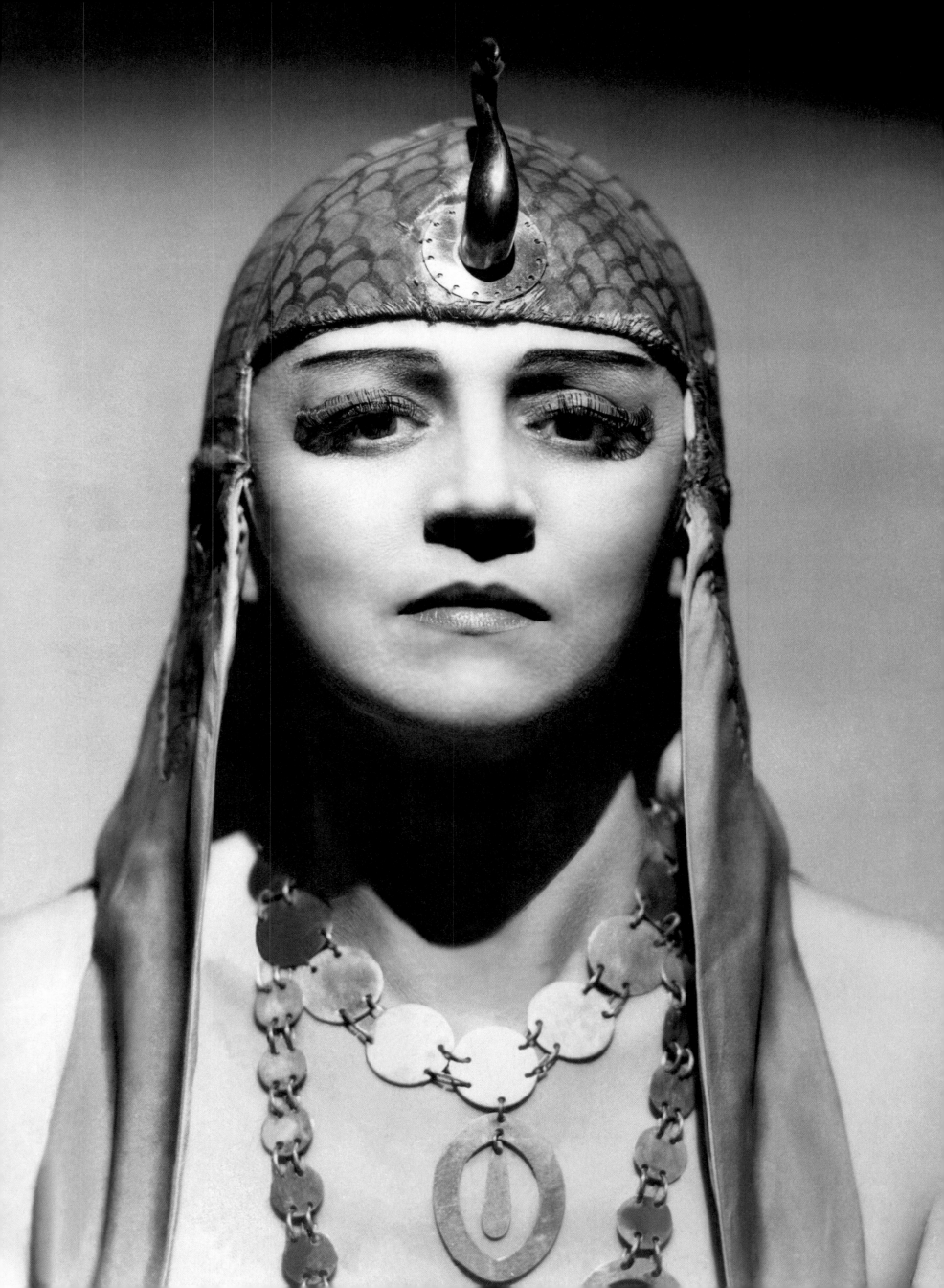

# Anna von Mildenburg

## (1872/1947)

An absolute legend and, in certain ways, a female Dracula, she was born for tragedy and uncharted territories. Blessed with an imposing voice and a natural authority, which may have been because of her origins (her father was a major in the imperial army), Anna von Mildenburg met Gustav Mahler during his Hamburg period and wasted no time in seducing him. He brought her back to his native Vienna when he became conductor there, and made her into his prima donna, casting her in the greatest dramatic roles, in the footsteps of another legend, Materna. It is rumored that Austrian stage designer Alfred Roller was heavily influenced by her allure, her bearing, and her unusual power when he reformed the architecture of theater sets. Better yet: Gustav Klimt used Mildenburg's imperious and hieratic traits for the *Allegory of Music* now hanging in the Secession palace in Vienna. In 1897, when she was barely 25, Mildenburg first set foot on the Bayreuth stage, which she would return to many times, to play a memorable Kundry in *Parsifal.* Her Isolde and her Fidelio have remained more or less untouchable examples of scenic grandeur, of visible pain, and of strong accenting. Outside of Wagner, her Klytämnästra in Richard Strauss's *Elektra* displayed a bold operatic expressionism which anticipated silent film expressionism by ten years. As she got older and settled in to married life with the poet Hermann Bahr, who was hugely influential in Salzburg, she naturally continued to innovate with *Rezitation* (or diction) performances that frequently turned what was technically melodrama (or declamation on the edge of singing) into pure and simple theatrical chaos. Today we are blessed with only a single side of a 78 rpm record by this authoritative and monumental singer, the recitative Ozean, du Ungeheuer from *Oberon,* in which her voice seems capable of leveling the ocean's furious waves.

RIGHT:
Anna von Mildenburg: Gustav Mahler's beloved tragedienne as Ortrud.

FOLLOWING PAGES:
Anna von Mildenburg invented expressionism to play Klytämnästra in Elektra.
She was one step ahead of film.

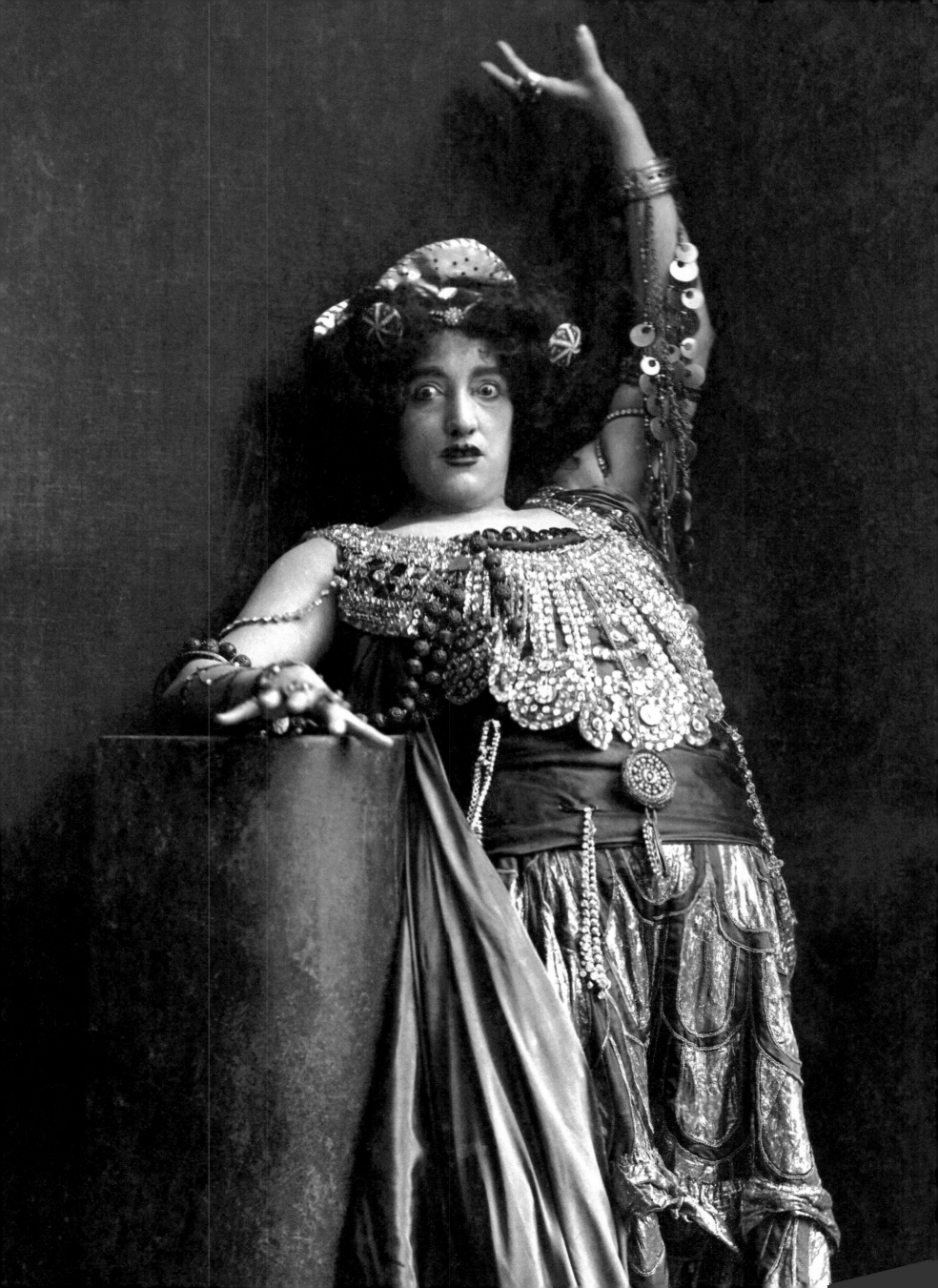

# Viorica Ursuleac

## (1894/1985)

She was probably the strongest and supplest of the great opera singers. She was certainly the only one to put herself through a daily regimen of the most demanding vocal exercises (such as Rossini's notorious grand arpeggio, which could break weaker voices), topped with respiratory gymnastics that included climbing a set of stairs without taking a single breath and then exhaling for a full minute. To guarantee that she would step onstage at the height of her powers, Ursuleac used to arrive at the theater a full two hours before anyone else and sing through her entire role at top volume. Through unrelenting discipline, this Romanian-born daughter of a Greek Orthodox priest initially trained as a mezzo, became vocally inexhaustible, and acquired a lightness of touch and flexibility that made her the most remarkable Strauss soprano in an era that was hardly short on Strauss sopranos. Far more beautiful than Elisabeth Rethberg, who originally created the role of Helen of Egypt, Ursuleac also had a phenomenally high range, which inspired Richard Strauss to tailor the so-called Salzburg version of Ägyptische Helena to her abilities. She turned this reputedly impossible work into a triumph. She had begun by creating *Arabella* in Dresden, then, dashing between Munich and Vienna, *Friedenstag*—the opera with the innumerable B and C notes—and *Capriccio.* The dress rehearsal for another of her unforgettable creations, *Die Liebe der Danae,* was authorized to take place in Salzburg in August 1944, but the war on two fronts led composer Goebbels to order that all theaters in the Reich go dark, and Strauss was left to ask his singers to meet him in some better world. If you throw in Ursuleac's other Strauss roles (the Marshal's Wife, Ariadne, the Empress in *Die Frau ohne Schatten*), you come to the astonishing figure of 487 evenings singing Strauss, including four world premieres. What was the secret of her endurance? Could it have been receptiveness, the moral form of flexibility? The great conductor Clemens Krauss (who later married her) booked his ensemble's star players for the extensive concert tours that found Ursuleac singing Beethoven's Leonora and Wagner's Sieglinde with unusual warmth and nobility, and bringing a glacial magnetism to Puccini's Turandot. Sadly, her few recordings do not accurately convey the dimension and charisma of her immense yet subtle voice, a voice that needed the theater, and the hours of warming up that went into it. Yet nothing can erase her place in history.

Ursuleac at the end of *Der Rosenkavalier:* the Marshal's Wife discovers who really loves whom. And what a devastating gaze!

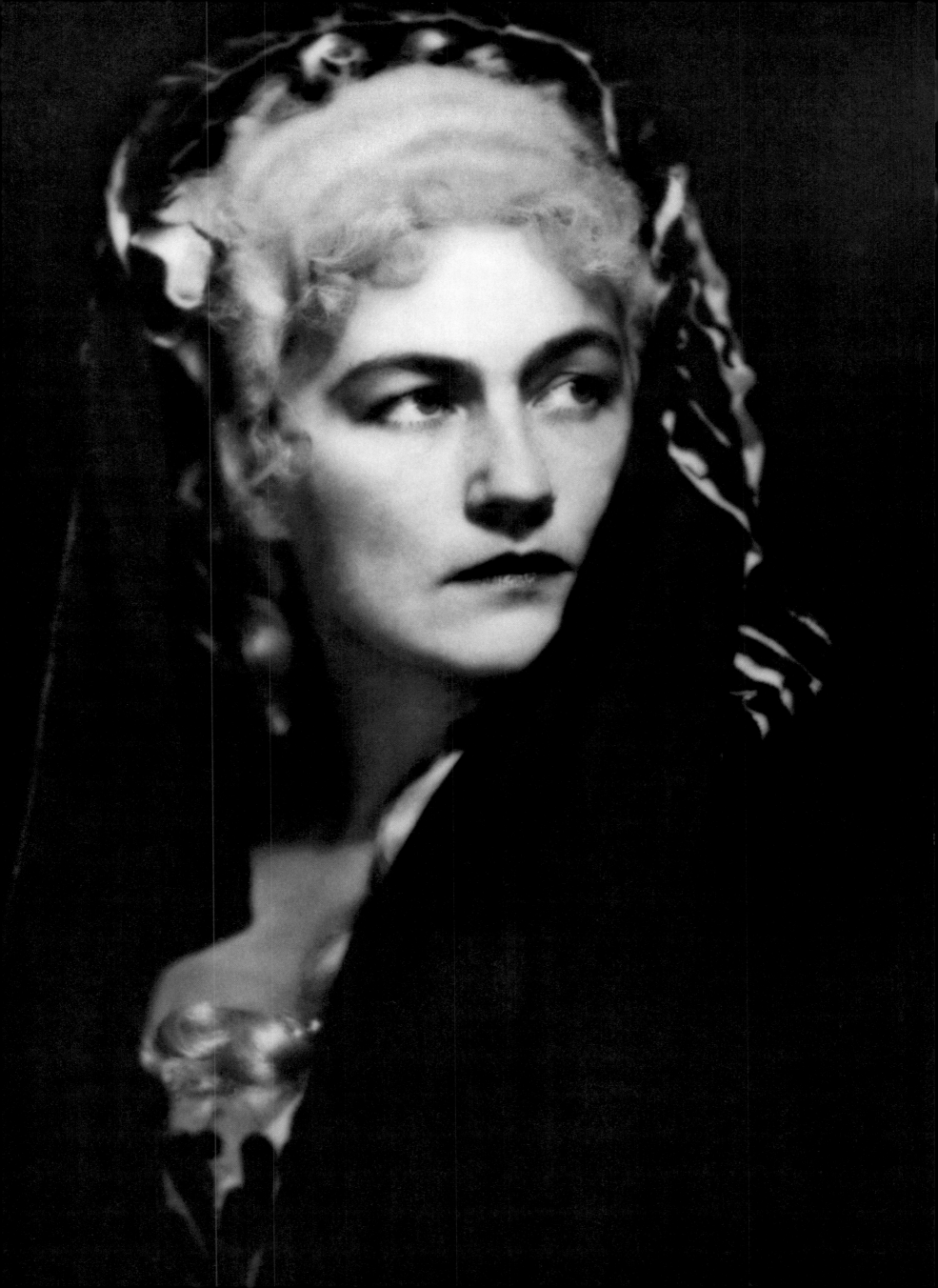

# Marie Gutheil-Schoder

## (1874/1935)

Gutheil-Schoder wasn't a true beauty and her voice wasn't all that captivating. Mahler, her director at the Vienna Opera, found her middle register quite thin. Yet Marie Gutheil-Schoder had a personality and a will for challenge that drove her to the top and kept her there throughout her career (which was exclusively Viennese). While the Secession's developments in painting and architecture were at their apex, she devoted herself to the contemporary, regularly singing Schoenberg's *Pierrot lunaire* and creating his Second Quartet with soprano and, finally, his *Erwartung*. She dared to try everything new: Salomé and Elektra, but also the cross-dresser in *Der Rosenkavalier* and a strange, Nietzschean Carmen. She stood out no matter the role, even though many singers were more beautiful (such as Maria Jeritza) or outdid her vocally (just about all of them). She didn't shy away from mime, playing the Vienna premiere of Richard Strauss's *The Legend of Joseph*. The transition to directing was a natural one for this intellectual who had the ear of the Viennese salons and knew the ins and outs of theater. Her direction of Germaine Lubin in a Paris production of Elektra was a triumph for both women. And her marriage to Setzer, the proprietor of the famous photography studio in Vienna, explains her glorious iconography.

Marie Gutheil-Schoder, mime and actress as Madame Putiphar.

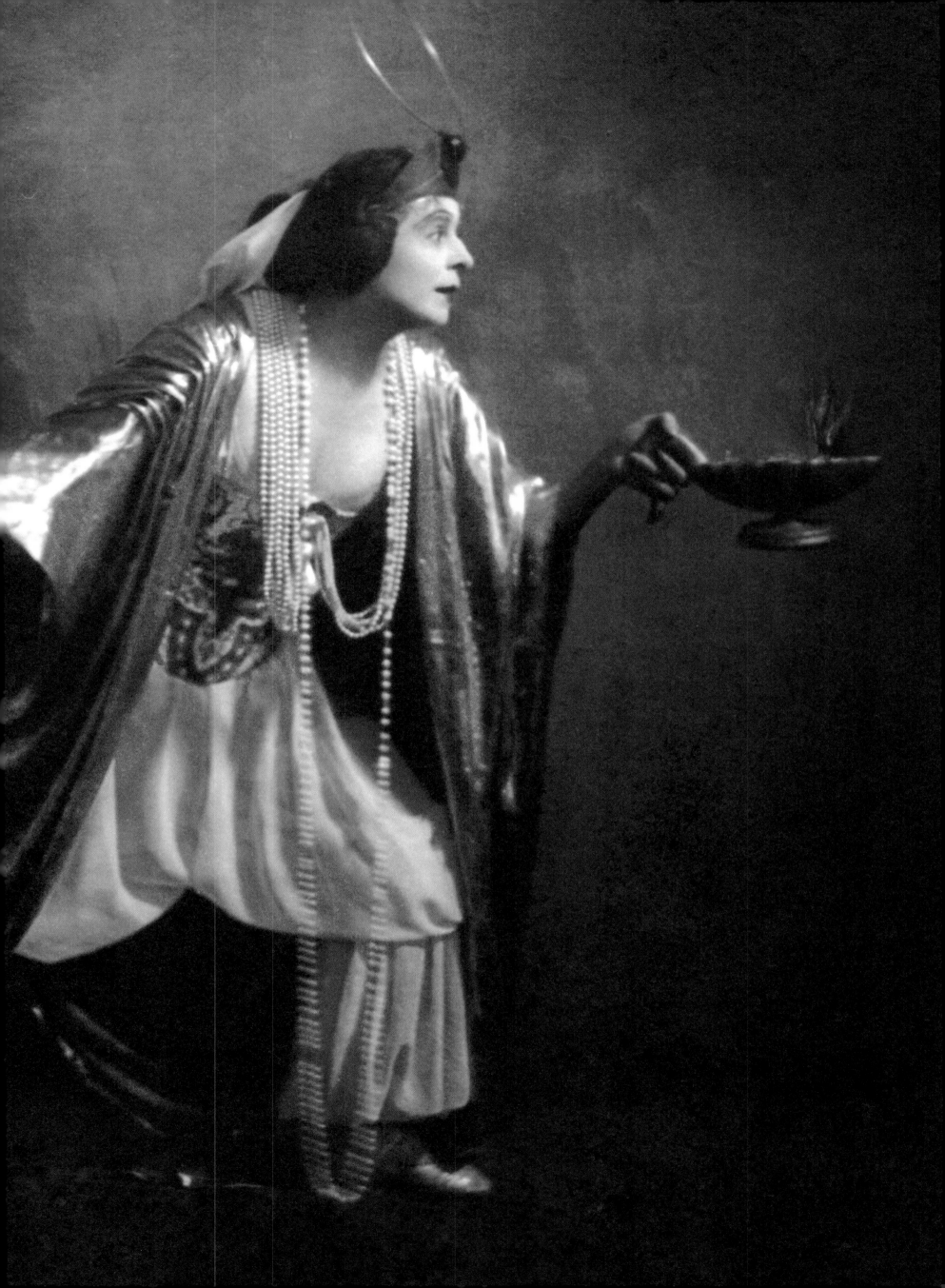

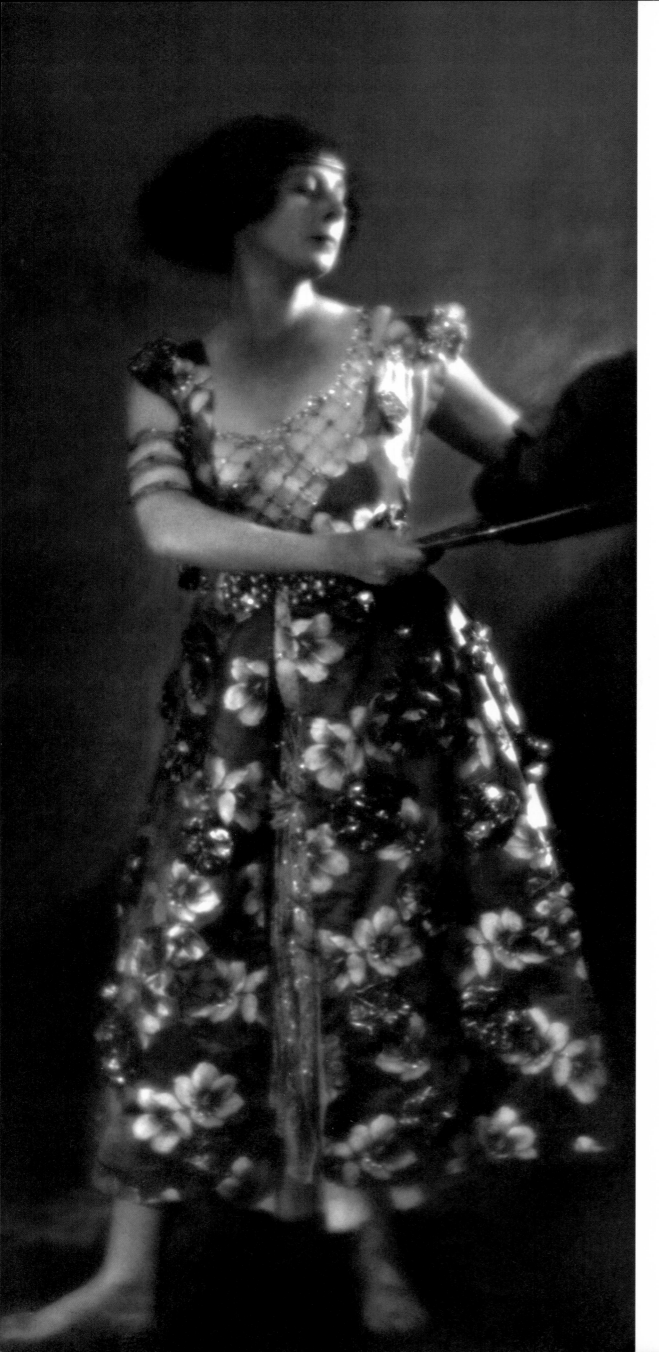

LEFT:
Klimt could have designed her dress for *Salomé*, but the dazzling bearing is all hers.

RIGHT:
Marie Gutheil-Schoder: in *Tiefland*, German realism. This could be a photo from a lost Ibsen play.

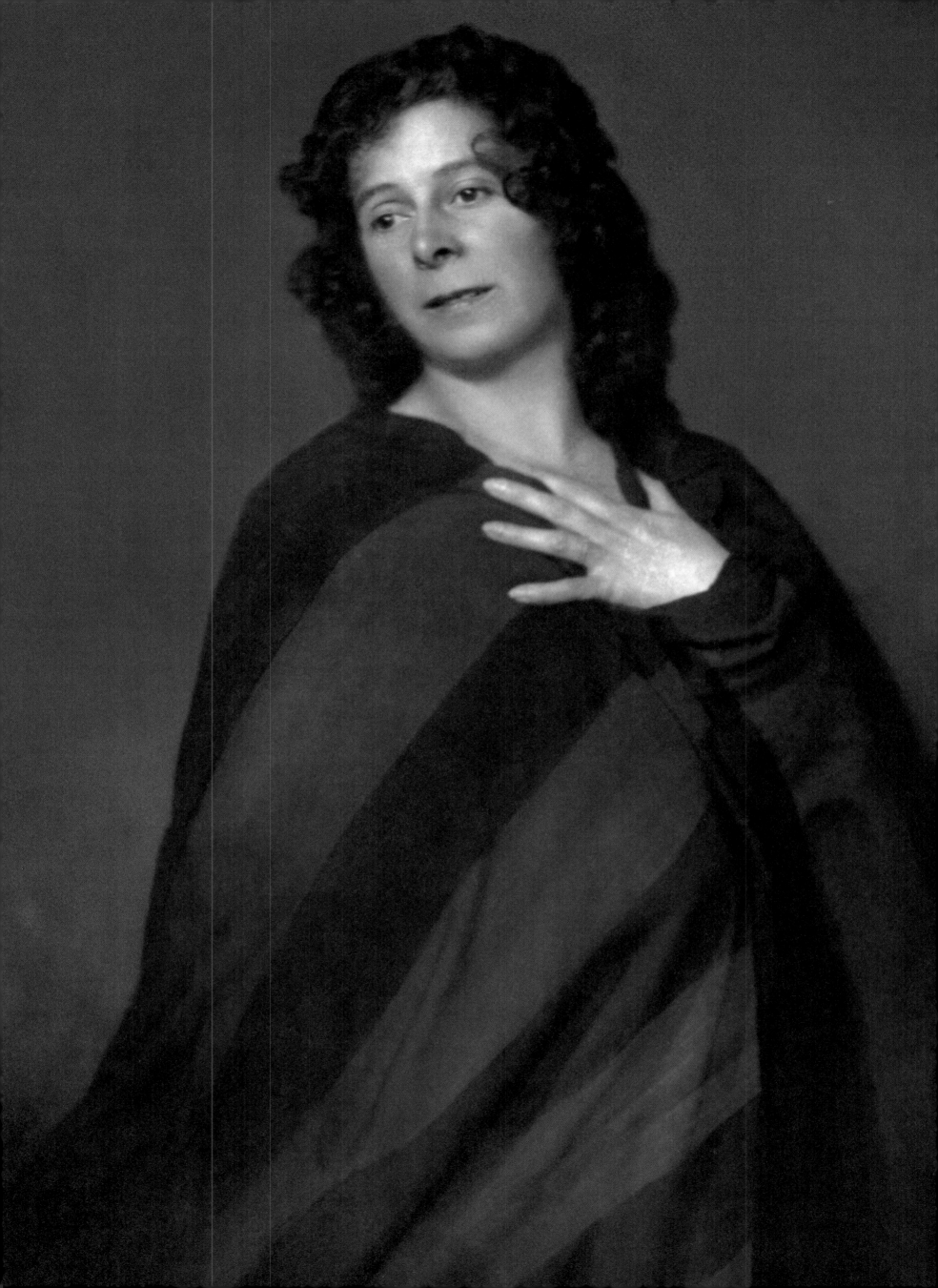

# Rose Pauly
## (1894/1975)

When she began her career in the German provinces, Rose Pauly knew the whole reper-toire, and her voice was adaptable to nearly the entire vocal range. Her tone was capti-vating, and her beautiful eyes added a dark, dangerous intensity to her singing but she somehow remained imperfect. In everything from *La Belle Hélène* to *Die Walküre,* she sang indifferently, as was often the case with those stars who were not ashamed to start off as troupers. Yet once Expressionism began to immerge in film and theater, she led the vanguard in introducing its attitudes and principles to opera. She was not afraid, as so many were, to put her voice at risk by undertaking new creations. In fact, she had a pas-sionate commitment to drama that others simply lacked. She pioneered Leos Janacek's Katia Kabanová in Germany (causing such a scandal that the run was cancelled after a single performance). She sang Paul Hindemith, Franz Schreker's *Ferne Klang* (a huge suc-cess in the nineteen-twenties), and turned a reticent Viennese audience into fawning devotees with her creation of Marie in *Wozzeck.* The great experiment of the Kroll Opera in Berlin would not have been possible without her contribution of a humble, ordinary, and unbearably real Fidelio, played with techniques that would easily have found a place in the new sound films. A plaque in the Trieste Opera House recalls that she was nick-named the German Duse, *La Duse tedesca.* Her performance of Elektra surpassed and destroyed all previous theatrical boundaries. Driven by inexhaustible energy, she set the stage afire with an explosive rage and dramatic poses that sent shivers down the spines of audiences in Salzburg, London, and New York. Yet this incomparable actress and opera tragedienne, who could so easily be imagined playing Strindberg or Aeschylus, made one statement that seems highly paradoxical: Pauly stated that she depended on the enlarge-ment provided by singing, and that she would never have been able to do anything with her parts, if she had been limited to speaking them. Something to meditate.

Rose Pauly: a nearly unbearable intensity as Marie in *Wozzeck.*

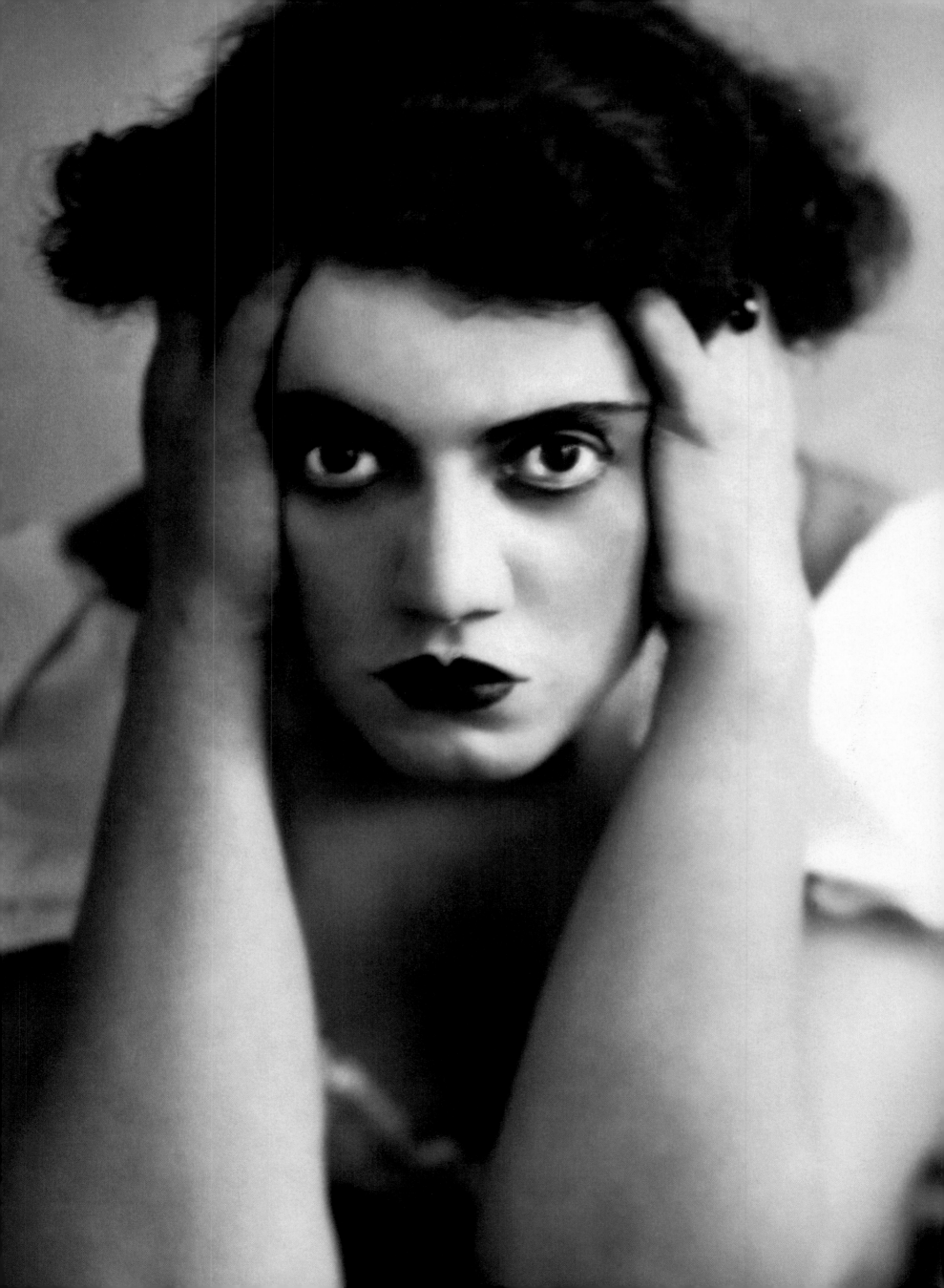

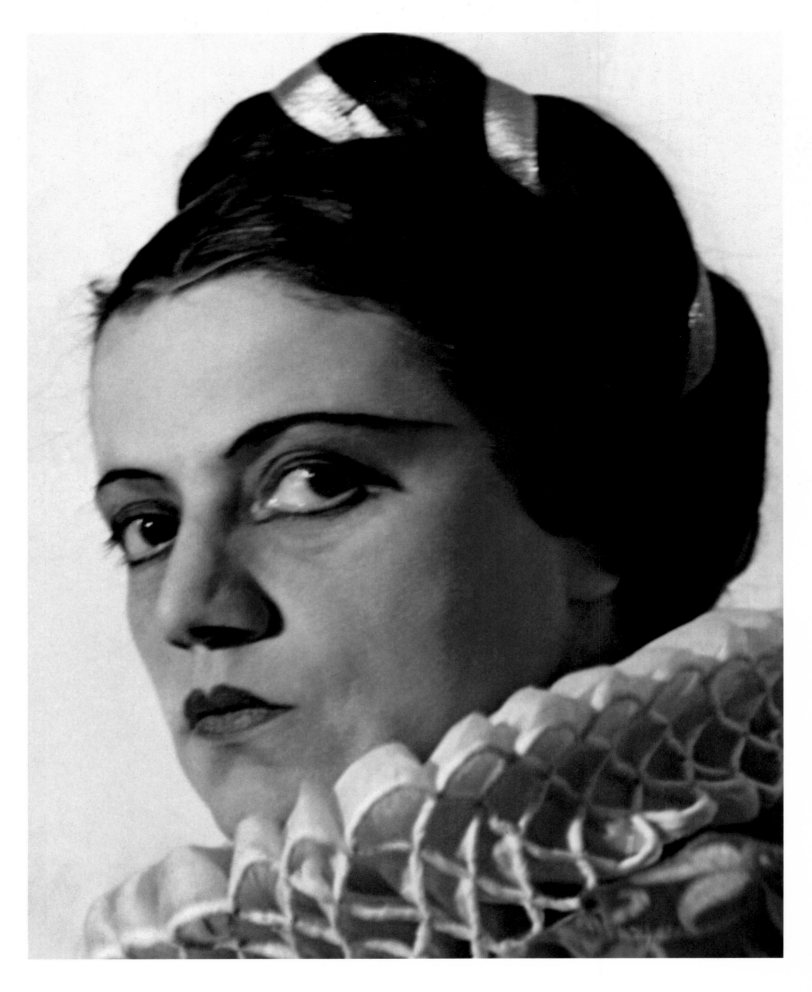

Rose Pauly in full costume as Princess Eboli. Her eyes are a theater to themselves.

A major operatic turn of the 1930s: Rose Pauly's shattering Elektra.

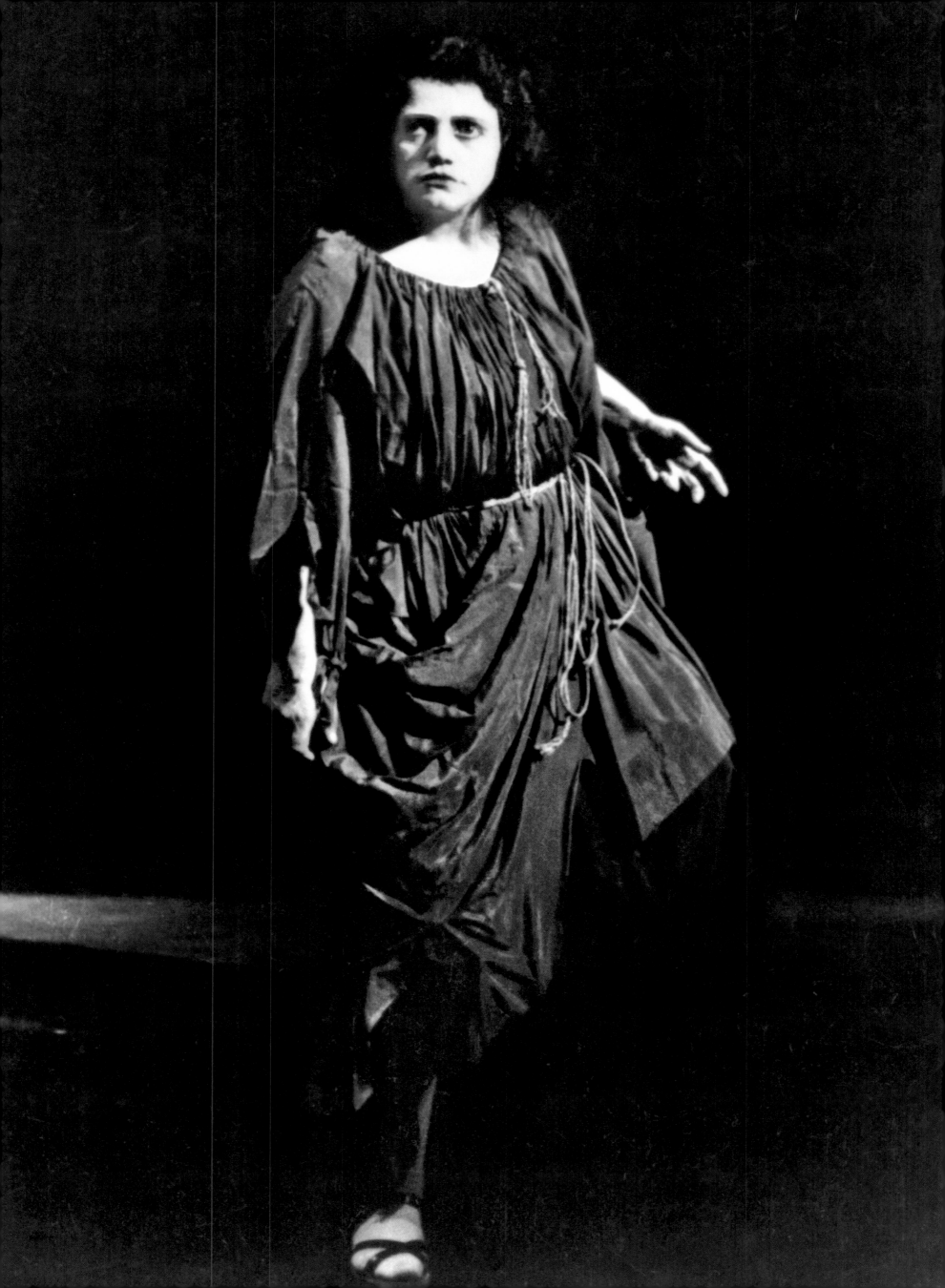

# Maria Ivogün

## (1891/1987)

She was so tiny, so sprightly and so fragile, that she seemed made to play children, elves, or fairies. And she had the lightest, brightest, most tender voice you could imagine. When she auditioned in Vienna, she seemed too small, and her voice and her trill were still far too inferior to those of Selma Kurz, the reigning diva. But when Bruno Walter left Vienna to take over the Munich opera, he took her with him and turned Ivogün, then barely 21, into the most celebrated debutant actress, and then the most brilliant star. She played the tailor-made role of Ighino, Palestrina's little boy in Hans Pfitzner's opera, at the triumphant 1912 world premiere. Next she played *Das Christelflein* (the infant Jesus's little elf), also by Pfitzner, in a role that included as much dancing as singing, and followed it with a nearly extraterrestrial rendition of Walter Braunfels's *Les Oiseaux,* which she played as if she were weightless. The hint of melancholy in her eyes and tone prepared her for more dramatic roles (Konstanze in *Die Entführung aus dem Serail* and Tatiana in *Evgeny Onegin*), performed under the careful supervision of Bruno Walter, whom she had followed from Munich to Berlin. She was also the most mischievous, most natural Zerbinetta in *Ariadne auf Naxos.* Her first husband Karl Herb was her Palestrina and partner in truly celestial Mozart duos. Later, she married her accompanist, the superb pianist Michael Raucheisen, who seconded her for concert renditions of stunning waltzes (during which Fritz Kreisler's violin seemed to be transformed into a human voice). Though Ivogün chose to withdraw from the stage at 40, at the height of her fame, she hardly took the opportunity to rest on her laurels. A great teacher, she was entirely responsible for training Elisabeth Schwarzkopf (Ivogün and Raucheisen referred to her as "our child according to the muses") and Rita Streich.

Maria Ivogün: Konstanze in Mozart's *Seraglio.*

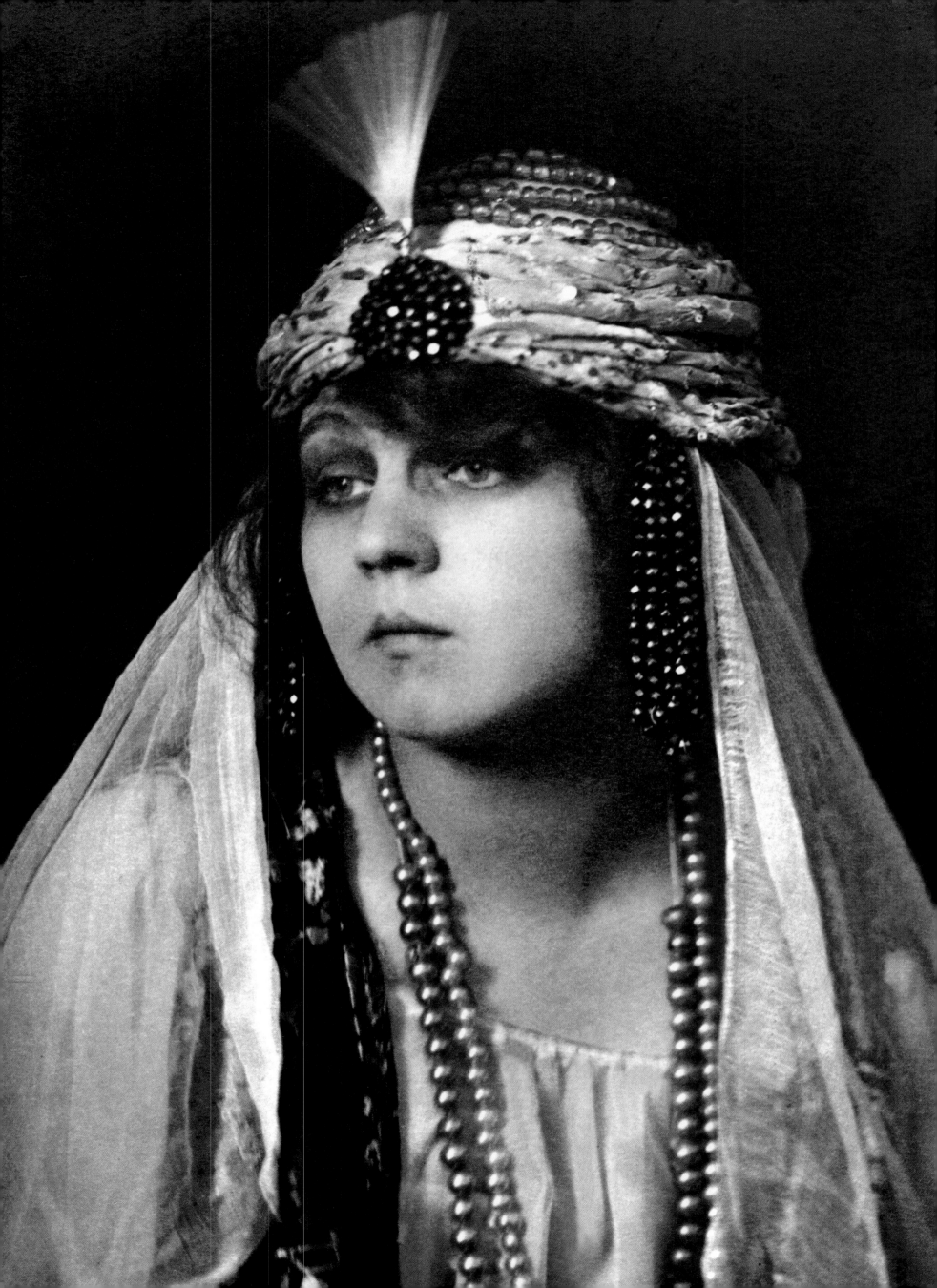

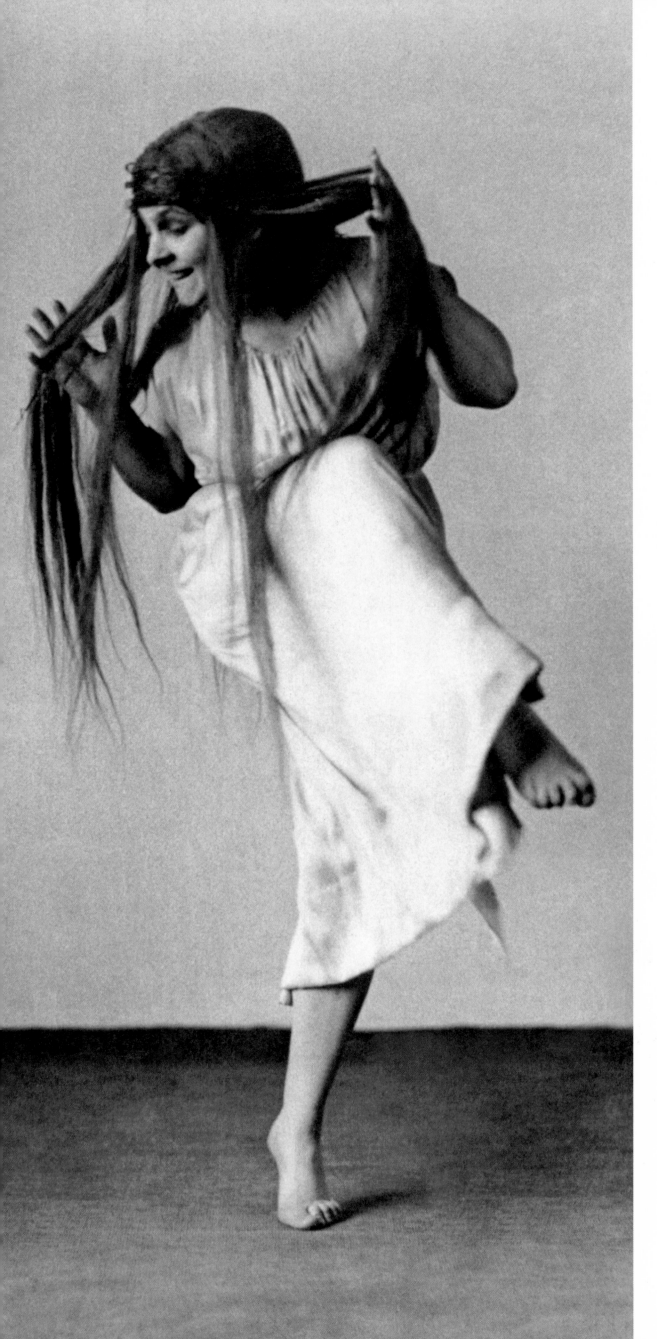

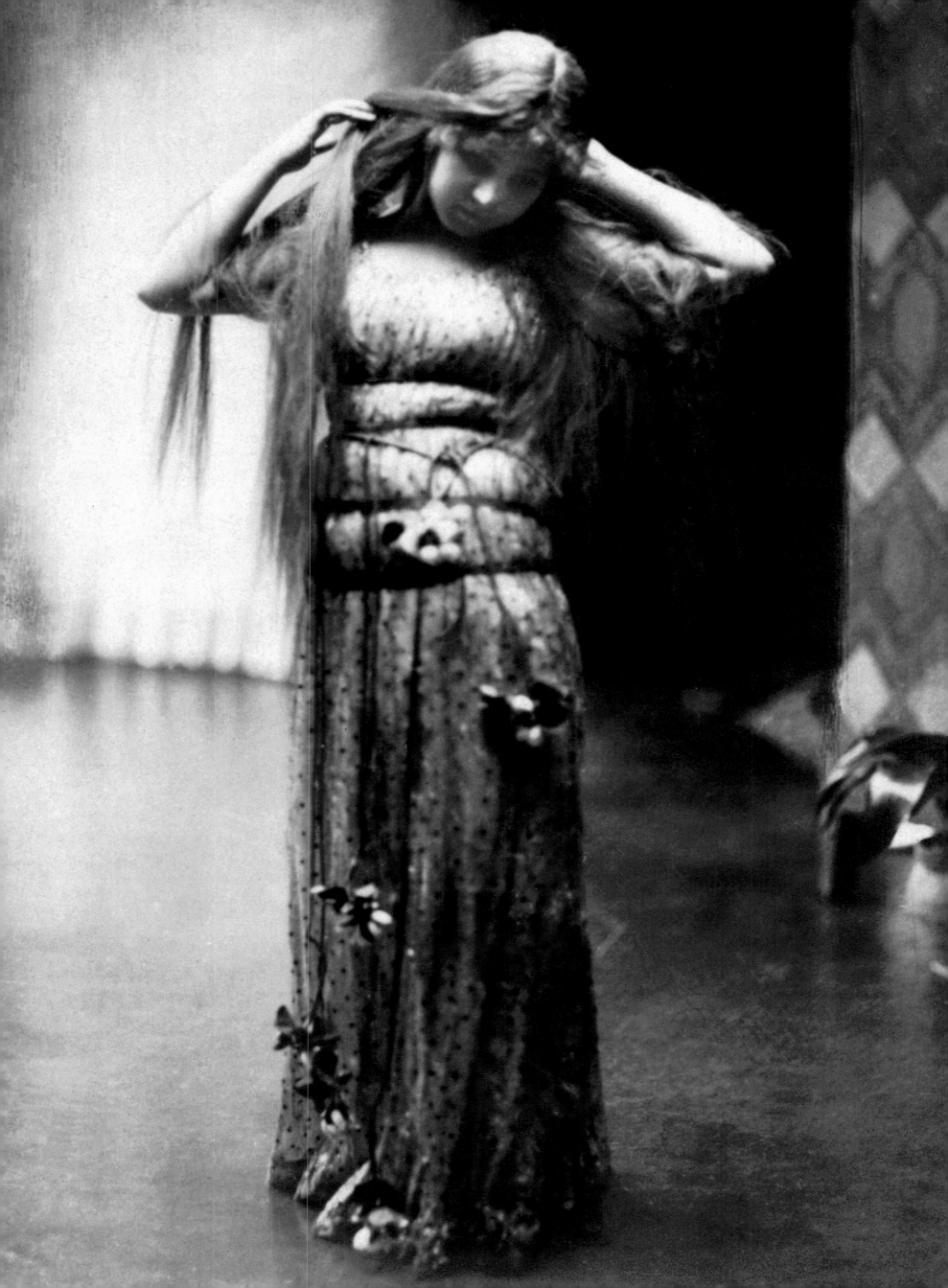

# Marthe Chenal

## (1881/1947)

Her voice is an acquired taste. It had many flaws, to the point that a colleague, tenor Thomas Salignac, described it as a trumpet. Early on, the judges for the conservatory encouraged her not to leave the Moulin-Rouge, where she was already highly successful. Nevertheless, she stuck it out and managed to make her mark. There is no doubt that it was her rare beauty and perfect physique that led enamored fans to flock to her door. She electrified the Salle Favart by replacing Mary Garden as Aphrodite and eclipsing her with her sheer carnal presence. She topped herself when she created another Frédéric d'Erlanger opera, *La Sorcière.* The honesty and passion of her acting surpassed even the great Sarah Bernhardt, whom everybody remembered from the original Victorien Sardou play. She created a sensation with a lorgnette and a string of pearls cascading over her daring décolletage as Mademoiselle Lange in *La Fille de Madame Angot.* And on the evening of the armistice, she wrapped herself in the tricolor flag and sang "La Marseillaise" from the steps of the opéra. The greatest of the greats dreamed of writing operas for her. Gabriel Pierné set Musset's *Badine* to music for her and gave her the opportunity to sing Camille. Anybody would have killed to see her in Cannes in 1921, playing Milady in the *Trois Mousquetaires,* written for her by London maven Isidore de Lara. Yet this free-living beauty quickly adopted a bourgeois attitude and ended up a fat smoker, playing bridge with her old friends from the Opéra Comique.

Chenal means charm. And she's playing Aphrodite!

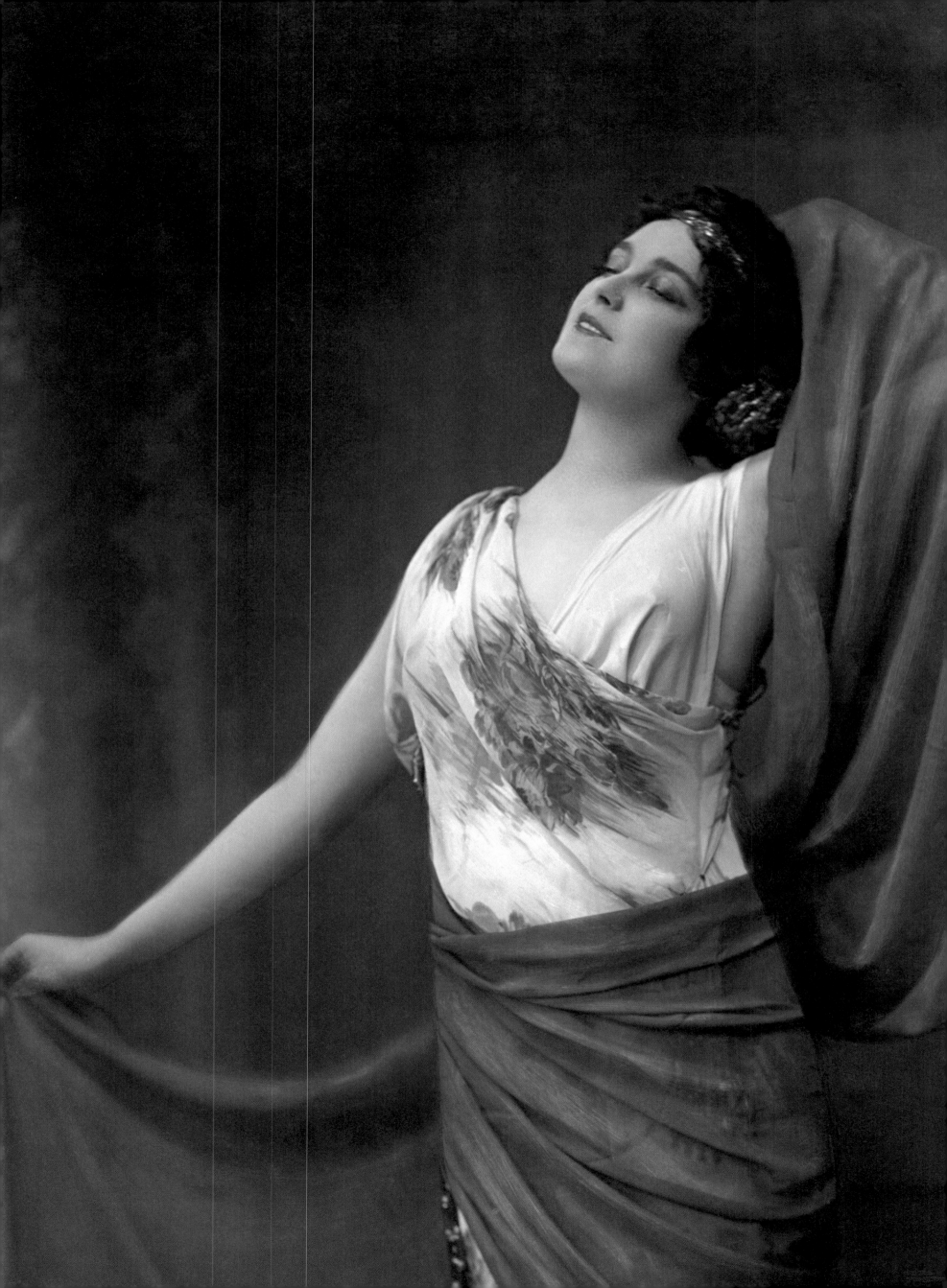

# Emmy Destinn

## (1878/1930)

A good musician, she played violin (and showed as much onstage in Dalibor) and even, it is said, the accordion. Nothing could frighten her: She even allowed herself to be locked in a cage with a real lion in the film *Löwenbraut.* Arthur Rubinstein used to tell the story of how he nearly lost his cool when, during a youthful passionate encounter, he discovered the boa she had had tattooed on her thigh. A devoted patriot, she left the Metropolitan Opera in the midst of the First World War to return to her homeland, but soon found herself cloistered in her chateau in Straz by the Austrian authorities, whom she considered the occupant. Of course, her "prison" was a golden one: It had a lake for canoeing; a library with seven thousand volumes dealing with occultism, necromancy, theology, and literature; as well as a sitting room devoted to souvenirs of Napoleon, including one of his legendary hats. A national heroine, she made a profound impact thanks to a fiery voice and the resolve and passion required by her exceptionally large repertoire, which ran from Mozart's Anna to Giuseppe Verdi's Aida via Richard Wagner's Senta (the first to be played in Bayreuth), Richard Strauss's Salomé, and Giacomo Puccini's *la Fanciulla del West* (created with Enrico Caruso and conducted by Arturo Toscanini). Her other conductor at the Metropolitan Opera was Gustav Mahler, who conducted her in *Die Zauberflöte,* The *Queen of Spades* (*Pikovaya Dama*), and *Figaro.* Her personal generosity was as unlimited as her vocal enthusiasm. Yet once she was confined to her chateau (in the company, it must be said, of a lover—the baritone Dinh Gilly, who, as a Frenchman, was also immobilized), she let her weight get the better of her. Once peace returned and the borders reopened, her voice was still immaculate, but other fashions had come, and other idols had replaced her. She withdrew to her property and died in 1930, completely forgotten at 52. And yet no other diva ever equaled the quality and projection of her voice.

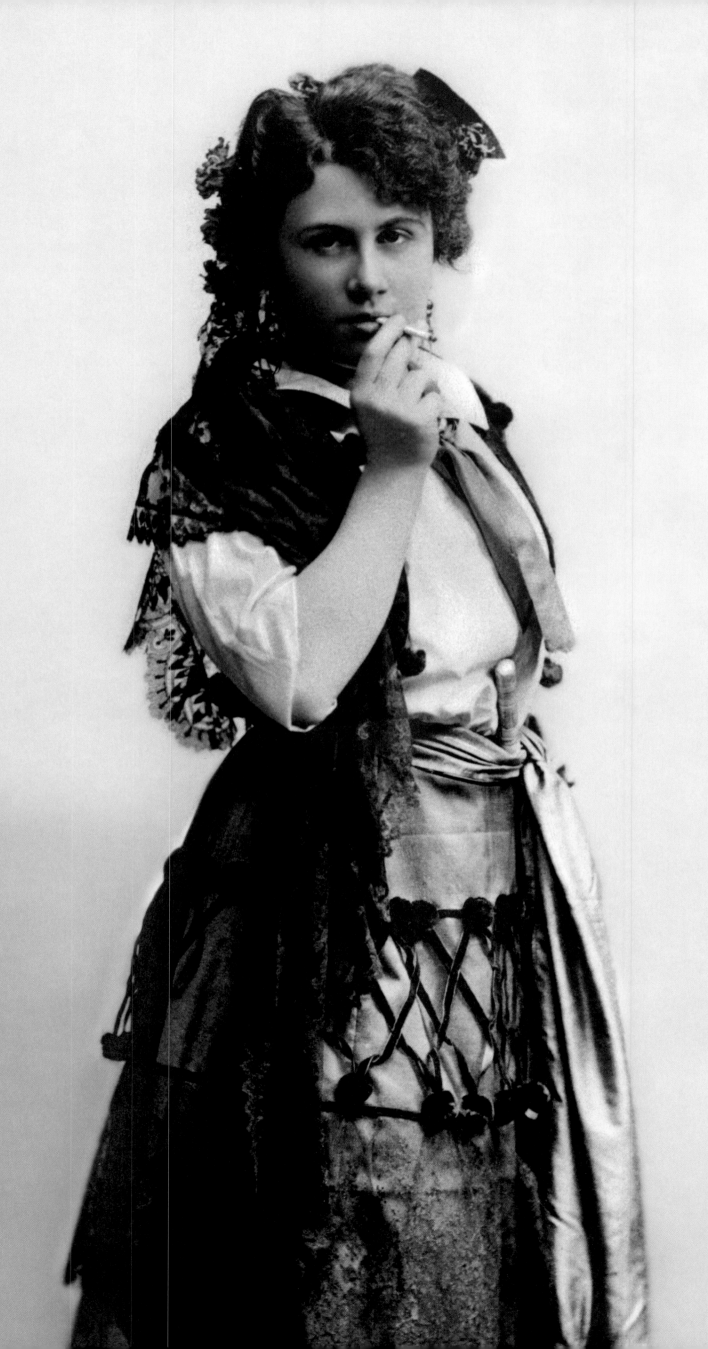

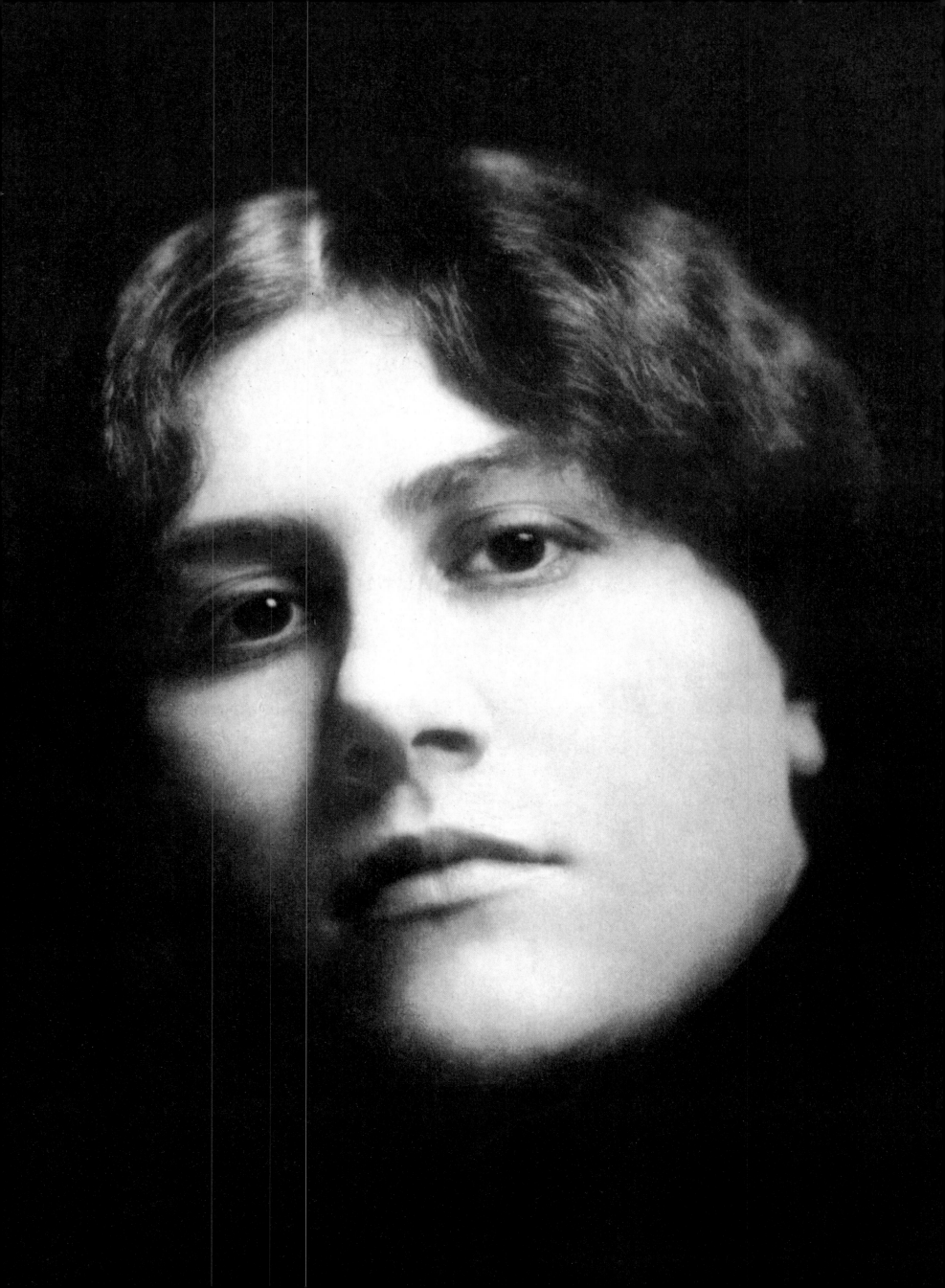

# Germaine Lubin

## (1890/1979)

Her initial fame had nothing to do with singing: She was "Toi" in *Toi et Moi*, a play by her husband, the poet and playwright Paul Géraldy. This slender blonde with astonishingly blue eyes drew light so beautifully that Carl Dreyer considered making a film with her soon after he finished his *Passion of Joan of Arc*. Her pleasant appearance and splendid deep voice opened the doors to a great Parisian career. Indeed, her reign over the Opéra de Paris started under Jacques Rouché, spanned the entire interwar period, and even stretched into the war years. Thanks to Géraldy's great reputation in Vienna, she had begun her career there and won the admiration of Hugo von Hofmannsthal and Richard Strauss. Spurred by her tireless perfectionism and her fascination with the great German parts (Strauss and, especially, Wagner), she took courses with the first-class soprano Lilli Lehmann at the Mozarteum. Max Reinhardt, who had directed her in Monte Carlo for the French premiere of *Der Rosenkavalier,* wanted her for his *Fledermaus,* but Lubin turned down the invitation, choosing instead to go to Salzburg to play Anna in a *Don Giovanni* conducted by Bruno Walter. Her performance was such a stunning virtuoso turn that even the orchestra stood to applaud. After *Don Giovanni,* she played Iphigenia at the Concertgebouw in Amsterdam. Her conductor for Iphigenia, Pierre Monteux, compared her to a Stradivarius. Her triumphant Elektra, played in Paris under the direction of Marie Gutheil-Schoder, Mahler's favorite opera singer, achieved the unique honor of being featured on the cover of *L'illustration,* a popular French weekly. She played Ariadne for Richard Strauss's 75th birthday in Berlin, then achieved her lifelong goal of playing Isolde in the high temple itself, Bayreuth, in the summer of 1939. But the outbreak of war caused Lubin to leave the festival before it had closed and, though invited back, she refused to sing in Germany throughout the war. She did not give up on Isolde, however. She sang the part in occupied Paris, giving Jean Cocteau cause to write her that she had revived his "deepest spirit." Unfortunately, others took Lubin's performances quite differently: In the realm of Valhalla, too much beauty and too many triumphs unleash jealousy and calumny. Despite the war prisoners and victims she had managed to save through her direct interference, Lubin was condemned to national indignity. She was eventually cleared, but it was too late. Her voice had been irredeemably broken.

Germaine Lubin in *Alceste*. Christoph Willibald Gluck wanted "marble to come alive."
His wish is her command.

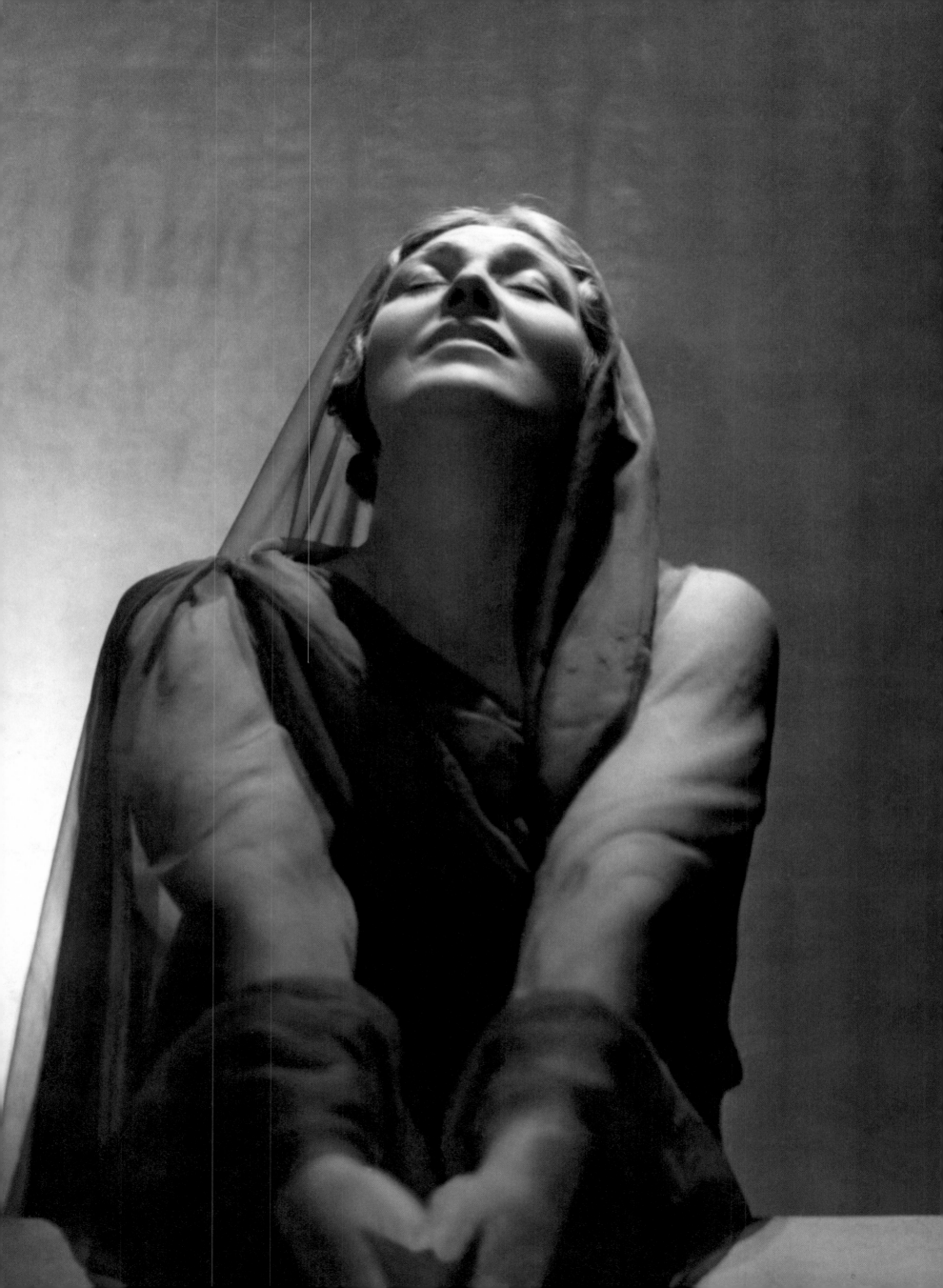

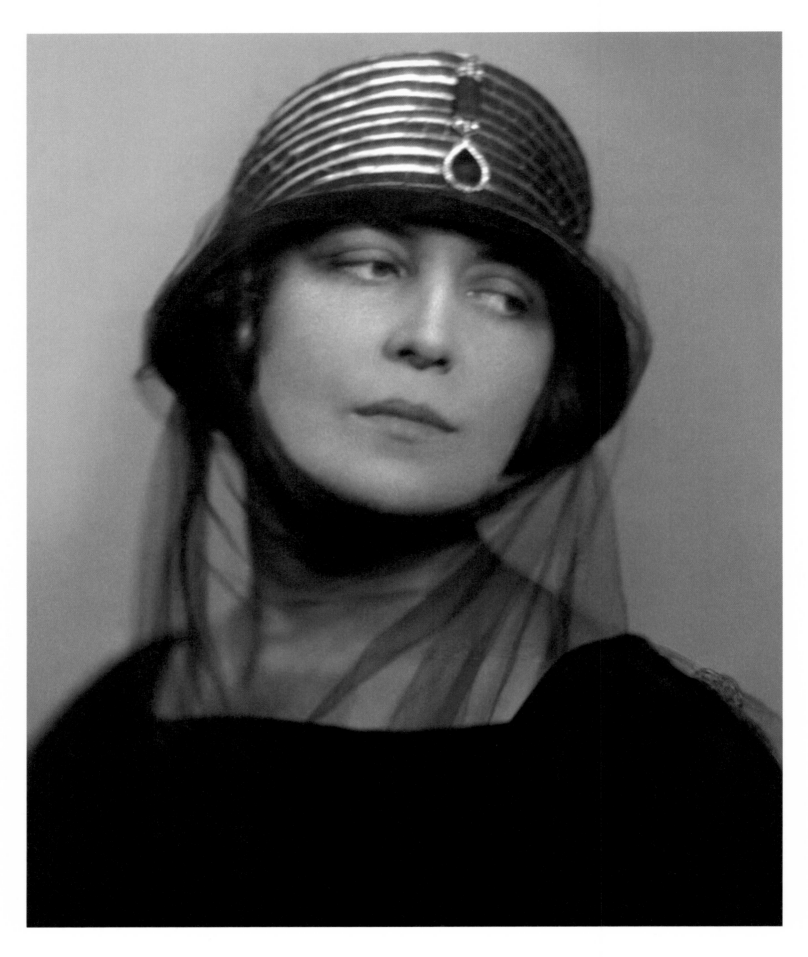

ABOVE:
Germaine Lubin at 30: "Toi" in Paul Geraldy's *Toi et Moi*. A face and a smile worthy of Da Vinci.

RIGHT:
She herself referred to this photo as "the stone mask". Penelope waiting.

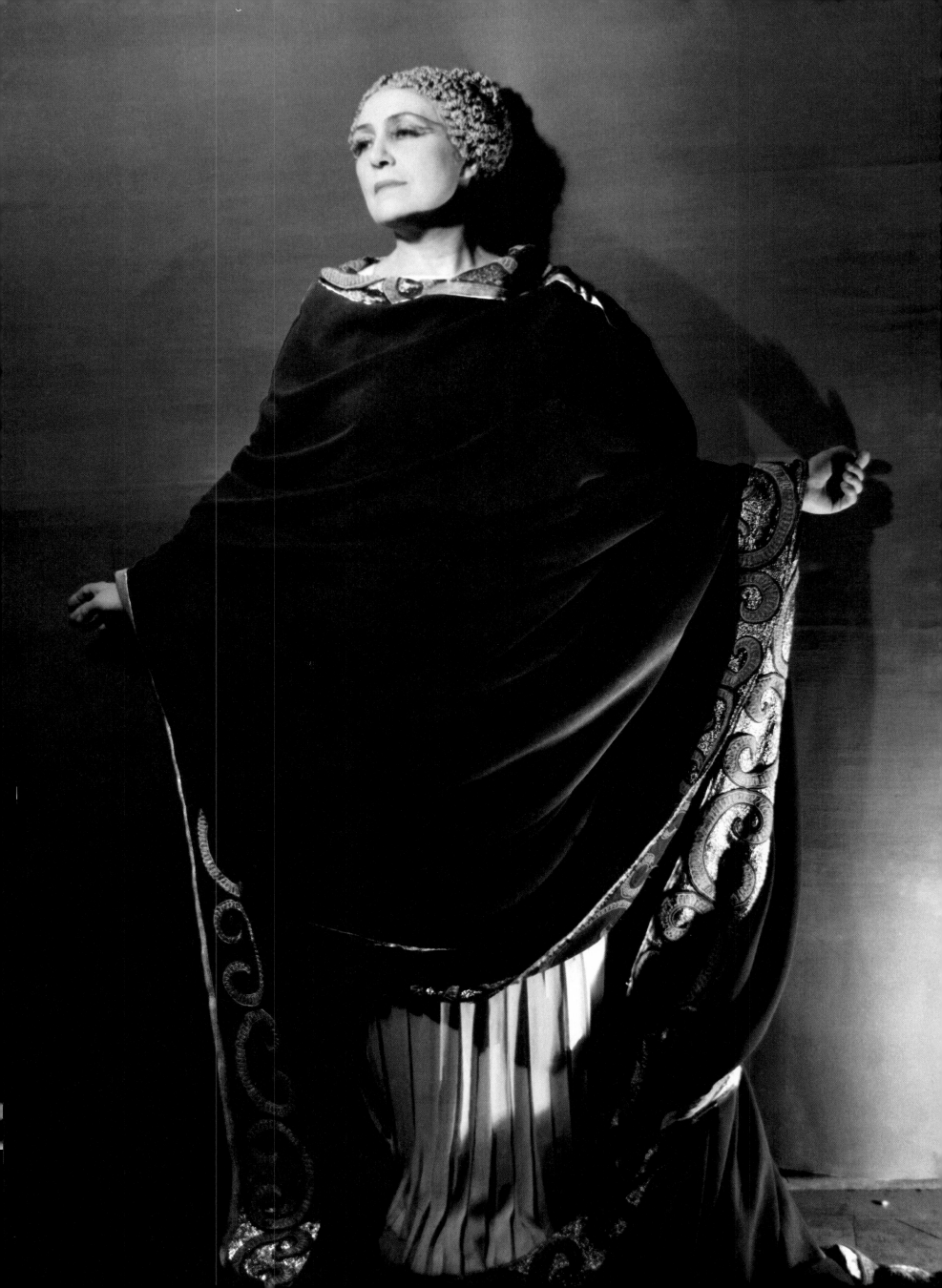

# Rosa Raisa

## (1893/1963)

She grew up in poverty in Bialystok, a forlorn corner of Poland that was heavy on pogroms. As a Jew, she was lucky to escape Bialystok in 1906, when she was 13. Italy was hospitable to her: Patrons of the arts helped her to develop her voice's incredible potential. The great Barbara Marchisio, an illustrious interpreter of Rossini, took her on for individual lessons. Her paradoxical beauty, which somehow combined luminosity and darkness, took care of the rest: At barely 20, she was ready to sing anything in the repertoires of Verdi, Mozart, and Meyerbeer. She made her debut in Parma, in Verdi's rare *Oberto,* went straight on to the Colon in Buenos Aires, then to Chicago, her home base for twenty years. In Chicago, she appeared in a phenomenal variety of roles, the most memorable of which include a sublime Norma, an Aida unmatched in her period for dramatic and vocal expressivity, and an unforgettable *La Juive.* According to Raisa, the human horror she had witnessed during the pogroms were responsible for her voice's poignant emotional depth. In Berlin, in December 1933, mixed in with La Scala stars hired for a gala performance, the singer born Raitza Bursztein had the bitter satisfaction of being applauded by Hitler and Goebbels. Following her Francesca da Rimini, the composer Ricardo Zandonai told her: "Divinity is within you." Giacomo Puccini had wanted her for *La Rondine,* the lightest of his operas, but after his death, she wound up singing his heaviest role: Turandot. During the famous Enigmas scene, she even managed to drown out the chorus and the orchestra with Turandot's impossibly sustained high notes, despite an unrelenting Arturo Toscanini's presence on the rostrum! In fact, Toscanini had specifically hired her to play another tragic role, Asteria in Arrigo Boito's *Nerone* (also a posthumous work), an opera whose world premiere he delayed until Chicago had given Raisa a leave of absence. Raisa sang with a power, freedom, and ability that remained boundless to the end, to the point that the other Rosa, the unique and much-loved Ponselle, spoke of her as "the great Rosa." Her records, which are numerous but rudimentary, bear witness to her splendor but naturally constrict the impact of a voice that may have been the largest and most brilliant voice of the twentieth century. Which leaves us with these sublime photos, documents that reveal her magnificent bearing and complete the image of a tragedienne who graced the stage with a purely royal presence.

Rosa Raisa: with her perfect Jewish beauty, and her fiery voice.

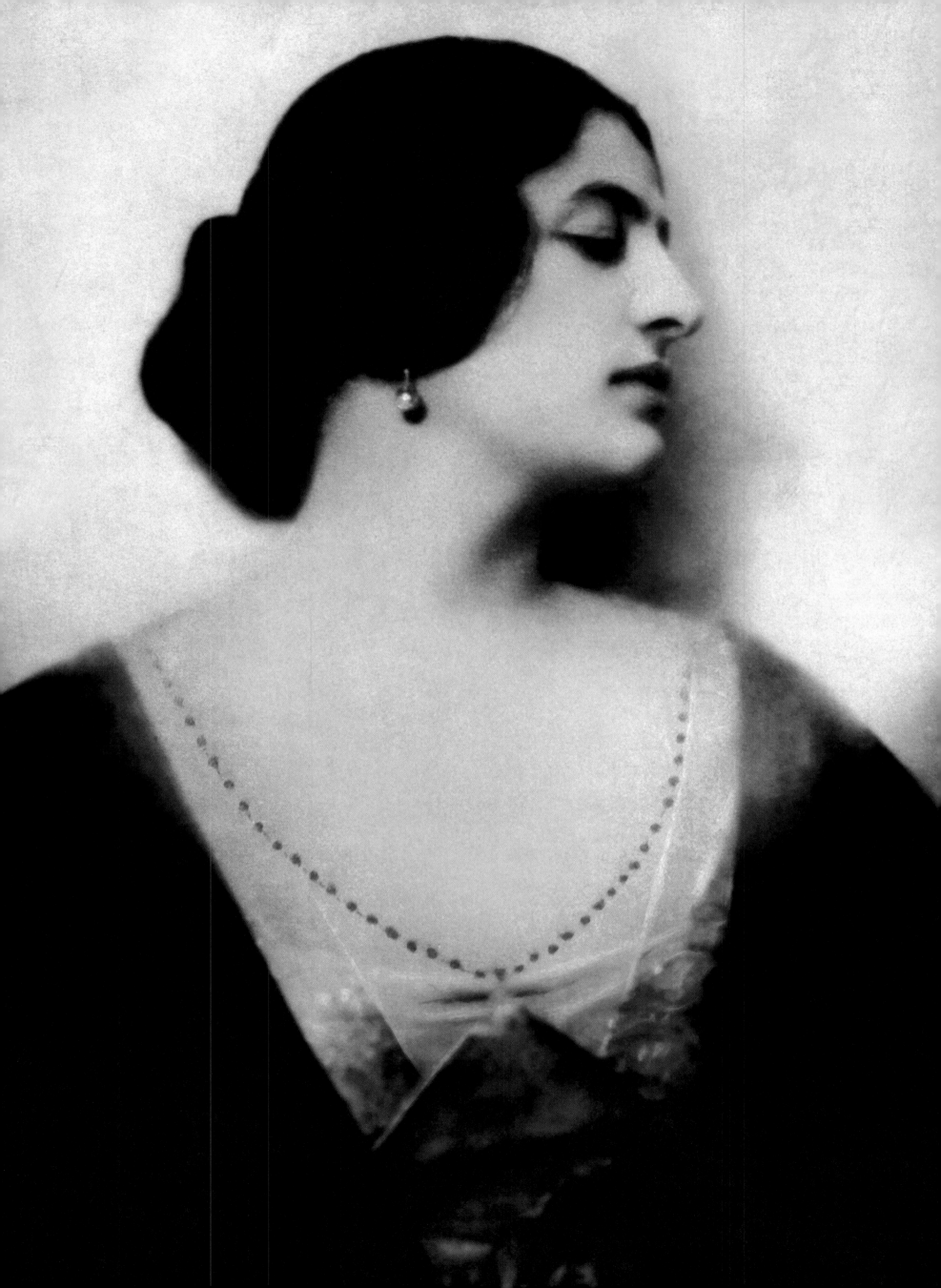

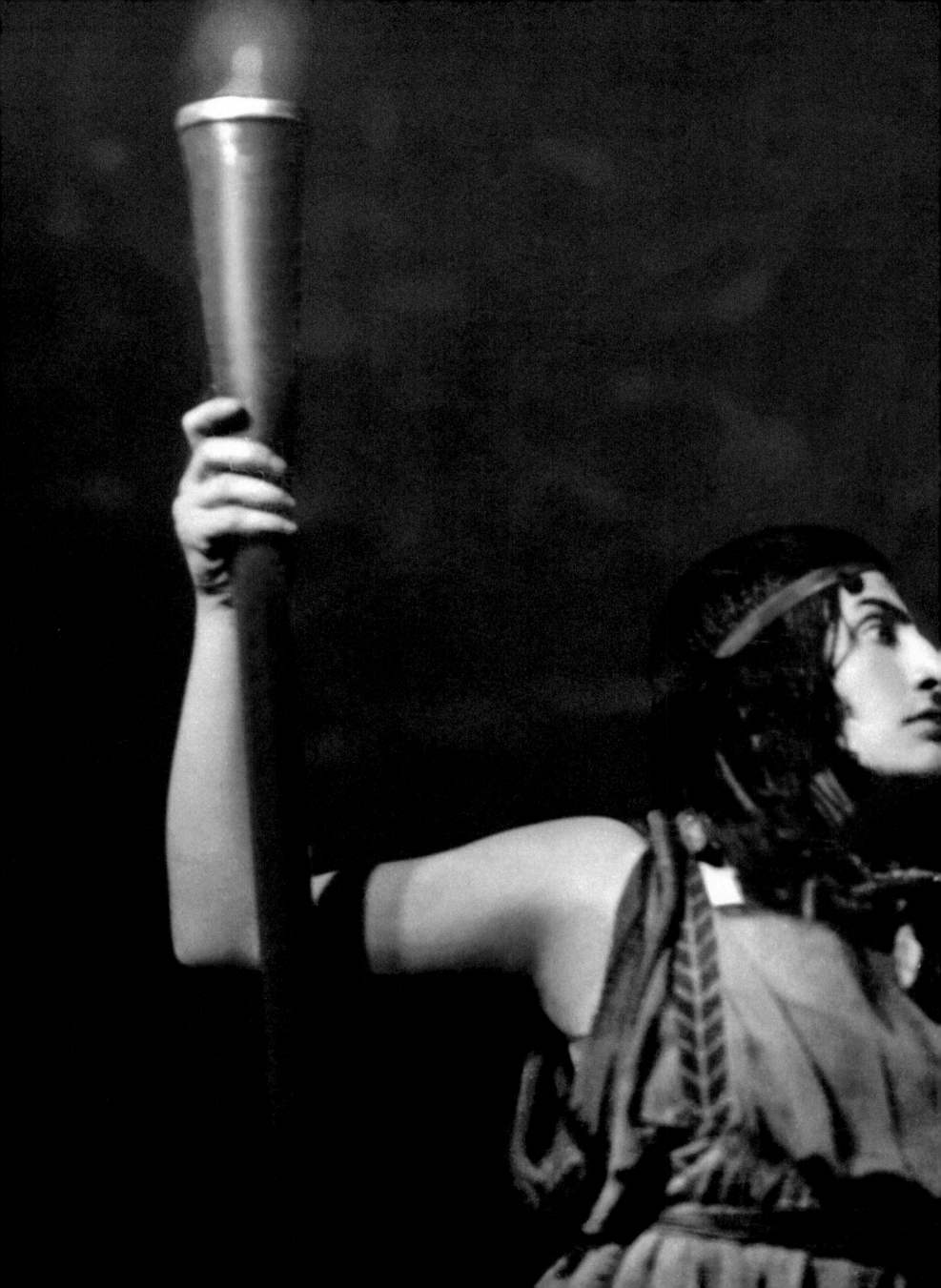

This books comes with a CD including the following famous opera airs:

A plaster statue? Actually no. Félia Litvinne,
sporting one of these plastic poses fashionable at the time.

PREVIOUS PAGES
Raisa as Asteria in *Nerone*: her face and her gestures were the essence of tragedy.

118

# PHOTO CREDITS

Flamboyantly daring, but ultimately sacrified: Violetta in *La Traviata* is the epitome of the diva.
She is featured here as she falters under the shower of banknotes that pay her.
The curtain is soon to fall onto Maria Callas at the Scala (1955). The divas are dead indeed.